Jacques Callot

JACQUES CALLOT

Artist
of the Theatre

GERALD KAHAN

THE UNIVERSITY OF GEORGIA PRESS
ATHENS

Library of Congress Catalog Card Number: 73–76787
International Standard Book Number: 8203–0345–3

The University of Georgia Press, Athens 30602

Set in 12 on 14 pt. Linotype Garamond No. 3
Printed in the United States of America

For my father and grandfather

Contents

Preface

My interest in Jacques Callot was awakened many years ago when I first encountered his incomparable series *I balli di Sfessania*. Since that time these *Commedia dell'arte* figures have reappeared constantly, not only as examples of a historical form but as symbols of the theatrical idea itself: a vital, fluid alternative for the traditional masks of comedy and tragedy. The more intrigued I became with Callot, the more I discovered of his wide range of genius. My own admiration was supported by the constant stream of praise afforded him by all the art historians who considered his works. He is generally conceded to be the "father of French etching" and a "master of graphics," credited with having produced some fourteen hundred etchings and engravings and approximately two thousand sketches and drawings.

Most of these etchings exist as single prints. Some can still be found in their original context where they were intended to illustrate souvenir or presentation books or printed editions of a play. A good example would be Callot's etchings for Bonarelli's tragedy *Il solimano*. It is occasionally possible to find the bound text complete with the six illustrations. Generally the prints are removed from the book and sold individually by the dealers. I have examined several hundred of Callot's original prints in various museums and private collections. His vast output is scattered throughout the world with some of the more impressive holdings to be found in the Bibliothèque Nationale, the Hermitage, the Chicago Art Institute, Princeton University, the British Museum, and the New York Metropolitan Museum of Art.

His plates range in size from miniatures about the size of a half-

dollar to large folios, sometimes twenty-five feet square, which depict extensive landscapes. Some are simple line sketches of solitary figures, while others are so detailed that one needs a magnifying glass to study them. Callot's subject matter is of endless variety. He was intrigued by the religious as well as the secular and could depict with equal ease a saint or a prince, a crucifixion or a hanging, a host of angels or a gaggle of gypsies. He was especially interested in the theatre of his day, both in Italy and in his native Lorraine.

Most of the books dealing with Callot are in French, while a few are in German, English, or Russian. None of them, however, deals exclusively with the work he has done for the theatre. These pieces when taken from the total canon provide a body of work which can be studied from a self-contained perspective. I have carefully examined all of Callot's prints either in their original state or in reproduction. Those which have been selected for treatment in this book are deemed theatrical according to the following criteria: a theatrical event is one which represents an action through the medium of performers on a stage for an audience. Thus any print which depicts such a representation or its performers or the stage used or the audience in attendance is included. Most of Callot's pieces are highly dramatic in nature. For example his series *The Punishments* depicts a variety of tortures common in his day. The victims appear in a somewhat theatricalized setting surrounded by curious onlookers, but the prints deal with the action itself rather than a representation of it and are not within the scope of this study. Perhaps it would be more accurate to say that the materials of this book deal with the representations of representations. Among his many works Callot records the formal tragedies, *intermezzi,* and operatic works of the ducal court, the familiar and not-so-familiar characters of the *Commedia,* the theatre of the streets, the fairs, the mountebanks, the stylized combats at the barrier, the troupes of deformed dwarfs, the river spectacles, and the elaborate allegorical procession wagons of the Florentine festivals. All of these pieces can be studied from various points of reference. In particular, they are a rich source of information for the theatre historian or practitioner since they record numerous details of costuming, stage business, bodily postures, physical staging, properties, musical instruments, settings, audience behavior, indeed much of the knowledge one would need in order to recreate or understand the theatrical moment. It is the intent of this work, therefore, to examine the theatrical world of Jacques Callot the better to understand it and the artist who recorded it.

Since Callot's biography is readily available, it is not the purpose here to deal with critical controversies surrounding his life and work, nor to dwell on those aspects of his art and career which are not immediately relevant to the intent of this book. The opening chapter is designed to provide a number of chronological points of reference as well as certain observations which will illuminate some of the works to be considered in the remainder of the study. Subsequent chapters will deal with such subjects as Callot's treatment of the *Commedia dell'arte,* Renaissance festivals, the formal court theatre, and various other theatrically relevant materials.

The standard critical work on Jacques Callot is the five-volume set by Jules Lieure entitled *Jacques Callot.* Part I, *La vie artistique,* comprises two volumes and Part II, *Catalogue de l'oeuvre gravé,* comprises three volumes. This second part contains reproductions of the prints, critical and historical commentary on them, and an assigned catalog number for each. Edouard Meaume in his *Recherches sur la vie et les ouvrages de Jacques Callot* assigns his own numbers to the prints. Both the Lieure and Meaume numbers are used here for initial identification, that is, L. 180 / M. 638.

The following rationale has been adopted for the titling of most of the illustrations in this book. The Callot title is used if it is inscribed on the print itself and clarifies the piece, either in French, Italian, or Latin; otherwise the Lieure catalog designation is given. The Callot, or Lieure, title is followed by an English approximation.

Most proper names are not rendered into English where the translation would be obvious.

The sequence of prints discussed in each chapter may seem somewhat arbitrary. They are treated in order of significance and interest rather than according to their chronology. Thus plates from *The Caprices* and others conceived when Callot was in Florence may follow those works done by the artist when he had returned to Nancy.

Various words are used interchangeably throughout the text, namely, *interlude, intermezzo, intermède, intermedio; etching, plate, print, work* (etchings and engravings are carefully distinguished); and *wagon, chariot, machine, pageant wagon, float.*

Callot's prints exist in various states. Some are unique in that the copper plates have never been altered from the time they were first created. Other plates have undergone modifications such as numbers being added or the wording altered to the extent that as many as three or four different states have been formed.

A number of the sketches and drawings by Callot are related to the theatrical etchings. He used them to work out various ideas of composition, body postures, costuming, and other details. Unfortunately they are not always identified, and it would be mere conjecture to determine consistently their exact relationship to the prints. Moreover, a study of these sketches and drawings is of primary interest to the art historian rather than the theatre historian, and consequently they are not given more than passing attention in this work.

Acknowledgments

My very special thanks are given to Professors Oscar G. Brockett, George R. Kernodle, and Orville K. Larson whose wide knowledge and judicious advice have helped to make this a better book.

Sincerest thanks are given to the following for their permission to reproduce prints from their collections.

National Gallery of Art, Washington, Rosenwald Collection: Fig. 1 *Frontispiece to the Balli di Sfessania*, Fig. 2 *Cucorongna and Pernoualla*, Fig. 3 *Cap. Cerimonia and Signora Lavinia*, Fig. 5 *Cicho Sgarra and Collo Francisco*, Fig. 6 *Gian Fritello and Ciurlo*, Fig. 7 *Guatsetto and Mestolino*, Fig. 8 *Riciulina and Metzetin*, Fig. 9 *Pulliciniello and Signora Lucretia*, Fig. 10 *Cap. Spessa Monti and Bagattino*, Fig. 13 *Cap. Bonbardon and Cap. Grillo*, Fig. 14 *Cap. Esgangarato and Cap. Cocodrillo*, Fig. 15 *Cap. Mala Gamba and Cap. Bellavita*, Fig. 16 *Cap. Babeo and Cucuba*, Fig. 17 *Fracischina and Gian Farina*, Fig. 19 *Razullo and Cucurucu*, Fig. 20 *Pasquariello Truonno and Meo Squaquara* Fig. 21 *Signora Lucia and Trastullo*, Fig. 22 *Cap. Cardoni and Maramao*, Fig. 24 *Taglia Cantoni and Fracasso*, Fig. 29 *Round Dance*, Fig. 30 *Two Pantaloons Back to Back*, Fig. 31 *Two Pantaloons Face to Face*, Fig. 45 *The Fan*, Fig. 48 *The Entry of MM. de Vroncourt, Tyllon and Marimont*, Fig. 49 *The Entry of MM. de Couvonge and de Chalabre*, Fig. 50 *The Entry of MM. de Couvonge and de Chalabre* (supplementary plate), Fig. 51 *The Entry of M. de Brionne*, Fig. 55 *The Procession on Foot*, Fig. 57 *Fireworks on the Arno*, Fig. 58 *A Festival at the Square of the Signoria in Florence*, Fig. 61 *Second Interlude*, Fig. 63 *Frontispiece to Il Solimano*, Fig. 68 *Il Solimano Act V*, Fig. 70 *Frontispiece to the Gobbi*, Fig. 71 *Dueller with Two Sabres*, Fig. 72 *Dueller with*

Sword and Dagger, Fig. 73 *The Violin-Player*, Fig. 74 *Masked Figure with Twisted Legs*, Fig. 75 *The Lute-Player*, Fig. 76 *Masked Comedian Playing the Guitar*, Fig. VII *Man with a Large Sword.*

National Gallery of Art, Washington, Rudolf L. Baumfeld Collection: Fig. 4 *Smaraolo Cornuto and Ratsa di Boio*, Fig. 11 *Scaramucia and Fricasso*, Fig. 12 *Scapino and Cap. Zerbino*, Fig. 18 *Bello Sguardo and Coviello*, Fig. 23 *Franca Trippa and Fritellino*, Fig. 25 *Pantalone*, Fig. 26 *The Captain or Lover*, Fig. 27 *Zanni or Scapino*, Fig. 28 *Two Comedians*, Fig. 33 *The Wagons and Participants*, Fig. 34 *The Entry of the Wagons of Africa and Asia*, Fig. 35 *The Infantry Battle*, Fig. 37 *The Wagon of Mt. Parnassus*, Fig. 38 *The Wagon of Thetis*, Fig. 40 *The Wagon of the Sun*, Fig. 41 *The Wagon of Love*, Fig. 42 *Ensemble View*, Fig. 46 *The Entry of the Prince of Phalsbourg*, Fig. 47 *The Entry of M. de Macey*, Fig. 52 *The Entry of Henry of Lorraine*, Fig. 54 *The Entry of Duke Charles IV*, Fig. 56 *The Combat at the Barrier*, Fig. 59 *The Public Square of Nancy*, Fig. 60 *First Interlude*, Fig. 62 *Third Interlude*, Figs. 64–67 *Il Solimano Acts I–IV*, Fig. 77 *The Fair at L'Impruneta*, Fig. XIV *The Temptation of St. Anthony* (Second Version).

St. Louis Art Museum: Fig. 32 *January*, Fig. II *February.*

New York Public Library: Fig. 36 *The Plans of the Maneuvers.*

Columbia University: Fig. 69 *Frontispiece to L'harpalice.*

Jacques Callot

 Introduction

Jacques Callot was born in Nancy sometime in 1592; the exact day has not been verified. His father, Jean, was closely associated with the court of Duke Charles III of Lorraine and served as painter, heraldic designer, and organizer of various court festivities. When Charles III died, Jean Callot supervised the details of his funeral. Jacques was exposed to the visual arts at an early age. As a boy he was apprenticed to the goldsmith-engraver Demenge Croq and presumably studied under Claude Henriet and Jacques Bellange. Legend has it that Callot ran away to Italy twice by the time he was fifteen years old. It is much more certain, however, that he left Nancy some time after the funeral of Charles III and arrived in Rome during the winter of 1608–1609.

Callot remained in Rome almost three years. Upon his arrival he studied drawing with Antonio Tempesta and then went to work for the engraver Philippe Thomassin who instructed him in the use of the burin. Callot also met Francesco Villamena at Thomassin's studio, and it is believed that Villamena "gave Callot the idea of putting large figures in the foreground to give distance to the landscapes in the background."[1] During his apprenticeship Callot copied the Collaert engravings depicting the months of the year and some time later assisted Tempesta by etching a number of drawings the latter had done for *The Funeral Book of the Queen of Spain*. Callot left for Florence at the end of 1611 to deliver the drawings and etchings to Giulio Parigi who was in charge of the funeral ceremonies.

Parigi was to exert a most significant influence on the artistic career of Jacques Callot. Parigi was attached to the Medici court as

an architect, engineer, artist, and as designer and director of many of the theatrical events and festivities so popular during the reign of Cosimo II. Callot studied with Parigi from 1612 to 1615 and remained in Florence for a decade where he produced or conceived some of his most important pieces.

On 18 October 1614 he had formally entered the service of the Medici. This sponsorship relieved him of the necessity of earning his living by copying the works of other artists and executing various hack assignments. One of his major projects from 1615 to approximately 1620 was the completion of a series of sixteen engravings entitled *The Life of Ferdinand de' Medici*. During these years he also completed his etchings for *The Caprices, The War of Love, The War of Beauty*, the first version of *The Temptation of Saint Anthony, The Fan, L'Impruneta, Il solimano*, several of his early *Commedia* portraits, and numerous other religious and secular pieces.

The Caprices is a landmark in Callot's career for two reasons. It was here that he learned to perfect his almost microscopic backgrounds using the magnifying glass which supposedly had been given to him by Galileo Galilei. Also, Callot made use of his newly developed hard varnish technique. In order to improve upon the soft varnish or groundwork used by etchers of the period, Callot experimented with the harder varnish of the Florentine lute-makers. It enabled him to do more careful, precise, and detailed work, and Callot was so satisfied with it that he later had his special varnish sent to him from Florence after he had returned to Lorraine. Indeed, *The Caprices* can serve as a microcosm of the entire oeuvre. Here in this early work one can find almost all of the characteristics to be observed throughout his career: the exquisite detail made possible by the hard varnish technique, his sensitivity to the human form, his predilection for miniaturizing his figures, the vast range of subject matter, and his dramatic sense of composition.

Cosimo II died early in 1621 and shortly thereafter, as an economy move, Callot's patronage by the Medici was discontinued. He left Florence and arrived in Nancy on 15 May 1621. With his financial security withdrawn and very few commissions coming his way, Callot found the going very difficult and fell into melancholy and despair. He did a large number of minor religious works but also spent a great deal of time and effort etching prints based on drawings done in Italy as well as reetching some earlier Florentine plates. He reetched *The Caprices, The Massacre of the Innocents*, and *L'Impruneta*. He also created on copper *The Gypsies*, the *Gobbi, The Beggars* and his most important series of the period, the *Balli di Sfessania*. Before leaving for a short trip to the Netherlands in 1627 Callot completed his *Fair of Gondreville, The Palace Garden at Nancy, The Carrière of Nancy*, and the elaborate series *The Combat at the Barrier*.

Callot's reputation became firmly established during these years at Lorraine. He was patronized by the court and sought after by various European noblemen who wished to have their military exploits recorded. The middle of 1627 was spent in the Netherlands where Callot researched materials for his extensive work *The Siege of Breda*. While there he had his portrait painted by Van Dyck. Between 1629 and 1631 Callot traveled between Paris and Nancy. He did two more sieges, one of the Isle of Ré and the other of La Rochelle. Callot's friend Israel Henriet became his publisher and Callot supplied him with plates for the rest of his life. In his remaining four years, 1631–1635, Callot lived in Nancy where he executed his second *Temptation of Saint Anthony, The Martyrdom of Saint Sebastian, The Miseries of War, The Punishments*, and five important religious series. Callot developed a serious stomach disorder during these latter years which was further aggravated by the hunched position over his worktable. He died in Nancy on 24 March 1635.

The theatre world in which Callot lived was a varied and exciting one catering to diverse tastes and circumstances. The art, architecture, and literature of the Renaissance looked in two directions

simultaneously: to the ideal of classical Greece and Rome and to the innovations that grew out of experiment, imagination, and the new view of man which marked the humanism of the sixteenth century. Of Callot's exposure to the theatre we know very little other than the specific evidence of his etchings. He was, however, well read and well traveled and lived much of his life among cultivated people. Although only part of his output is directly related to the theatre, he must have been strongly influenced by it for almost all of his work is dramatic in feeling, a quality which can be seen in his choice of theme, his arrangement of figures, his use of theatrelike backgrounds, his tableaulike scenes and the extravagant excitement of his subjects.

The chart included here is intended to place Callot in perspective among some of his significant contemporaries in the arts. Almost all were involved in the theatre in some way, and Callot was personally acquainted with some of them and knew the work of most. The specific cross-influences that existed among these figures is far beyond the scope of this work, but there is little question that in many cases their ideas and techniques touched and fed upon one another and had great impact on the generations to follow. Callot, for example, must have known the work of the great *Commedia dell'arte* troupes of Andreini and Martinelli. Inigo Jones, the great seventeenth-century English architect and designer, was strongly influenced by Callot. Several of his antimasque characters for *Chloridia* and *Salmacida spolia* are strongly reminiscent of Callot's style, but many of the figures from Jones's 1631 masque *Love's Triumph through Callipolis* are almost identical to those of *Iballi-di Sfessania*. Art historians have pointed to the impact Callot had on Rembrandt and Velásquez, Goethe and Sir Walter Scott mention him in their writings, and Bechtel gives further evidence of Callot's influence:

The popular German romanticist, E. T. A. Hoffman, described his novel, *Prinzessin Brambilla*, as a "Capriccio in the manner of Callot." He also appropriated eight etchings of the *Balli* set for illustrations and called his four volumes of tales *Die Fantasiestücke in Callots Manier.*

With the same poetic license and imagination, Gustav Mahler composed a "Dead March in Callot's Manner" in the fourth movement of his *Symphony in D Major, No. 1.* Perhaps Mahler, in this ironic, macabre music, had in mind Callot's *Temptation of St. Anthony,* where devils burlesque the playing of many musical instruments.

The number of times Callot has been mentioned in French literature is beyond discovery.[2]

During Callot's lifetime significant theatrical developments were taking place in England, Spain, France, and Italy. Callot's familiarity with these events are limited to the two latter countries since this is where he spent almost all of his years.

He was not yet born in 1576 when James Burbage built England's first permanent playhouse, The Theatre, and was twenty-one when the first Globe burned down in 1613. Queen Elizabeth had reigned for over a quarter of a century during this thirty-seven-year span and had nurtured the greatest period of English theatre. Marlowe and Shakespeare had written all of their plays, Ben Jonson was becoming the most significant author of the day, and such other public playhouses as The Curtain, The Rose, The Swan, The Fortune, and The Hope were in full operation. In addition, the court masques which were directly influenced by the Italian *intermezzi* had been brought to perfection with the collaboration of Ben Jonson and Inigo Jones.

In Spain the *autos sacramentales* of the Middle Ages were now competing for public favor with the *comedias* of Lope de Vega, the most prolific writer of his time, as well as the plays of Calderón who had already achieved his reputation by the time Callot had died. The French theatre was also caught up by the Renaissance ideal. While remnants of medieval staging were still to be found, it was the work of Alexandre Hardy which provided France with a vigorous popular theatre. His tragicomedies and pastorals were often neoclassic in form, medieval in staging, but Renaissance in spirit. At court the *ballet de cour,* so similar to the *intermezzi,* was utilizing Italianate scenery by 1620.

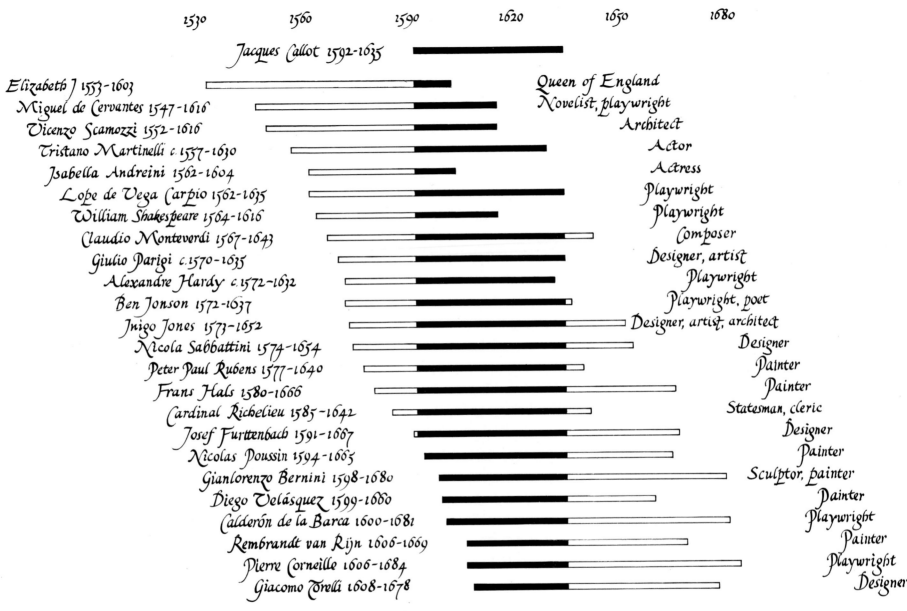

Callot & His Contemporaries

By the time Callot reached Florence early in the seventeenth century, theatrical entertainment had become well established and some of the indigenous forms had found their way to the rest of Europe. Two of these activities are of special interest to us: the *Commedia dell'arte* and the spectacular presentations at court which exploited the new scenic developments. Although the origins of the *Commedia dell'arte* are obscure, there is ample evidence that it had achieved great popularity in Italy shortly after 1550 and before the century was over, troupes had traveled all over Europe spreading its influence and affecting the popular theatre wherever it was seen. It is likely that Callot saw these comedians during his boyhood in Lorraine and it is certain that he was captivated by them in Italy. His etchings for the *Commedia* apparently do not generally depict any specific performers or troupes, but they have so captured their style and grace that they have become, like the masks of tragedy and comedy in modern times, symbols of the theatre and are found on countless books, programs, and posters.

To the best of our knowledge Callot was not a theatre designer. What work he did in this regard in Florence was to record the scenic spectacles that Giulio Parigi had designed for court performances and to illustrate souvenir books of the various extravaganzas sponsored by the Medici. Even when he returned to Lorraine his illustrations of *The Combat at the Barrier* may have been secondhand. But we are indebted to him for providing us with visual evidence of those seventeenth-century spectacles and processionals.

Along with his contemporaries, the Parigis, Cantagallina, Della Bella, and Buontalenti, Callot was among the first of a group of artists to record faithfully the theatrical experience and helped establish the tradition of theatrical iconography so strikingly continued in the following centuries by Torelli, the Vigaranis, the Berains, the Burnacinis, the Bibienas, Juvarra, Piranesi, and countless others.

Although Callot was not a theatrical practitioner, he was thoroughly immersed in the formal entertainment of his time, and his perceptive eye and skilled hand have left us a priceless legacy.

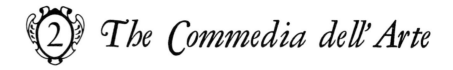

The Commedia dell' Arte

HISTORY AND BACKGROUND

No one can assert with any authority just how or when the *Commedia dell'arte* began. Some scholars see this theatrical form emerging from the social and artistic traditions of sixteenth-century Italy while others present a strong case for its origins in the Atellan farce of ancient Rome with the tradition maintained by itinerant actors during the Middle Ages and the early years of the Renaissance. It is most likely that both of these theories account for the origins and early development of the *Commedia*.

The name *Commedia dell'arte* is difficult to translate. Literally, it approximates "comedy of the artists," implying performances by professionals as distinguished from the courtly amateurs. This form has been given other names which are more revealing of its nature and characteristics. These include *Commedia alla maschera* (masked comedy), *Commedia improviso* (improvised comedy), and *Commedia dell'arte alla improviso*.

The performers of the *Commedia* were a highly skilled group. Many actors would develop a role in the early years of their maturity and play it until they quit the stage. They would become identified with a role by virtue of their stage personality, voice, individual pieces of stage business, and their own unique idiosyncrasies. Female parts were played by women and the *Commedia* provides us with the first significant record of professional actresses. The names of hundreds of characters have come down to us, but they are mostly variations of a few stock types who constantly reappear in the plots.

The largest and most interesting group includes the *zanni*, an

7

array of comic servants, buffoons, braggarts, tricksters, and dupes. Prominent among these is the Capitano whom Callot depicts in many guises. The Capitano shows many similarities to the miles gloriosus type immortalized by the Roman playwright Plautus in the second century B.C. He is a swaggering, blustering, arrogant coward, full of bombast, threat, and vanity who invariably runs from the presence of immediate danger. It is believed that the Italian Capitano, depicted as a vainglorious and ridiculous Spanish military figure, functioned as a kind of satirical commentary at a time when the Spanish mercenary was a familiar figure.

The vast gallery of comic servants retained their popularity in later years when the *Commedia* was adopted and adapted by other European countries, particularly France and England. Arlecchino, the sly and clever acrobat who originally wore irregular patches and a black mask, eventually developed into the French Arlequin and the English Harlequin of pantomime, both easily recognized by the formal triangle or diamond patterns on their costumes. Pulcinella, with his gross belly and humped back, came to England as Punchinello and Punch of the Punch and Judy shows. Pedrolino, in his loose-fitting tunic and white-powdered face, is best known as Pagliaccio (immortalized in Leoncavallo's opera), as the French Pierrot, and in his present-day manifestations as a mime or circus clown. Colombina, a characteristic *servetta* or *fantesca* (serving maid) later appears as Colombine in amorous association with Harlequin or Pierrot.

Another prominent group includes the old men types, notably the Pantalone and Dottore. Pantalone, one of the best-known characters of the *Commedia*, is usually the father of the ingenue and is gullible, prosy, and miserly, tricked by the servants and frequently cuckolded by his young wife. He is of Venetian origin and is usually depicted in a tight-fitting jacket and trousers, with a long black cloak and a hooked nose on his mask. He is Shakespeare's "sixth age," the "lean and slippered pantaloon / With spectacles on his nose and pouch on side," described by Jacques in *As You Like It*. The Dottore is frequently paired with Pantalone. He is often a doctor of laws, letters, or philosophy, his head crammed with an incredible amount of irrelevant knowledge which he usually manages to expound upon in a garbled and comic manner.

Of great importance to the plot, but of considerably less interest than the other parts, are the young lovers. While most of the other characters were masked, they, like the serving maids, were not. They were comparatively dull and insipid, expressing an attitude rather than a characterization. The males, or *innamorati*, appeared under such names as Orazio, Lelio, and Ottavio while the females, or *innamorate*, were called Isabella, Lavinia, and Flaminia. It was around their amorous intrigues that many of the comic plots developed. Finally, many *Commedia* companies included a singer, or *cantarina*, and a dancer, or *ballerina*, who provided specialty numbers.

Actors of the *Commedia* did not perform from written scripts as we know them today. The plot was traditionally set down in the form of a scenario which outlined the main course of the action of the individual scenes and specified the roles. The greater part of the performance was improvised and the dialogue was analogous in its own way to free variations on a musical theme. Certain aspects of the performance, particularly songs and some stock speeches, had a permanent place in the repertory and could be used over and over again as the occasion demanded. Of special interest were the *lazzi*. These were pieces of stage business associated with particular characters, comical and ingenious in nature and often acrobatic. The *lazzi* were eagerly awaited showstoppers, often serving as a trademark of the performer.

Early records indicate that the *Commedia* performances were given by troupes which toured the countryside and cities, playing at fairs, on holidays, for special engagements, or at random. They carried their few properties and costumes and their stage with them. The

stage was a simple affair; little more was needed than several boards across a few trestles and a curtained backdrop behind which the actors could make their entrances and exits. As the popularity of the *Commedia* grew, some of the more talented groups were invited to play at court where they were frequently able to utilize the elaborate stage machinery of the day. These troupes were known by such names as the *Accesi*, the *Confidenti*, and the *Gelosi*.

Callot's works on the *Commedia* are so unique and incisive that he has almost become its definitive visual interpreter. Most of Callot's theatrical prints are contemporary documents recording an actual event in the greatest detail so that they have historical as well as aesthetic value. This is not always true of the *Commedia* etchings. Few, if any, deal with specific actors or companies or performances. They are, as Dr. George Kernodle so astutely suggested to me, "a kind of fantasy capturing the essence of movement and appearance. Apparently the companies which we know did not do this much dancing. But dance they certainly did, and perhaps the *Balli di Sfessania* is a dream of dancers based on the idea of *Commedia* characters." Most of the costumes and postures are different from anything we have seen elsewhere. Many of the names he gives to the characters have not been recorded in other sources. It is almost as though Callot has created an abstract visualization of the theatrical ideal.

BALLI DI SFESSANIA
(L. 379–402 / M. 641–664)

Callot's masterpiece on the *Commedia* is his series of plates entitled *I balli di Sfessania*, etched in Nancy in 1622(?) from drawings made some years earlier in Italy.

The set is very rare. It must be seen in the handsome proofs of the first state drawn at Nancy, especially on the paper with the "Angel" or "Double C" watermarks which reveal all the details of facial expression as well as the backgrounds which were done with a light touch. These have disappeared from subsequent pullings. . . . The complete set was numbered 1 to 24 by Fagnani at the beginning of the 18th century. The plates are preserved at the Musée Lorrain in Nancy.[1]

The series consists of a frontispiece showing some of the actors on a stage in a scene and twenty-three other etchings, each depicting a pair of performers in a stylized, characteristic pose. The movements are highly fluid, not only in the individual figures, but also in the unity of the pairings. The eye is taken on a graceful journey of curves, swirls, and arabesques, and the visual rhythms are created through the use of the complete body, a turn of the head, the torso, legs and arms, and even fingers. In almost every pairing, far in the background, there is a center of interest in miniature between, and sometimes flanking, the major figures. At the center is usually found a group of comedians engaged in some characteristic action—acrobats jumping or tumbling, a mock combat, someone on stilts, a serenade, a beating, dancing figures, and even a play in performance. The whole panoply of the *Commedia* is spread before our eyes, in large detail and in microcosm. Except for five young ladies all of the characters are masked and many of them are wearing a phallus enhanced comically with a cloth draped over it. Swords and slapsticks abound, some characters have musical instruments, and one is brandishing a rather terrifying syringe. Paired plumes adorn most of the caps, and many of the males, except those naked and those in the loose-fitting garb of the comic servants, wear a row of pompon buttons down the center from neck to groin.

The *Balli* epitomizes the *Commedia*—its adroitness, skill, cleverness, and sense of the comic. For a moment in time the artist has grasped the elusive quicksilver.

Although the meaning of the title is uncertain, there have been various conjectures. Smith makes reference to "Callot's *Balli di Sfessania* ('little dancers'),"[2] and Kennard states, "In ancient times

the Sfessania in Piedmont invented popular verses characterized by improvised pleasantries, postures and scenes resembling the Atellanae."[3] Nicoll writes that "the collection is entitled *Balli di Sfessania*, the Neapolitan dances."[4] Ternois indicates that the title has never been satisfactorily explained and that an Etruscan etymology, suggested by some scholars, is unconvincing. He concludes that the word *Sfessania* is probably nothing more than a joke of some kind.[5] The series has also been variously referred to as *Cucurucu, Les danses, Les pantalons, Les polichinelles,* and *Danse des defessés.*[6]

(Figure 1) *Frontispiece* (L. 379 / M. 641)

This etching which introduces the series shows a small, temporary platform stage such as those frequently seen at country fairs and city squares. It is backed by a simple curtain with openings for entrances and exits. Five characters from a troupe are shown. There is considerable disagreement concerning the attribution of names to the characters. Rasi quotes a passage from Giambattista del Tufo which refers to the "Sfessania" dances at which one can hear the phrase "Lucia mia, Bernagualà!" sung to the sound of a mandolin, tambourine, and harmonica.[7] This is a plausible explanation of what Callot has written across the bottom of the print. It does not, however, aid us in identifying the figures. Lieure says that Benemia refers to the character peering through the curtain at left,[8] and both he and Duchartre claim that Cucurucu is behind the curtain at right.[9] Cucurucu is more likely the figure in the right foreground and is holding open an empty box with his right hand apparently exhorting the audience to fill it with coins instead of, as implied by Rasi, playing on a musical instrument.[10] His left hand holds a stick which he has thrust between his legs from behind in a vigorous phallic gesture. Rasi is probably correct in identifying the two actors peering through the curtain as Lucia and Trastullo who can be seen paired later in figure 21. Lea points out that "when painted hangings were used instead of scaffolding the actors unashamedly disturbed walls by holding back the curtains to eavesdrop."[11] Figure 1 in the Appendix gives evidence of this practice and there are numerous other contemporary illustrations to support it. Spectators can be seen at both rear corners of the stage. Note in particular one figure standing near the top of the ladder which reinforces the effect of the raised stage and the access provided to it.

(Figure 2) *Cucorongna and Pernoualla* (L. 380 / M. 642)

Here is as grotesque a pair as can be found in the series. Cucorongna is looking over his left shoulder, his arms describing an **S**. His knees are together but the legs below are widespread. Pernoualla (a variant spelling of Bernoualla of the *Frontispiece*)[12] is on tiptoe with his knees bent. In the middle ground are promenaders and spectators and at center a juggler with both arms raised above his head. At left rear is a fortified castle atop a small rock formation.

(Figure 3) *Capitano Cerimonia and Signora Lavinia* (L. 381 / M. 643)

This is the first of many variations of the captain type shown by Callot. The name suggests an officious, punctilious type who is seen addressing the unmasked *innamorata* Lavinia. His sword, draped with his cape, sticks out behind him. Lavinia stands with her hands hidden beneath the folds of her gown. In the middle ground a man and woman dance to the accompaniment of a long-necked lute while groups of spectators look on. A row of buildings forms the background. "Behind the dancer in the middle ground can be seen a small figure from the background which the artist doubtlessly forgot to recover with varnish and which, as a result of the prolonged biting of the acid, attained the value of the figures of the middle ground,"[13] states Lieure.

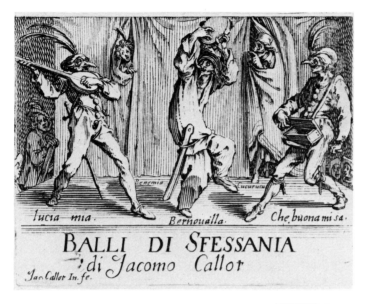

FIGURE 1

FIGURE 2

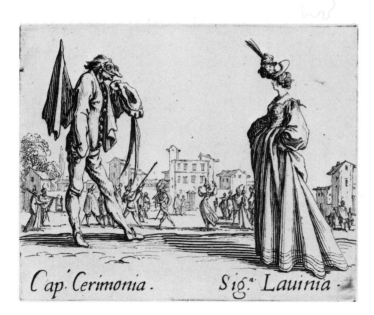

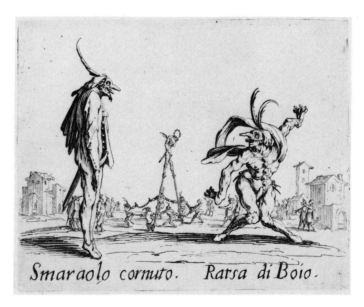

FIGURE 3

FIGURE 4

(Figure 4) *Smaraolo Cornuto and Ratsa di Boio* (L. 382 / M. 644)

The masked figures are sticking their tongues out at each other. Smaraolo Cornuto (The Cuckold) stands stiff-legged on his toes and seems to have horns, the mark of the deceived husband, growing from the top of his mask. Ratsa di Boio crouches low with his knees together and his legs below them spread wide apart. In the middle ground one of the comedians plays a tambourine as he balances himself on a pair of high stilts. Six other comedians, with their hands joined, dance in a circle around him while various groups of spectators look on. The print is flanked by buildings at the rear.

(Figure 5) *Cicho Sgarra and Collo Francisco* (L. 383 / M. 646)

Both figures are wearing similar costumes and masks and have a knotted ribbon below the right knee. Cicho Sgarra's posture is especially noteworthy with his extended arms counterbalanced by the two parts of his flowing cape. Groups of spectators are in the middle ground, and several houses are at the rear.

(Figure 6) *Gian Fritello and Ciurlo* (L. 384 / M. 647)

Gian Fritello (Greasy John) is essentially the same character as Fritellino.[14] (See figure 23.) He stands upright in his Pierrot-like garb and sports a hat with a long, notched front brim. He is contrasted with the crouching Ciurlo (Pirouette) whose right hand is almost touching the ground. In the middle ground are two comedians dancing to the accompaniment of a long-necked lute. Various groups of spectators look on. A house can be faintly seen in the rear.

(Figure 7) *Guatsetto and Mestolino* (L. 385 / M. 645)

Guatsetto's name is a pun on "sauce" or "pottage" and Mestolino can roughly be translated as "little lout."[15] The figures face each other in an almost mirror-image profile. At middle ground are three performers: at center a dancing female, at left a musician playing on a viollike instrument, and at right an acrobat leaping high in the air with his sword extended. His costume is reminiscent of the early characteristic patchwork of the Arlecchino.[16] Several houses are seen at left rear.

(Figure 8) *Riciulina and Metzetin* (L. 386 / M. 648)

In this gay dancing scene Riciulina, a typical *fantesca*, is poised on her left toe while Metzetin (Half-measure) poised on his right toe and wearing a hat with an enormous brim, accompanies her on a long-necked lute.[17] At middle ground are various groups of figures, some on horseback, some playing musical instruments, with several children to be seen. At rear are some houses and trees.

(Figure 9) *Pulliciniello and Signora Lucretia* (L. 387 / M. 649)

Signora Lucretia, a popular *innamorata*, rests her right hand on Pulliciniello's left arm while he extends his long-brimmed hat towards her.[18] In the middle ground at center are two performers, a man and a woman engaged in a comic chase. Two comedians at left and various other spectators and a dog watch the action. A series of houses is at the rear.

(Figure 10) *Capitano Spessa Monti and Bagattino* (L. 388 / M. 650)

The figures have their backs turned to each other. The tattered Spessa Monti (Man Mountain) is spitting at Bagattino (Little Juggler) who is bent over, his right hand on his right knee, his left hand holding a hat which covers his backside.[19] Some comedians and spectators can be seen in the middle ground; at the rear are some promenaders and houses.

(Figure 11) *Scaramucia and Fricasso* (L. 389 / M. 651)

The figures are standing back to back in a fighting pose with their capes draped over their left arms. Scaramucia (Little Skirmisher),

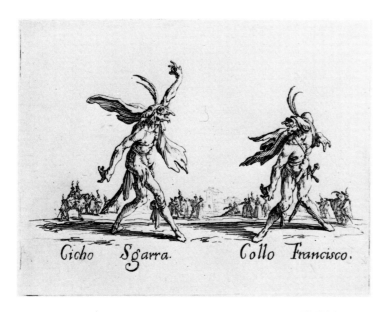

Cicho Sgarra. Collo Francisco.

FIGURE 5

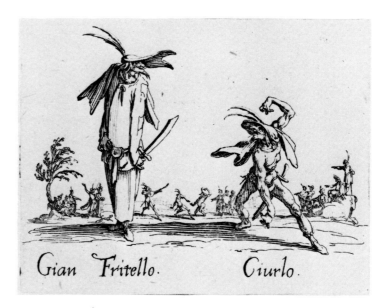

Gian Fritello. Ciurlo.

FIGURE 6

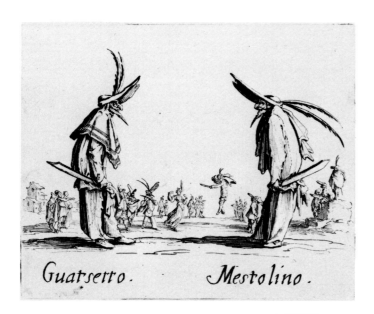

Guatserto. Mestolino.

FIGURE 7

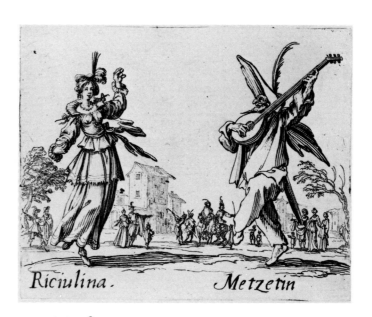

Riciulina. Metzetin

FIGURE 8

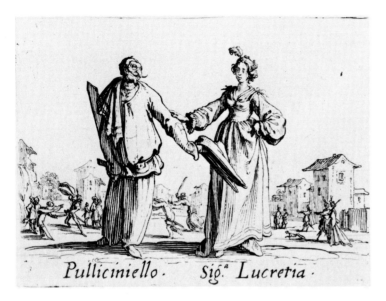

Pulliciniello. Sig.ª Lucretia.

FIGURE 9

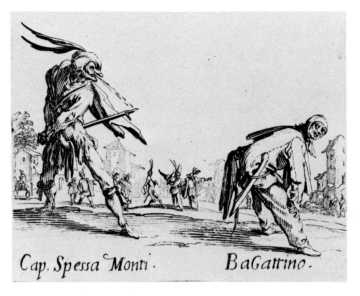

Cap. Spessa Monti. BaGattino.

FIGURE 10

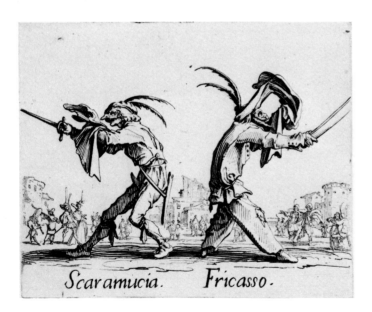

Scaramucia. Fricasso.

FIGURE 11

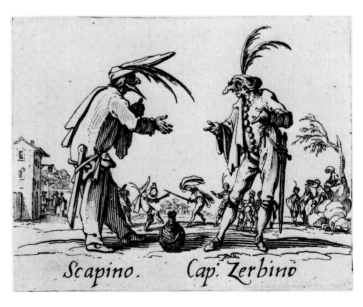

Scapino. Cap. Zerbino

FIGURE 12

an early version of the French Scaramouche, wields a rapier and Fricasso (Hurly-burly or Hubbub) a saber. Fricasso is also shown as Fracasso in figure 24. Both weapons are cut off at the side edges of the print. There are various figures in the middle ground. At the extreme left a *gobbo* (see chapter 5) is playing on a wind instrument; next to him are a lute player and two figures, apparently the young lovers of the troupe. At the extreme right is another Arlecchino figure engaged with a young lady. At the rear are three groups of houses.

(Figure 12) *Scapino and Capitano Zerbino* (L. 390 / M. 652)

Lieure's comments on this etching are of great value. He points out that Molière has used the names Scapin and Zerbinette for his characters in his comedy *Les fourberies de Scapin*. He suggests that the two figures are engaged in playing the game of *morra*, wherein "each player attempts to guess, in his turn, the total number of fingers randomly extended from the hands of the two players. This number must be announced in advance of the moment the fingers are extended."[20] On the ground between them is a *fiasco*, a wine bottle wrapped with raffia, and in the middle ground of the picture the same two figures seem to be struggling for possession of the bottle which Scapino holds in his right hand. The middle ground and rear contain some spectators.

(Figure 13) *Capitano Bonbardon and Capitano Grillo* (L. 391 / M. 653)

Bonbardon (Bassoon, Oom-pah-pah, Pomposity) is poised on the toes of his right foot and holds his hat in his left hand with the feathers swooping downward. The body of Grillo (Cricket) is twisted at a grotesque angle, his palms and fingers turned upward. In the middle ground are some spectators and at the rear a tree at left and some houses at right.

(Figure 14) *Capitano Esgangarato and Capitano Cocodrillo* (L. 392 / M. 654)

In this highly rhythmic composition Esgangarato (Gangling) and Cocodrillo (Crocodile) are balanced on the toes of the left foot, each with his left hand raised above the head, each with his right foot raised off the ground and held on the lower part with the right hand. Note that the feathers of Esgangarato's hat have been carelessly drawn and appear to be growing out of his arm. At middle ground several groups of spectators are watching three performing figures at center. Two of them doing handstands are flanking a musician who is playing on a long-necked lute. At the rear are other figures and houses.

(Figure 15) *Capitano Mala Gamba and Capitano Bellavita* (L. 393 / M. 655)

Both figures are dressed in ruffs and slashed costumes and stand with their legs awkwardly turned inward. Mala Gamba (Limpy) holds his hat above his head with his left hand and with his right presses down the hilt of his sword forcing the point upward with part of his cape draped over it. Bellavita, with his cape draped over his right arm like a shield, provocatively passes his sword between his legs. At middle ground center spectators watch a *ballerina* dancing to the accompaniment of a very long necked lute.

(Figure 16) *Capitano Babeo and Cucuba* (L. 394 / M. 656)

Babeo (Blockhead) in profile passes his sword through his legs at Cucuba (a variation of Cucorongna and Cucurucu) who stands with his backside to Babeo, legs widely spread and arms raised and bent as he looks back over his left shoulder. At middle ground center is a comedian with a basket on his shoulders mounted backwards on a donkey. He is holding the animal's tail high in the air, while another comedian is vigorously applying a pair of bellows to

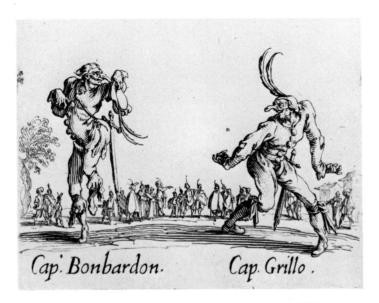

Cap. Bonbardon. Cap. Grillo.

FIGURE 13

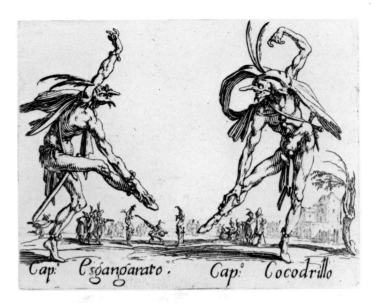

Cap. Esgangarato. Cap. Cocodrillo

FIGURE 14

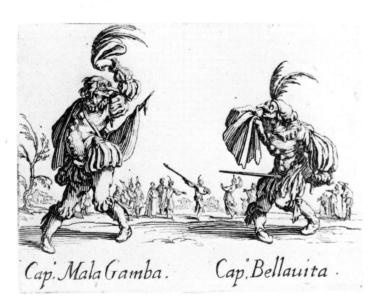

Cap. Mala Gamba. Cap. Bellauita.

FIGURE 15

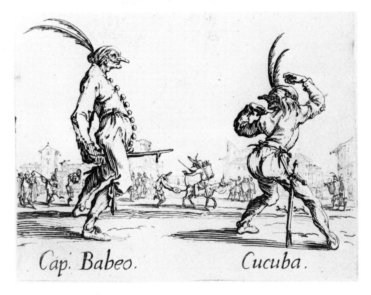

Cap. Babeo. Cucuba.

FIGURE 16

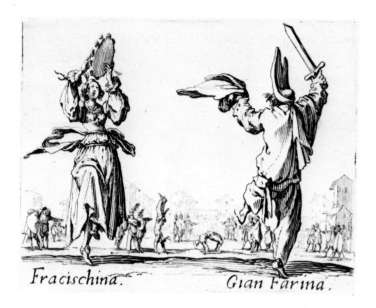

Fracischina. Gian Farina.

FIGURE 17

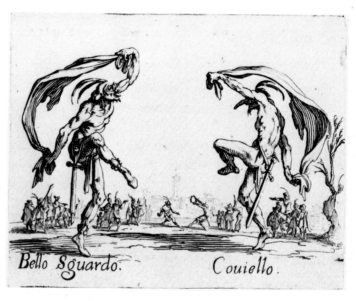

Bello Sguardo. Couiello.

FIGURE 18

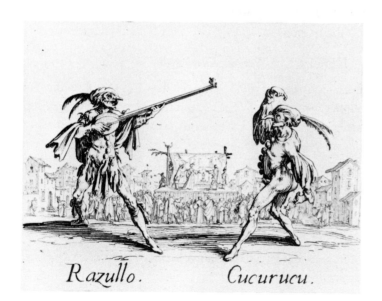

Razullo. Cucurucu.

FIGURE 19

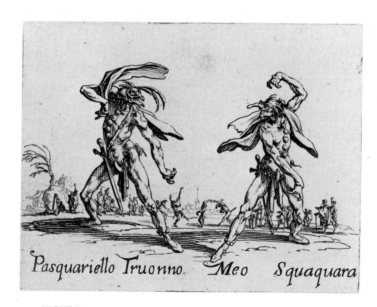

Pasquariello Truonno. Meo Squaquara

FIGURE 20

the donkey's rear end. At left middle ground are two dancing comedians, one playing a long-necked lute, the other a tambourine.

(Figure 17) *Fracischina and Gian Farina* (L. 395 / M. 657)

Fracischina, the *ballerina,* is facing front. She wears a sash around her waist and plays on a tambourine which she holds above her head. Gian Farina is seen from the rear.[21] He has a scarf wrapped around his left hand and in his right he holds a saber aloft. At middle ground center are two acrobats; one, an Arlecchino-like figure, is doing a handstand and the other, a woman, is doing a backbend with her body arched high in the air. Nearby are spectators and groups of houses at the rear. "It should be noticed that under Gian Farina's leg Callot seems to have forgotten to design the line which delimits the background," Lieure notes.[22]

(Figure 18) *Bello Sguardo and Coviello* (L. 396 / M. 658)

Here is another strongly rhythmic composition. Both figures are perched on the toes of one foot, the other foot raised above the knee and flung across the body. Facing one another, each holds a long, billowing scarf in both hands. At middle ground are two dancing comedians, one extending a tambourine in front of him, who are watched by various groups of spectators. At the rear is a city.

(Figure 19) *Razullo and Cucurucu* (L. 397 / M. 659)

This is one of the best-known etchings in the series. Razullo stands with his feet widespread and plays upon a long-necked lute while Cucurucu seems to be dancing to the accompaniment. At middle ground is a small raised platform set in a city square with four actors on the boards performing a scene. Behind them is a painted backdrop with a figure peering through it at the left (cf. *Frontispiece* of this series). A crowd of spectators surrounds three sides of the stage watching the action. The houses of the city form a back-

ground to the composition. Lieure notes that this etching is difficult to find without a well-worn background.[23] The plate has been used so many times that it does not give a clear print in the finer, softer parts.

(Figure 20) *Pasquariello Truonno and Meo Squaquara* (L. 398 / M. 660)

Both figures are facing front, heads turned to each other with each extending a foot forward to the center of the composition. In the middle ground are three dancers, one of which with a lute, and several groups of spectators. In the far distance is a town with a church clock tower at center. According to Duchartre, "Pasquariello Truonno and Meo-Squaquara belonged undoubtedly to a variety of Captains, acrobats, and dancers in vogue during the sixteenth century. They all wore swords. Callot adds 'Truonno' which means 'terrible,' to Pasquariello's name. The name Squaquara rattles like the beak of an enraged heron; the owner must have belonged at one time to the family of Captains, otherwise Scaramouche would not have included him in the list of his own ancestors."[24]

(Figure 21) *Signora Lucia and Trastullo* (L. 399 / M. 661)

Lucia, an *innamorata,* extends her left hand while holding her slipper which she offers to Trastullo (Laughing Stock) to be kissed. He is on his knees, both arms extended towards Lucia, holding an enormous hat the feathers of which hang downward to the ground. At center between them in the middle ground is another wooing scene in miniature. At right and left groups of comedians look on.

(Figure 22) *Capitano Cardoni and Maramao* (L. 400 / M. 662)

Maramao holds an enormous syringe, the contents of which he is squirting at the exposed backside of Capitano Cardoni. This was a common *lazzo* (see another example in Figure VI of the Appendix),

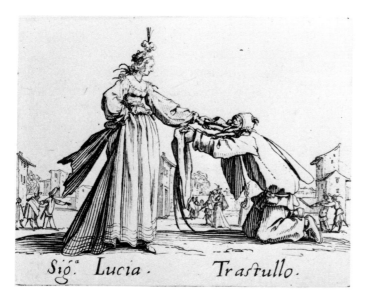

Sig.ª Lucia. Trastullo.

FIGURE 21

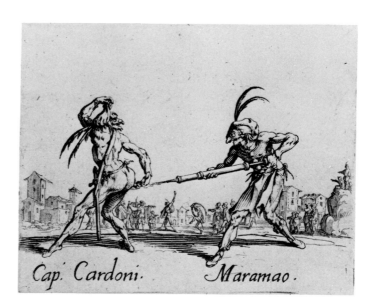

Cap. Cardoni. Maramao.

FIGURE 22

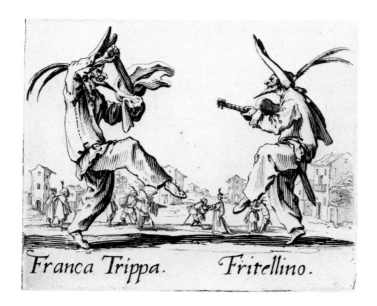

Franca Trippa. Fritellino.

FIGURE 23

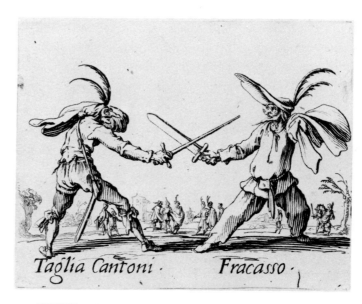

Taglia Cantoni. Fracasso.

FIGURE 24

and a variation was used by Molière in *Le Malade imaginaire*.[25] In the middle ground are dancers and spectators. Lea indicates that in Buonarrotti's *La fiera*, acted in 1618, the Captain Cardone "stands apart twirling his black moustaches fiercely, his hand on his sword ready to meet mountains, penetrate to the Earth's centre, to cut Pluto's horns, take him by the tail, and having soused him in the Stygian marsh to eat him alive and raw, while he is actually a bigger coward than an officer of the watch."[26]

(Figure 23) *Franca Trippa and Fritellino* (L. 401 / M. 663)

The dancing figures are each poised on one leg. Franca Trippa[27] flourishes a saber and scarf while Fritellino (Little Grease Spot), a variant of Gian Fritello (see figure 6), in a huge brimmed hat, plays upon a guitar.[28] In the middle ground are four groups of comedians. The houses extend into the distance.

(Figure 24) *Taglia Cantoni and Fracasso* (L. 402 / M. 664)

The two figures face each other in a mock duel with crossed swords. Taglia Cantoni extends a rapier while Fracasso wields a saber.[29] Various groups of figures are in the middle ground and at the rear are houses and trees. The etching shows "a nearly vertical line after the word Fracasso."[30]

LES TROIS PANTALONS (THREE COMEDIANS)
(L. 288–290 / M. 627–629)

The term *Pantalons* in the title given to this set of three etchings is generic and refers to basic *Commedia* types rather than the pantalone character himself. *Pantalone or Cassandra* is included along with *The Captain or Lover* and *Zanni or Scapino*. These plates done in Florence in 1618 are each shown in the same stylistic format. A large representation of the character dominates the plate as he stands in an unlocalized area and addresses himself to our attention.

He is also seen in the background in miniature, in a scene set on a large outdoor stage of unlikely proportions, decorated with perspective scenery. The performance is watched by crowds of spectators who sit or stand with their backs turned to us. The dimensions of time and space for the character do not correspond, and these etchings cannot be viewed in quite the same manner as *I balli di Sfessania* where the major figures have a much more realistic relationship to their backgrounds. In addition, the source of light is inconsistent here. In all three plates the shadows of the large figures do not correspond with those of the stage buildings and performers. Perhaps Callot used this contradictory source of light as a subtle device to reinforce the distinction between the two dimensions.

(Figure 25) *Le pantalon ou cassandre* (*Pantalone or Cassandre*)
(L. 288 / M. 627)

Pantalone, sometimes called Il magnifico, was also known as Cassandre, or Cassandro. We find reference to the type as early as the 1611 collection of *Commedia* scenarios by Scala entitled *Il teatro delle favole rappresentative*. Duchartre explains that "Cassandro of Siena and Zanobio of Piombino were two sixteenth century copies of the Venetian Pantaloon, with whom, in fact, they often made their appearance on the stage of the Gelosi troupe. Cassandro and Zanobio always played the part of a levelheaded father, which served as a strong contrast to Pantaloon's eccentricities. Cassandro disappeared at the end of the Renaissance."[31] However, Nicoll takes issue with this point of view and clarifies it: "Cassandro appears several times alongside Pantalone, apparently . . . occupying the place taken by the Dottore. This being so it seems hardly correct to describe him . . . as a 'copy' of Pantalone. Nor was he always a Sienese; Perrucci, indeed, makes him definitely Florentine."[32] It should be further noted that following the decline of the improvised comedy and its subsequent renewal in France at

FIGURE 25

the end of the eighteenth century, the pantalone character was rebaptized as Cassandre, reviving a tradition almost two hundred years old.

Although there is little evidence to support the fact that this etching represents any particular performer, Pandolfi suggests that it may be a portrait of the actor Pasquati.[33]

In the foreground of the print is a traditional representation of the pantalone figure. A slippered foot is extended, one hand is at his chest and another at his back holding out the cape. His long hose, short jacket, and tight fitting bonnet were traditionally red, and the cape black.[34] The mask has a hooked nose, the beard extends forward in two tufts, and wisps of hair show at the back of the head.

The background seems to be composed of three levels: the stage, the "pit" where most of the spectators stand, and a raised section with three standing figures at the right and a seated one at the left. The three figures include a young man with his arm around a lady's waist and a man lounging against the building. On the stage at right, Pantalone is addressing an *innamorata* on a balcony above. Behind him is a solitary actor who is watching him.

(Figure 26) *Le capitan ou l'amoureux* (*The Captain or Lover*)
(L. 289 / M. 628)

The designation of "Captain," with the subtitle "Lover," given to this figure has created unnecessary confusion. This type is in the tradition of the *innamorato* rather than that of the Capitano. There is ample evidence for this. The figure is not created in the same spirit as Callot's Capitani. He is not grotesque in manner or costume, and perhaps more to the point, he is unmasked. His swagger and officiousness carries a sense of genteel pomposity rather than bizarre braggadocio. One can almost hear him saying "See how brave, handsome, and appealing I am!" There is more than a bit of G. B. Shaw's Sergius Saranoff about him. Duchartre reproduces the

plate and categorically labels it "The actor Zanotti as Fabio" which would put him in the same company with the Ottavios and Silvios.[35]

The large foreground figure faces us full front. His entire attitude is stilted and artificial: his feet are set in a ballet position while one hand rests on the hilt of his sword and the other points meaninglessly. His costume is impeccable, his moustachios carefully curled, and the hat lavishly decorated with plumes.

The background again appears with three levels. The Captain can be seen on the stage at left engaged in conversation. This pair is balanced at the right by two female figures, probably an *innamorata* and her attendant. Spectators are watching the play from a roof top, a balcony, and windows as well as from the area in front of the stage. As in the previous plate, they are arranged in a variety of body positions. Note the seated figure at the right whose pointing arm directs attention to the stage action.

(Figure 27) *Le zani ou Scapin* (*Zanni or Scapino*)
(L. 290 / M. 629)

Scapino's ancestry is uncertain. The name is mentioned as early as 1612 and is believed to have originated in Milan.[36] He is frequently described as a variation of Brighella and his name is presumed to be derived from the Italian word *scappare*, meaning "to flee" or "to escape."[37] He is one of the many comic valets serving his master's intrigues as well as his own.

The character here is similar in appearance to the Scapino Callot has depicted in the *Balli* set (Figure 12).[38] He wears a loose-fitting, two-piece outfit with a short cape. The present hat contains the same two thin, pointed feathers, but the brim has a torn and jagged edge. His right hand rests on the hilt of his favorite weapon, the slapstick. His face is full front,[39] and the mask appears to cover the upper two-thirds of his face. Lieure suggests that he is sticking out his tongue,[40] and Nicoll, maintaining that the mask is full-faced,

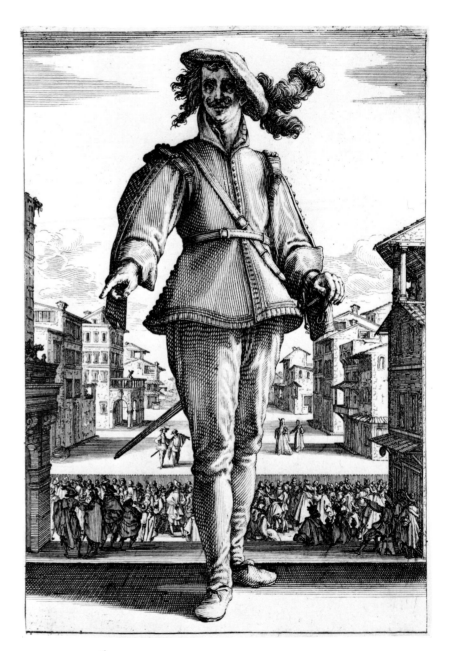

FIGURE 26

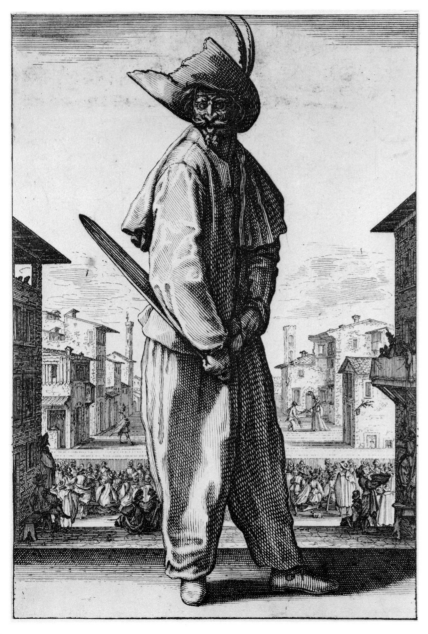

FIGURE 27

says, "His bearded mask is characterized by a large, hooked nose."[41]

The action on the background stage is described by Lieure: "With an obsequious bow Scapino presents his master's letter to a lady while he stands waiting at the left."[42] The spectators are generally arranged as in the two previous plates. There is an interesting bit of action taking place in the lower right corner as some vendors are raising refreshments of some sort to several ladies watching the play from a draped balcony.

LES DEUX PANTALONS (TWO COMEDIANS)
(L. 173 / M. 626)

This early etching dated 1616, reproduced here as figure 28, is from Callot's Florentine period. The two major figures are akin to the *zanni* and several of the raggle-taggle Capitani of the *Balli* and are not Pantalones. They are paired in a strongly stylized balletic movement, delicately balanced in grotesque apposition. Their costumes are slashed, and they have very little decoration. The figure at the left[43] cowers from his companion who, with the fingers of his right hand, "gestures to ward off the evil eye."[44] In the near foreground are diverse groups of the gentility, while the remainder of the landscape is filled with dancers, mounted horses, wagons, farmhouses, and trees.

I CAPRICCI (THE CAPRICES)

The Caprices is a series of etchings depicting a wide variety of subjects: figures, landscapes, buildings, pastorals, animals, and several characters from the *Commedia dell'arte*. This series is an example of Callot's very early use of his hard varnish technique. He etched the first version in Florence in 1617. The series was reetched in Nancy in 1621 and contained minor variations. Several of these are noted below. The three plates which are reproduced belong to the

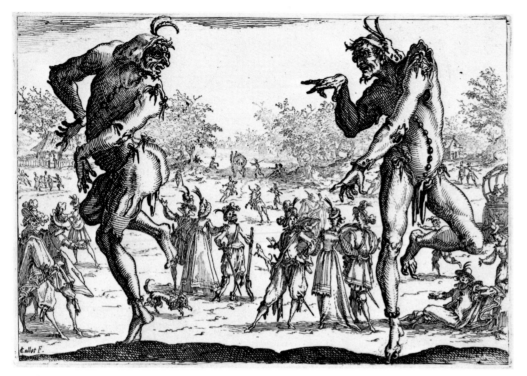

FIGURE 28

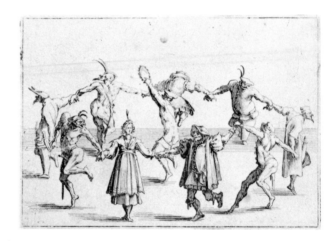

FIGURE 29

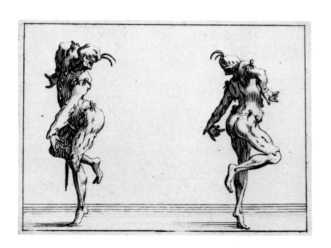

FIGURE 30

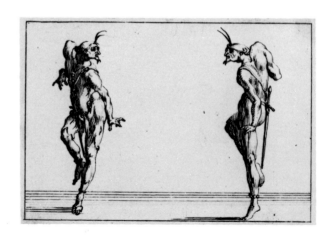

FIGURE 31

Florentine series. The Lieure and Meaume numbers indicate both the Florence and Nancy versions.

(Figure 29) *La Ronde* (*Round Dance*)
(L. 223/437 // M. 786/787)

Here is a stylized composition of ten *Commedia* figures: nine are dancing around a tambourine-playing *zanni* at center. The characters are not identified but several are easily recognizable. In the foreground, at left of center, is a *servetta* type (cf. figure 8). Next moving clockwise is a figure strongly reminiscent of Capitano Cocodrillo, a *zanni* similar to Fracasso, an unidentifiable naked *zanni*, a character vaguely related to the swaggering Capitano, a figure resembling a Brighella, a Pantalone in profile, another *zanni*, and finally a figure similar to the Captain-Lover type. The whole composition is a graceful arrangement of body positions and postures.

The Nancy etching differs in the respect of having, in most cases, larger feathers in the hats of the figures so costumed. The *servetta* in particular has double feathers of unequal size in her headdress.

(Figure 30) *Les deux pantalons se tournant le dos*
(*Two Pantaloons Back to Back*) (L. 248/462 // M. 838/839)

(Figure 31) *Les deux pantalons se regardant*
(*Two Pantaloons Face to Face*) (L. 249/463 // M. 840/841)

Both of these plates can be described together. Each shows a pair of tattered and contorted *zanni* in stylized juxtaposition. Note the similarity between the left-hand figures in figures 28 and 30. The simplicity of the compositions is reinforced by the lack of background as the figures stand in stark relief. As is probably the case with most of the plates in this set, these etchings may have been intended as study pieces for apprentice artists.

The differences between the Florence and Nancy plates are insignificant.

LES MOIS (THE MONTHS)

This series of the twelve months of the year is among the earliest of Callot's works. It is a group of engravings copied from originals by Adrien and Jean Collaert. The set was done in Rome approximately 1612, and there is some disagreement whether all of the pieces are from Callot's hand. The engraving reproduced here appears to be authentic, however, and bears his signature in the lower right-hand corner.

(Figure 32) *Janvarivs* (*January*) (L. 2 / M. 723)

The left side of the engraving is of particular interest. In the foreground are two masked figures. At left is a traditionally costumed pantalone in a typical stance with one arm doubled behind his back and a foot extended (cf. figure 25). To the right is a *zanni* type playing on a lute. To the left of this pair is a group which may be performers or spectators, probably the latter. At right, in the middle ground, are two performers on a trestle stage almost completely surrounded by a small audience.

Although this immature piece does not display the vitality and technical virtuosity of the later works, it is interesting to note that even at this formative stage in his career Callot was intrigued by figures from the theatre. See figure II in Appendix.

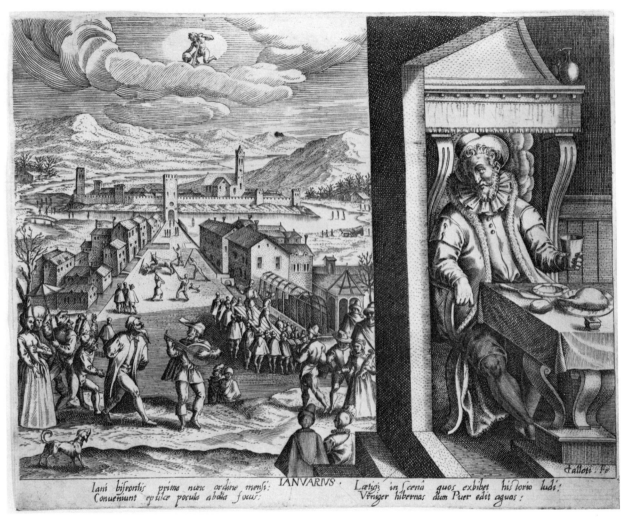

Iani bifrontis primo nunc ordine mensi: IANVARIVS. Laetisq; in scena quos exhibet historio ludi:
Conueniunt epulae pocula abolla focus: Vriger hibernas dum Puer edit aguas:

FIGURE 32

 Festivals

HISTORY AND BACKGROUND

It has always been difficult for the theatre historian to distinguish clearly between theatrical and paratheatrical activities. If the enacting of a story upon a stage is to be the least common denominator, then many kinds of activity must be considered. The Europe of Callot's time did not limit its dramatic entertainment to the professionals of the *Commedia*, the courtly entertainments in such theatres as those described by Serlio and Sabbattini, or the court masques similar to those designed and costumed by Inigo Jones in England. A formalized stage was not always needed. A courtyard, a hall, a city square, or even a river could become the setting for a spectacular pageant. The technical, artistic, and literary ingenuity expended on the more traditional presentations were also applied to extravaganzas designed to flatter a visiting dignitary, celebrate a forthcoming wedding, or commemorate a holiday or anniversary. Some of the greatest talents of the day were called upon, and incredible sums of money were spent. Most of these royal entries, processionals, mock military engagements, ballets, tilts and jousts, and fireworks displays were recorded in the form of paintings, line drawings, and more comprehensively in books which contained not only illustrations but also the descriptions, verses, songs, and music of these events. They are a rich source of information, providing us with countless details of staging methods, "theatre" construction, costumes, properties, floats and pageant wagons, audiences, expenses, and the names of the poets, composers, choreographers, designers, producers, and performers. These books are among the richest legacies we have of the theatrical activity of the period, and in

addition to helping us recreate in our imaginations a picture of great splendor and ingenuity, they remind us of traditions that are still with us today—a ball park turned into a theatre, Broadway during the Thanksgiving Day parade, or New Orleans at Mardi Gras time.

Callot, while at the Medici court and also later in his career, devoted part of his time to the recording of these events. Two major sets of etchings, *Guerra d'amore* and *Guerra di belleza*, were done to illustrate entertainments provided by the Medici.[1] Festivals of this type were favorites not only during Callot's stay but for many years thereafter. They were a combination of various forms. They resembled the masques in that members of the nobility participated in the guise of allegorical figures, and they perpetuated the heritage of the triumphal processions and entries with their symbolic and elaborate wagons. In addition they culminated in a variation of the tournaments with large numbers of mounted and foot soldiers engaged in carefully planned mock encounters with special emphasis placed on the horsemen and their stylized maneuvers and formations. These equestrian ballets involved many hours of preparation and practice and served to enhance the glory of the Medici court. Although both of these festivals were created and probably executed as well by the great theatrical designer Giulio Parigi, Callot was given the responsibility of preparing the etchings which were published in the presentation volumes. Callot cannot be credited with the original designs and thus was primarily in the position of a chronicler. There are unique touches, however, which are almost certainly not part of the original Parigi scheme. In addition, there are numerous discrepancies between what Callot has shown us and the written description of the events. Whether these are the results of inevitable changes made between design and execution, faulty memory, limitation of the medium, or artistic license, the fact remains that Callot has left us representative examples of his art which are of great aesthetic and historical value.

Several other plates record festivals given on the Arno River in Florence and one of them, *L'éventail,* is among Callot's most important pieces. Then there are the *Combat à la barrière* and the *Carrière* at Nancy, works done after Callot had returned to France. The plates are considerably more characteristic than those of the Medici group and reflect not only his own inimitable style, but also the conventions and practices he had been exposed to during his Italian sojourn.

GUERRA D'AMORE (THE WAR OF LOVE)
(L. 169–172 / M. 635, 633, 634, 620)

At Carnival time in Florence, on 11 or 12 February 1616,[2] a spectacle entitled *Guerra d'amore* was presented by Cosimo II, grand duke of Tuscany, in honor of the Grand Duchess Maria Magdalena. The square in front of the Church of Santa Croce was converted into an outdoor theatre and the production given there was the combined effort of a number of prominent artists. Giulio Parigi designed the grandstands, chariots, and costumes. Jacopo Peri, Paolo Grazi, and Giovan Battista Signorini composed the music which was supervised by Giovanni del Turco. The theme of the spectacle and its verses were the work of Andrea Salvadori who was also largely responsible for the souvenir book published to commemorate the event.[3] The four plates etched by Callot for the book illustrate various aspects of the production.

Following is a translation of the description of the performances as recorded by Salvadori and edited by Lieure.[4] It helps to determine to what extent Callot served as an accurate chronicler of the event and where he felt free to exercise his own imagination.

The festival began with a "marvelous symphony" soon after which the chariot of India appeared. It was the most beautiful one ever seen in Tuscany. At its top an extraordinarily ornamented queen sat in state on a golden throne. At her feet on the chariot, were sixty-four superbly

dressed persons. They included the ladies of the queen's entourage and those Brahmin priests who are so famous in the Orient. They all played various instruments and a very sweet harmony was heard. The chariot was followed by one hundred Indians on foot with bows in hand. These were soldiers of the queen's guard dressed in a rich and fanciful costume. It was marvelous to see Dawn arrive on top of the chariot on small clouds. The clouds were white, purple, and gold and bore small zephyrs similar to cupids, who moved their flower-covered and dewy wings. Dawn was crowned with rays and roses. Her costume was white, vermillion, and yellow. In one hand she held a very brilliant torch and with the other continually strewed flowers. The chariot stopped in front of the grand duchess and Dawn sang a song (fifty-one stanzas) relating to *The War of Love*. After this the chariot toured the arena while the Indians sang the praises of the royal house of Austria.

Then the two enemy armies appeared. One was commanded by the grand duke under the name of Indamore, king of Narsinga, the other by Prince Lorenzo under the name of Gradameto, king of Melinda. The first army was followed by a chariot of marvelous design and poetic invention. In spite of its great dimensions it was easily drawn by his highness's camels and also by aid of ingenious machines hidden from the spectators. The chariot was filled with trophies from Asia and displayed the grandeur and nobility of the empire which Indamore governed. On the top of the chariot was a flowered lawn in the middle of which stood a tree similar to the royal laurel. Its branches were golden, the leaves and fruits extremely precious, and on its top was a phoenix in a flaming nest. It flapped its purple and gold wings and wore a crown of rays. It was admirable in its stature and beauty. On one side of the lawn was a fountain from which gushed crystalline water. The statue of Asia was seen leaning on one of those famous palm trees which bears all that is necessary and delicious for human life. At Asia's feet were scattered royal scepters and crowns. The statue was on a camel which was stretched out on the ground. In one hand she held a golden vase in which burned precious perfumes, in the other she bore a large scepter whose extremity showed a half globe divided between water and earth thus signifying that Asia gave her name to half of the world. Between four grottoes on the steep slopes were four Rivers, each differently dressed, who abundantly poured the royal water. This water bathed the feet of four statues which represented the four Kingdoms of Asia most

famous for their military glories. One of the Rivers, the Meander, had a swan near its urn and it watered the kingdom of the Turks. The second River was the Volga which directed itself towards the kingdom of Tartary. Near its urn was a ferocious tiger. The River, frightful in its appearance, seemed to be dressed in congealed snow and had a beard and long locks which were dishevelled and sprinkled with icicles. The third River was the Tigris directed towards the kingdom of Persia. Near its urn was seen a ceremoniously armed horse. The last River was the Ganges which watered the kingdom of India. Near its urn was a white elephant. The gown of this River was of gold and pearls which also fell from its hair and beard which seemed to be made of a very fine gold. (A description of the Kingdoms followed.) Around the chariot marched eight giants of immeasurable height and terrible appearance.

Behind the armies of King Gradameto came a chariot of marvelous grandeur and beauty drawn by animals which imitated elephants thanks to the industry and ingenuity of the artists. This chariot represented the grandeur of the African empires. It had two immense obelisks which bore golden urns in memory of ancient Egypt and as sepulchres of the kings of these countries. They were engraved all over with symbols of various purposes used by this mysterious nation in bygone centuries. Between the two obelisks on an ivory and gold base, standing between two lions, was a statue of Africa with a black and terrible face. The statue's helmet was an elephant's head. She was half-naked, half dressed in red. In one hand she held an assegai, in the other several chains which were wound around the necks of the other statues. At Africa's feet were two black Rivers similar to Ethiopians. They were the Nile and the Niger. The statues enchained by Africa represented some of the provinces conquered by the Moors in ancient times. On the side of the chariot various episodes of the African wars were represented. Around the chariot marched twelve savages.

The author then described the battle. He indicated in detail the maneuvers which conformed to the two prints of Callot as well as the sixteen oval figures of the *Plan of the Festival*. All the extras then divided into several groups and paraded in a very handsome order, which for everyone's greatest clarity, has been engraved on copper as seen in figure 1. [In the following quoted account the description of figures numbered 1 through 18 refers to the sixteen ovals of figure 36 and apparently to two other prints done by Callot for the festival. There is

a great deal of confusion here which is clarified to some extent in the discussion of figure 36.]

When they were lined up in the order as shown in the print the two enemy troops stopped on each side of the theatre. The chariots arranged themselves at the two entryways, one surrounded by the giants, the other by the savages. Shortly thereafter the trumpets gave the signal for battle and suddenly the four chiefs of the cavalry squadrons impetuously collided with their assegais. Then, after having traversed the entire arena, they resumed their places and gradually reassembled their squadrons as shown in figure 2.

They then took their bludgeons and, in varying formations, attacked each other. It was truly marvelous to see forty-two horses maneuver in such beautiful order and in such a varied manner, first during the fray then during the tilt as seen in the other figures. The maneuver with the bludgeons can be seen in figures 3 and 4.

When the horsemen had ended this maneuver they took up their positions again in a formation similar to two crescents. This can be seen in figure 5. Then the infantry, divided into ten sections, advanced to the sound of drums and passed through the spaces between the squadrons of cavalry and spread into two semicircles. The captains of the two opposing forces then advanced and shot forth three iron balls. They attacked each other with axe strokes of such intensity that it seemed they would shatter their arms. This combat was very beautiful because the captains were chosen from among the best of soldiers. A general fray then took place as shown in figures 6 and 7. The infantry stopped and the cavalry continued its patterns alone as shown in figures 8, 9, 10, and 11. The cavalry then took its place again and the infantry made three successive attacks with increasing fervor as shown in figure 12.

During this combat there was heard a noise like the rumbling of thunder towards the middle of one of the sides of the arena which corresponded to one of the streets leading to the square. Suddenly this side opened and a chariot entered, drawn by very spirited horses. On this chariot was Mars, the god of war. Near him was Venus, the mother of love. The chariot was drawn by Impetuosity and Fury and carried all the ministers attributed to these divinites. It impetuously moved among the combatants and upon passing between them suddenly divided itself into two parts or, to be more precise, into two chariots of which the one bore Venus and her company and the other bore Mars. To the

amazement of the spectators these two chariots separated the extras each moving to an opposite side and Mars, rising on his throne, terrible to see, and shaking his lance, sang a very short poem inviting the combatants to stop and listen to the commands of Venus. The latter, in her turn, sang a madrigal of 117 stanzas dedicated to the grand duchess which explained the end of the combat and the equestrian ballet which followed it. After the madrigal the ballet music began. The two kings advanced, followed by their horsemen who made their horses dance to the great wonder of the spectators. This can be seen in figures 13, 14, and 15.

After the ballet the chariot of Queen Lucinda moved to the theatre exit accompanied by her singing entourage. This can be seen in figure 16. The infantry followed running and the horsemen, after graceful maneuvers, quickly left from the side where the queen had gone. The exit of the foot soldiers and cavalry is shown in figures 17 and 18. A grand masquerade was held at night to conclude the festival. The chariots rolled through the city and the Indians sang a madrigal amidst a crowd of spectators.

Thus ended the festival of the most serene grand duke of Tuscany entitled *The War of Love*. Its memory is worth preserving as is that of every other equestrian ballet because of its novelty, beauty, and variety. The arrangement of the battle and of the ballet was the work of Agnolo Ricci, ballet master to his highness. He was also responsible for its organization. The chariots, costume designs, and theatre designs were done by Giulio Parigi; the music was the work of Jacopo Peri, Paolo Grazi, and Giovanni Baptista Signorini. The overseer of the festival was the Knight Giovanni del Turco, who also composed the masquerade music.

(Figure 33) *Les chars et les personnages* (*The Wagons and Participants*) (L. 169 / M. 635)

This plate is composed of three rows of figures. Each of the first and second rows shows two chariots and the third delineates eight representative participants in the festival, two on horseback and the remaining six on foot.

The first line shows Asia's chariot on the left drawn by a pair of dromedaries. The lawn and laurel tree, the phoenix in the flaming

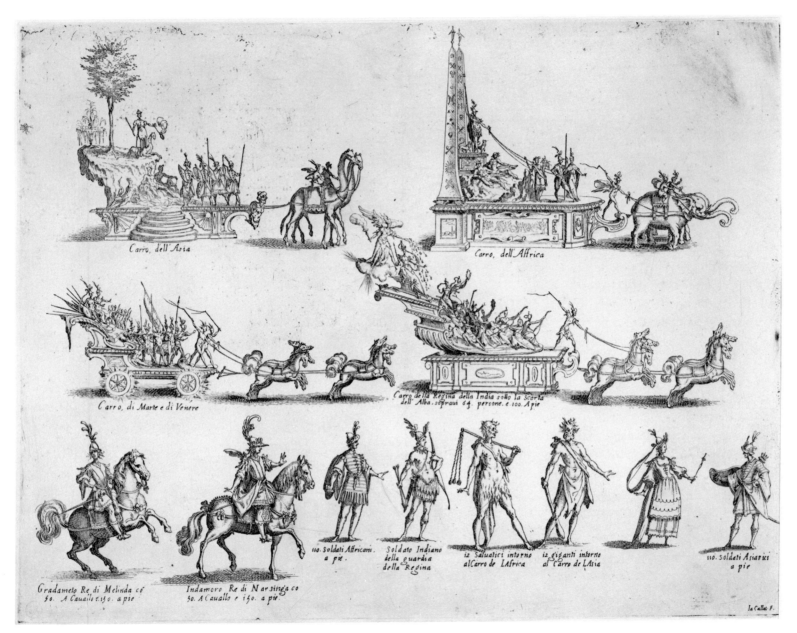

Carro, dell'Asia

Carro, dell'Affrica

Carro, di Marte e di Venere

Carro della Regina della India sotto la Scorta
dell' Alba. sopraui 64. persone. e 100. A pie

Gradameto Re di Melinda co
50. A Cauallo e 150. a pie

Indamoro Re di Narsinga co
50. A Cauallo e 150. a pie

110. Soldati Affricani.
a pie.

Soldato Indiano
della guardia
della Regina

12 Saluatici intorno
al Carro de LAffrica

12 giganti intorno
al Carro de LAsia

110. Soldati Asiatici
a pie

la Callot F.

FIGURE 33

nest, and the gushing fountain are all clearly visible, and the statue of Asia can be seen on the camel, although she does not lean on a palm tree as described. We are shown the censer in her left hand but not the globe at the tip of her scepter. Three of the four Rivers are shown with water pouring from their urns towards the feet of the four Kingdoms. The swan, tiger, horse, elephant, and eight giants have been omitted, and the Rivers' costumes are not distinctive. The chariot itself has a figurehead at its prow and a series of five curved steps are seen on the near side.

At the right is the chariot of Africa drawn by its two artificial elephants. The two obelisks with what may be urns and the half-naked Africa, standing on her base flanked by two lions, are quite clear. In most respects this representation conforms very closely to the description. Note also the naked elephant driver with a whip in hand and the two figures seated atop the animals.

At the left on the second line is the chariot of Mars and Venus drawn by two pairs of spirited horses. The chariot is wheeled and shows the two divinities seated at the rear with spears and banners behind them. Various poorly proportioned figures are scattered on the chariot including two who wield whips and hold the horses' reins. It is impossible to tell from this view how the chariot managed to separate itself into two parts.

At right, on the same line, is the chariot of the queen of India. Beneath is inscribed "Chariot of the Queen of India beneath the escort of Dawn. Above 64 persons and 100 are on foot." Winged Dawn is seen at the highest point standing on a cloud holding her torch and strewing flowers.[5] Immediately below her the queen of India sits enthroned above a group of something less than sixty-four of her followers who play on musical instruments. The chariot, with its wheels hidden, is directed by a driver with a whip in hand who controls eight horses.

On the third line the first figure at the left bears the legend "Gradameto, King of Melinda, with 50 horsemen and 150 foot

soldiers." The grand duke sits on a rearing horse and is richly attired with sword and plumed casque. Next is another mounted figure with the inscription "Indamore, King of Narsinga with 50 horsemen and 150 foot soldiers." Prince Lorenzo is as richly attired as his counterpart. The third figure represents one of the one hundred ten African infantrymen. Fourth is an "Indian soldier of the Queen's guard," one of the one hundred who accompanied her chariot. He is shown naked to the waist, with a winged helmet, sword at side, a bow over the left shoulder and arrows in the right hand. Next is one of the twelve savages surrounding the chariot of Africa. The giant carries a weapon with three chains with a ball at the end of each. The sixth figure, carrying a bludgeon, is one of the twelve giants accompanying the chariot of Asia. Next is an unidentified female holding a scepter in her left hand. The final figure is one of the one hundred ten Asiatic foot soldiers elaborately dressed with a shield on his right arm and a sword shown beneath his costume.

Callot has inscribed the following in the lower right-hand corner of the plate: "Ia Callot. F."

(Figure 34) *Le défile. Entrée des chars de l'Afrique et de l'Asie* (*The Entry of the Wagons of Africa and Asia*) (L. 170 / M. 663)

This plate shows a prospect of the Piazza Santa Croce which has been converted into an arena for the presentation of *The War of Love*. A huge wooden grandstand in the shape of a flattened oval has been erected for the occasion.

Outside the oval, in the background, is a line of houses facing north toward the Arno River. To the left are the steps of the Church of Santa Croce. Spectators are on the steps as well as other vantage points such as balconies, rooftops, windows, and ledges. The square itself is filled with people, horses, and carts. The foreground is of special interest. Here the figures are on a large scale and carefully

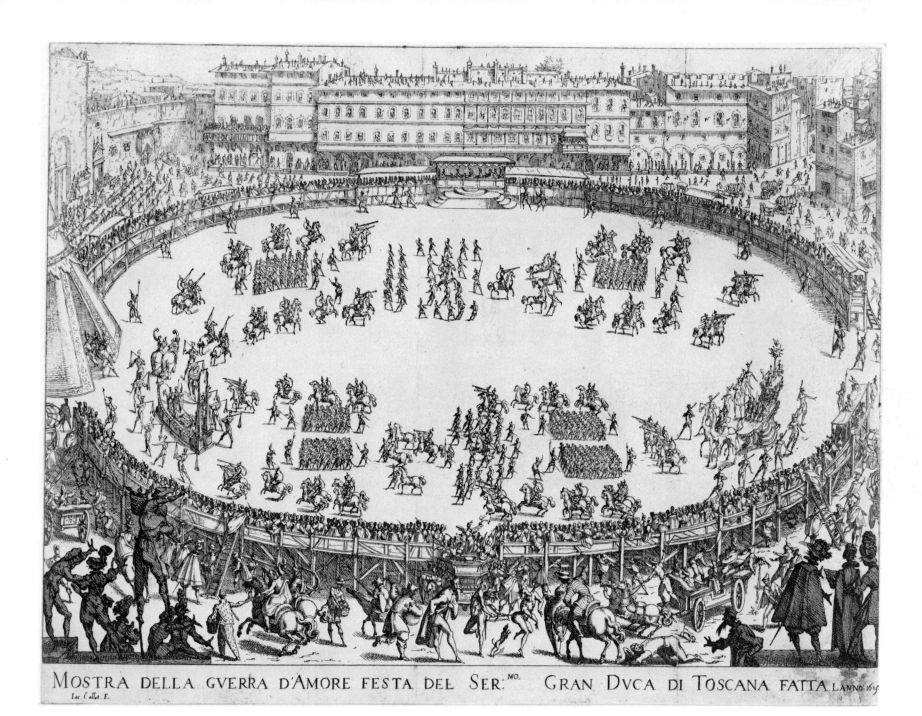

MOSTRA DELLA GVERRA D'AMORE FESTA DEL SER:MO. GRAN DVCA DI TOSCANA FATTA L'ANNO 1615

Iac. Callot. F.

FIGURE 34

defined. A variety of types and activities are shown, some directly related to the festival and others symbols of the nature of the occasion. At center are three figures from the *Commedia*, the one at left a Pantalone and the other two *zanni*. A dog is barking at a figure strongly reminiscent of the one at the left in the plate *Two Pantaloons* (figure 28). There are well-dressed figures at the corners; at right are a *zanni* talking to a man on horseback, a driver on a wagon pulled by two horses, two riders, a mountebank, a lute player, and a figure vomiting; at left are various mounted figures, a peddler selling wares from a basket, and a figure on stilts with a basket filled with what may be bottles on his left shoulder. Three ladders can be seen providing access to the grandstands, and a figure is on each, taking advantage of the elevation either to watch the festival or converse with the spectators.

The grandstands are some ten feet high and have several rows of seats. At center rear is the private canopied box of the grand duchess fronted by a large platform flanked by four curved steps and topped by a smaller platform of two semicircular levels. Adjoining the box on both sides are several feet of roofed-over grandstands. There are five additional roofed areas, three having peaked roofs and two with flat ones. Two figures are seated on the roof at the right of the oval's lower half.

Three openings offer access to the arena. There are two at the ends of the lateral axis of the oval, and one is at the center of the lower half. At left is a huge tent with three soldiers in the doorway, at right the opening is guarded by two soldiers, and at bottom center the opening is occupied by the wagon of Lucinda, queen of India, who has just completed her tour of the arena.

Inside the oval can be seen the wagons of Asia at right and Africa at left, each accompanied by its retinue of giants, horsemen, massed infantry, and individual foot soldiers. Other infantrymen are spaced around the inside of the perimeter. While the etching does not accurately conform to the sequence of events in the published description of the festival, it most effectively conveys an impression of the magnitude and splendor of the occasion.

At the bottom of the print is printed "View of *The War of Love* —Festival in honor of the Most Serene Grand Duke of Tuscany— given in the year 1615." At bottom left is inscribed "Jac. Callot. F."

(Figure 35) *Le combat des sections d'infanterie (The Infantry Battle)* (L. 171 / M. 634)

This print reproduces the battle of the massed infantry in *The War of Love*. The setting is the same as the previous plate but the view has been reversed.

The buildings in the rear are facing south. Spectators are using the same vantage points, and the crowds in the square are of similar composition. In the upper left-hand corner Callot has included a realistic detail showing a figure with a portable brazier who may be selling hot chestnuts or other delicacies. The foreground again carries a variety of large-scale figures. The *Commedia* characters are seen once more, this time as heavily shadowed groupings in the corners, arranged on and near raised platforms. Guards stand behind the grand duchess's box, and at least one can be seen trying to keep a spectator from climbing up the back of the grandstands. At center, on a donkey, with a collection of cats, is a peddler carrying a sign reading "Rimedio da Topi" (Remedy for Rats). Behind, and to the right, is a horse-drawn wagon with several musicians riding on it. Immediately in front of the wagon is a pair of *gobbi* (see chapter 5). Elsewhere there is a figure on hands and knees with a dog nearby, a masked reveler with a wine bottle and glass, a man on a defecating horse, and numerous other intriguing details. Three ladders with spectators on them are similar to those in the previous view.

The box of the grand duchess is seen from the rear in considerable detail and the duchess herself is at center with four guests on each side of her. The adjoining roofed boxes are filled with ladies

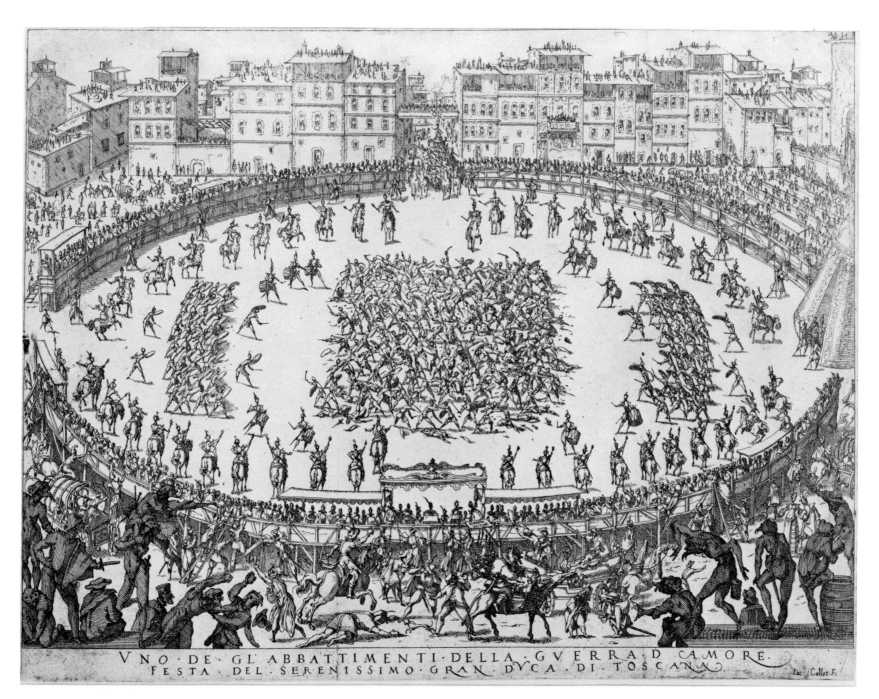

VNO·DE·GL'ABBATTIMENTI·DELLA·GVERRA·D'AMORE.
FESTA·DEL·SERENISSIMO·GRAN·DVCA·DI·TOSCANA

Iac·Callot·F.

FIGURE 35

and a careful examination of the roofed areas seems to indicate that they were reserved for female spectators. In addition to the royal box there are five roofs, the same number as in the preceding plate, but they do not appear in the same positions, nor do the roof shapes correspond. The roof at lower right also has a person sitting on it.

Three openings to the arena are shown again: one with the tent, another as an open space, and the third at center rear with a pageant wagon about to make an entrance. According to the description of the festival the reader would expect it to be the chariot of Mars and Venus about to divide the combatants. The arrangement of the figures at the rear, however (that is, one behind the other rather than side by side) strongly indicates the chariot of the queen of India.

An infantry battle is taking place in the center of the arena. There are three groups of foot soldiers with the largest at center engaged in a fray. Callot shows us a great variety of body positions and individual combats in extraordinary detail. At right and left, two smaller groups wait to attack. Surrounding the soldiers is a ring of forty-two cavalrymen as indicated in the ovals in figure 36. In the outer ring, close to the grandstands, is a series of evenly spaced soldiers with lances. Also inside the arena are ten drummers.

The legend at the bottom of the plate reads, "One of the encounters from *The War of Love*—Festival in honor of the Most Serene Grand Duke of Tuscany. At bottom right "Jac Callot. F."

(Figure 36) *Les figures du carrousel*
(*The Plans of the Maneuvers*) (L. 172 / M. 620)

This plate is divided into sixteen rectangles each containing a view of the oval arena with the various diagrams intended to represent the formations described above. They are numbered sequentially from right to left in each of the four lines. Not only do the numbers fail to correspond to those used in the description of the festival

but there has also been some disagreement regarding the proper attribution of the designs. Lieure discusses both problems:

In his *Recherches sur la vie et les ouvrages de Jacques Callot*, Meaume has written the following note: "The figures engraved as a souvenir of this festival number a minimum of nineteen of which three are by Callot. The others must have been done by Parigi, Canta Gallina, and other artists. The printed account mentions only two pieces engraved by Callot which, following the indicated sequence, would be the second and the twelfth." There are two reasons for Meaume's error. First, he had seen no other copy of the work containing the proofs (not very surprising since the complete work is extremely rare and even when one is found the engravings have usually been removed.) Second, he had incorrectly classified the piece he labeled *La plan de la fête* (number 620) which he believed to represent "the different positions which the actors or combatants must have taken during the different phases of the festival" as another festival given on the Arno, which he described under the preceding number (number 619).

It should be added that the text mentions eighteen figures which doubtlessly correspond to the two views of the festival and to the sixteen ovals of the *Plan*. However, the two views are not numbered and the numbers of the ovals do not always agree with the numbers of the text. Moreover, a numeral, 16, has been crudely etched in the place of number 15 by which it has been replaced and number 16 itself is scarcely bitten in as if one were afraid to make it too visible. This partial lack of agreement is probably a result of the rapid publication of the work which had to be printed in great haste. The title page itself is carelessly done and the wood cuts of the coat of arms found on it are poorly realized.[6]

The sixteen diagrams are reminiscent of band formations at a football game during the halftime ceremonies. They each show the maneuvers of the forty-two cavalrymen represented by small ovals and the foot soldiers represented by small dots, with the following exceptions: figure 8 shows forty-four cavalrymen, figure 9 shows forty-three, figure 10 shows forty-one, figure 13 shows forty-three, and figure 14 shows forty (despite Lieure's saying that "forty-two horsemen can easily be counted in figure 2 and those following[7])

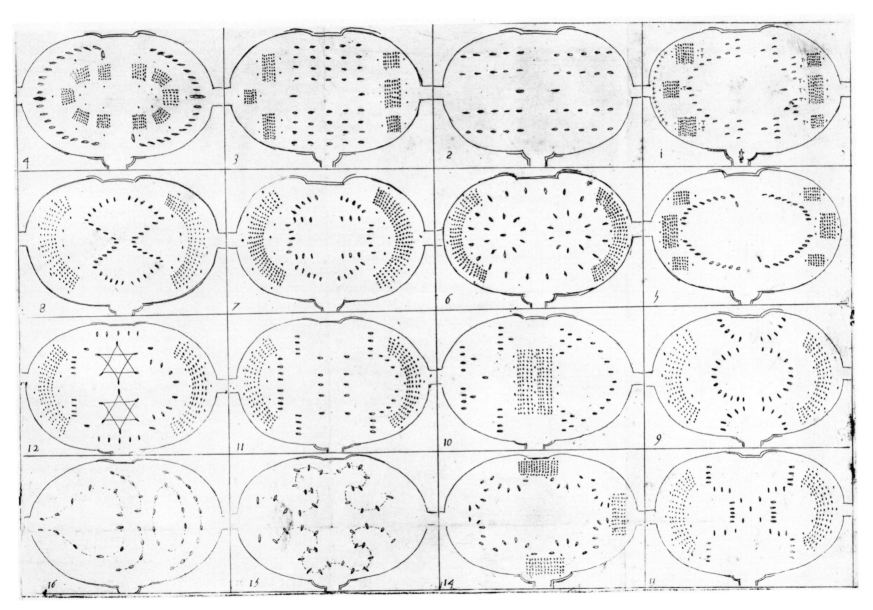

FIGURE 36

and figures 2, 15, and 16 show the cavalry but not the foot soldiers. Figure 1 shows "in particular the Chariot of India placed opposite the dais of the Grand Duchess just as the description indicates."[8] It also shows ten T-shaped figures variously arranged in front of six infantry groups. These probably represent the captains of the squadrons. Most, but not all, of the groupings are symmetrically arranged, and while there seems to be a relatively careful attempt to indicate an accurate number of cavalrymen, most of the infantry groups only suggest a total of two hundred twenty (that is, one hundred ten for each army).

It would be most satisfying if the numbering of the sixteen figures corresponded in some sequence to the numbers used in the description, but this is not the case and there is not always sufficient information in the text to enable us to make specific designations. In any event, one can hardly fail to be impressed by the imagination and variety which Agnolo Ricci brought to the manipulation of over three hundred persons and animals in this ballet.

GUERRA DI BELLEZA
(THE WAR OF BEAUTY)
(L. 178–183 / M. 636–640)

In October 1616 Federigo, duke of Urbino, bridegroom of Claudia de' Medici, paid a state visit to Florence. His arrival was celebrated with balls, masques, and *Commedia* performances and was climaxed on the sixteenth day of the month by an elaborate equestrian ballet entitled *Guerra di belleza*. As with the *Guerra d'amore* earlier that year, the presentation was given in the Piazza Santa Croce. The text was written by Andrea Salvadori, the music by Jacopo Peri and Paolo Francesino, the choreography planned by Agniolo Ricci, while the entire artistic organization was under the guidance of Giulio Parigi. Salvadori's text was published in Florence in 1616 and included five plates executed by Callot.[9] The relationship here probably is similar to that for the *Guerra d'amore*, although Parigi's name does not appear on those plates.[10] Following is a description of the festival as it appears in Solerti's *Musica*.[11] Again, it will be interesting to note how the Callot etchings vary from the details of the description.

A superb machine representing Mount Parnassus was the first to appear in the theatre. It was marvelously beautiful in design and filled with many people. The mountain was divided into two summits each completely surrounded by steep cliffs, encircled with laurels, and filled with grottoes and those places of sacred horrors so worshipped by the ancient Greeks. On the higher summit was a tall verdant oak tree, the emblem of the most serene house of Urbino. Its acorns were gold and from its branches hung military trophies and decorations. In the shadow of the oak sat the Muses. They were crowned with the leaves of this tree and played upon various musical instruments. Nearby was Pallas Athena leaning on her lance and holding upraised her shield with the head of Medusa upon it. Behind the tree was the horse Pegasus who, upon striking the ground, caused crystalline water to gush forth. Along the strewn slopes appeared all those famous scholars who could always be found at the court of Urbino, particularly those named in *Il cortigiano*.[12] They were also crowned with oak leaves. On the lower summit was Fame dressed as she is usually portrayed.[13] At her feet was Truth, a young girl dressed in white gauze who held a mirror in one hand and a whip in the other. At the foot of the mountain marched one hundred seventy persons representing the Vanities, followers of Fame, alluding to Virgil's verse: "Tam ficti, pravique tenax quam nuntia veri."[14] They all wore black wings, double-faced masks, and gowns and hairpieces of various colors. There were some musicians among them and as soon as they entered the theatre they were heard to sing in chorus the joyous song which follows: [song omitted]. When the song was finished the marvelous machine stopped in front of the most serene prince and Fame sang part of the preceding stanzas entreating his highness graciously to greet the Muses who came at her call. She gave him the details of the woeful battle between King Ussimano of Media and King Idaspe of Armenia which was caused by the beauty of their beloved Queen.

When Fame had finished singing and had, together with the chorus, stopped in front of the most serene prince, a superb retinue made its en-

trance. On one side was King Ussimano with the people of Armenia. Each group had four squadrons of horsemen and five large contingents of foot soldiers. The costumes of the two nations were each of a different color and were equally beautiful and rich. As they crossed the arena they revealed by the exquisite and brilliant weapons and by the beautiful costumes and the trappings of the horses an image of the majesty and richness with which these peoples had formerly confronted Alexander and then Lucullus and Pompey. Behind the Median army rolled the chariot of the Sun who on this day, in order to create a more solemn effect, desired to be borne by Atlas. Thus, Atlas was seen, some thirty-six feet high, carrying on his shoulders an immense globe covered in gold, on which the Sun was enthroned. He was represented as a young boy crowned with very brilliant rays, a torch in his hand, golden haired, and dressed in purple. Also on this chariot were the twelve signs of the zodiac all spangled with stars, the months represented as winged young men, and the hours as young ladies with white or black wings according to whether they represented day or night. There were also the four seasons and the serpent which, according to the Egyptians, represented the year. At the foot of the chariot marched several giants with long white hair and beards. They represented the centuries each of which is created by the Sun in a period of one hundred years.

On the other side, following the Armenians, came Thetis, goddess of the sea, on a chariot of admirable grandeur and beauty. The chariot was completely decorated with coral, sea shells, and sponges. Thetis, costumed in silver and a green hairpiece, was seated on a conch shell spangled with pearls. Accompanying her were Sirens, Nereids, Tritons, and other unnamed sea gods. Surrounding the chariot there followed on foot, in the appearance of giants, the Tyrrhenian Sea, the Adriatic, the Aegean, and still others with tridents in hand as Neptune is usually represented.

When the kings had entered the arena with their trains and the procession was over, the battle began, first among the horsemen and then among the foot soldiers. The cavaliers were armed with javelins, battle-maces, and rapiers while the foot soldiers carried battle axes and swords. It was marvelous to watch the agility and skill of the horsemen who, on forty-two horses, engaged in very beautiful combats for a long period of time. The battle among the foot soldiers was extremely desperate and terrible. At first, only several began to fight, then entire groups, and finally all the troops. All the accidents of a real war could be seen in this battle except for the sight of wounds and the horror of death.

At the climax of the combat there suddenly entered from a closed part of the theatre a white cloud bespangled with flowers which passed through the middle of the combatants. To the great astonishment of those who saw it, it opened into two parts and revealed within itself, as in a heavens painted of light and gold, Love [Cupid] with the three Graces, Laughter, Play, and Pleasure, and the other subjects of his court playing a sweet melody on different instruments. Then Love, with an arrow in his hand, rose on his throne and sang several stanzas in which he ordered that the combat cease and that upon his arrival, as a sign of joy, a celebration and dancing take place. The cloud retired to the side as the music of a joyful courante was sung and played by those many musicians who had earlier filled the theatre.

The festivities then being finished, Fame, who was present, told the other cities of Italy and Europe of the variety and beauty of the ballet and also told of the high perfection which the equestrian ballet had reached at the court of the most serene grand duke of Tuscany.

(Figure 37) *Monte di Parnaso* (*Mount Parnassus*)
(L. 178 / M. 636)

The following is a translation of the scroll which appears in the upper left-hand corner of figure 37.

Mt. Parnassus built in Florence for the equestrian ballet on the occasion of the visit of the most serene prince of Urbino. Seen on the highest part of the mountain was the Rovere coat of arms of the most serene house of Urbino. The Muses and Pallas stood in its shadow crowned with the leaves of this same Rovere [oak]. Scattered on the mountain, and similarly crowned, were all those scholars named in *Il cortigiano*. Fame was on the lower peak of the mountain and at the foot followed 170 of her ministers. 1616.

No method for moving the chariot is indicated. It was almost certainly on wheels and pushed by people hidden inside. Two summits are clearly shown but not the grottoes and "places of sacred horrors." The oak is seen as described but a detail as small as the

39

Monte di Parnaso fatto in firenze nella festa a Cauallo
per la uenuta del Serenissimo Principe d' Vrbino
si uedeua nella piu alta parte del Monte Rouere Arme
del Ser.mo Casa d'Vrbino le Muse e Pallade stauano
alla sua Ombra ueniua Coronate delle frondi
dell'istessa Rouere erano sparsi per il Monte tutti
quei letterati che nomina il Cortigiano con listessa Corone in
testa, ueniua la fama sul minor giogo del Monte et'apied la
seguiuano Cento settanta de sui ministri. anno 1616

FIGURE 37

Carro di Teti fatto in firenze nella festa a Cauallo per la
uenuta del Serenissimo Principe d'Vrbino.
Era sù quest Carro Teti con le tre Sirene, con le Nereidi,
et Tritoni, caminauano a pie del Carro Ouo Giganti
in forma di tanti Nettunni che figurauano i principali
Mari del Mondo. an. 1616.

Iul. Parig. I. Callot F.

FIGURE 38

41

acorns must be taken on faith. Pallas and the Muses cannot be identified with any certainty. Five female figures appear on the upper summit but only one seems to be leaning on a lance and she is not holding the Medusa shield. Since there are nine Muses, the other five figures were probably arranged on the back side of the chariot and cannot be seen in the illustration. It is interesting to speculate on how the effect of Pegasus' crystalline fountain was accomplished. Fame is shown playing on a double trumpet and Truth is accurately portrayed. Only a fraction of the 170 Vanities can be represented and no musicians are seen among them. They are not winged as described but they do wear the double-faced masks. The Vanities and the scholars' groups each contain a single deformed figure, perhaps a touch of Callot's fancy. At bottom right is inscribed "Jullius Parigii In. Callot delineauit et F."

(Figure 38) *Carro di Teti* (*The Wagon of Thetis*) (L. 179 / M. 637)

The following is a translation of the scroll which appears at the top of figure 38.

The chariot of Thetis built in Florence for the equestrian ballet on the occasion of the visit of the most serene prince of Urbino. On this chariot was Thetis with three Sirens, Nereids, and Tritons. At the foot of the chariot marched eight giants in the form of Neptune representing the principal seas of the world. 1616.

The chariot is a round tank filled with water. There is a large colonnade at the rear to support the throne of Thetis. According to Lieure, "The chariot is pulled by two animals in the shape of enormous billy-goats."[15] Bechtel describes them as "oxen in the skin of stags."[16] Although they are extremely grotesque, they are not easily identifiable. The scale of this plate does not permit showing two additional animals which can be seen in the *Ensemble View* (figure 42). Note Callot's fanciful addition of a snail on the ground near the right rear hoof of the forward beast in this plate. The beasts are

mounted by cupids, one of whom wields a trident. Thetis, described in the text as being dressed in silver, appears naked in the print. Perhaps she was covered with silver paint, a practice which seemed to have some currency in the staging of medieval religious plays. The sea gods are not identifiable and two of the bodies are submerged with only the heads showing. Seven of the giants are visible here but the eighth can be seen in the *Ensemble View*. At bottom right is inscribed "Jul. Parigi I Callot F."

(Figure 39) *Carro di Teti* (planche surnuméraire) (*The Wagon of Thetis* [supplementary plate]) (L. 183)

Callot did an additional plate of the Thetis chariot. It is very similar to figure 38. The scroll is essentially the same as above except for some minor variations in spelling and format. It is not dated. The cupids on the animals are smaller and the one in front does not have a trident. The postures of the figures in the tank are similar, but those of the giants are quite different. Instead of tridents the four giants in the foreground carry whips with three cords with an iron ball at the end of each cord. They wear animal skins from hip to ground. Lieure maintains that the first three giants at the rear are women (Nereids).[17] These are carrying the same whips and also wear animal skins. Their sex, however, would seem questionable. The fourth giant at the rear, seen behind the colonnade, has only two cords on the whip. The snail is missing here and the plate is unsigned.

(Figure 40) *Carro del sole* (*The Wagon of the Sun*) (L. 180 / M. 638)

The following is a translation of the scroll which appears at the top of figure 40.

The chariot of the Sun built in Florence for the equestrian ballet on the occasion of the visit of the most serene prince of Urbino. On this chariot was Atlas, thirty-six feet high with a globe of the sun itself: also the

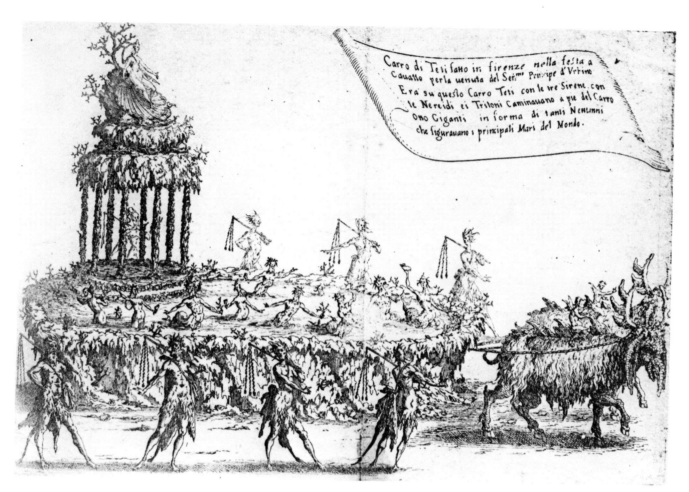

Carro di Teti fatto in firenze nella festa a
Cauatto perla uenuta del Ser.mo Principe d'Vrbino
Era su questo Carro Teti con le tre Sirene con
le Nereidi ei Tritoni Caminauano a pie del Carro
ono Giganti in forma di tanti Nenunni
che figurauano i principali Mari del Mondo.

FIGURE 39

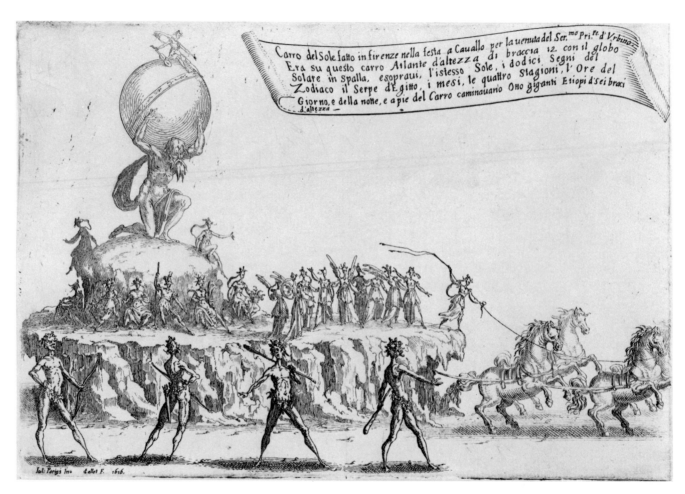

Carro del Sole fatto in firenze nella festa a Cauallo per la uenuta del Ser.ᵐᵒ Pri.ᶜᵉ d'Vrbino.
Era su questo carro Atlante d'altezza di braccia 12. con il globo
Solare in Spalla, esoprauі, l'istesso Sole, i dodici Segni del
Zodiaco il Serpe d'Egitto, i mesi, le quattro Stagioni, l'Ore del
Giorno, e della notte, e a pie del Carro caminauano Otto giganti Etiopi d'Sei braci
d'altezza —

Iul: Parigi Inᵛ dallot F. 1616.

FIGURE 40

44

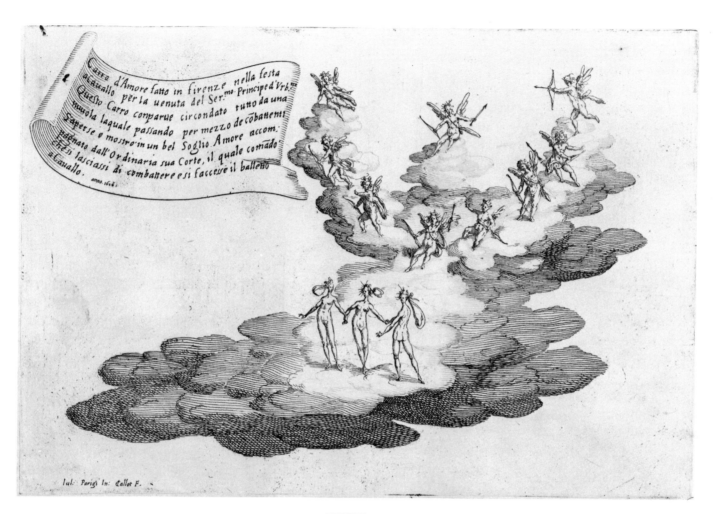

Carro d'Amore fatto in firenze nella festa a Cauallo per la uenuta del Ser.mo Principe d'Vrb.o Questo Carro conparue circondato tutto da una nuola laquale passando per mezzo de cobattenti saperse, e mostro in un bel Soglio Amore accompagnato dall'Ordinaria sua Corte, il quale comado che si lasciassi di combattere e si faccesse il balletto a Cauallo. anno 1616.

FIGURE 41

45

twelve signs of the zodiac, the Serpent of Egypt, the Months, the Four Seasons, the Hours of Day and Night, and at the foot of the chariot walked eight Ethiopian giants each eighteen feet tall.

The scroll does not carry the date, but it can be found in the lower left-hand corner of the print.

The chariot is pulled by four rampant horses, harnessed in pairs. An immense Atlas bears a band-encircled globe upon his back. The Sun does not have a crown of rays and a musical instrument has been substituted for the torch. Those groups representing the zodiac, months, hours, seasons, and giants, are either incomplete or difficult to identify and the Egyptian serpent cannot be seen. The *Ensemble View* does not clarify any of these problems although it does show seven of the eight giants specified above. Neither plate shows the giants with long hair and beards as described earlier. At bottom left is inscribed "Jul: Parigi In. Callot F. 1616."

(Figure 41) Carro d'amore (*The Wagon of Love*)
(L. 181 / M. 639)

The following is a translation of the scroll which appears in the upper left-hand corner of figure 41.

The chariot of Love built in Florence for the equestrian ballet on the occasion of the visit of the most serene prince of Urbino. The chariot appeared completely surrounded by a cloud which passed through the middle of the combatants. It opened itself and revealed Love on a beautiful throne accompanied by followers of his court. He commanded the battle to cease and called forth the equestrian ballet. 1616.

The plate shows us the revealed figures after the cloud has opened. There is no real indication of the chariot's construction, how it opened, or how it was meant to be carried on. No throne is seen for Love, but he can probably be identified as the upper central figure. The three persons in the foreground are probably the Graces. No instruments are shown. At bottom left is inscribed "Jul: Parigi In: Callot F."

(Figure 42) Vue d'ensemble de la fête (*Ensemble View*)
(L. 182 / M. 640)

Once again we are looking into the Piazza Santa Croce. The view is the same as that in *The Entry of the Wagons of Africa and Asia* (figure 34) in *The War of Love*. We are looking south with the row of buildings at the rear bordering the Arno and the Church of Santa Croce at the left.

The grandstands and arena are again in the shape of a flattened oval with obelisks. The tiers are approximately seven feet high on the inside and slope up to ten or twelve feet on the outside. Access to the stands is furnished by five curved stairways as shown in the foreground half of the oval and a similar arrangement was probably used for the south half. The stands accommodate several rows of spectators. The upper level, both interior and exterior, is adorned with a balustrade of small, turned balusters. The stands themselves seem to be made of blocks of stone. At the center of the south curve of the theatre is the roofed royal box, slightly higher than the stands. Almost certainly there is access from the rear, and a small platform is located immediately in front of the box with stairs on each side leading down into the arena.

As before, spectators can be seen everywhere. A long ladder placed against the facade of the church provides an additional vantage point. Over twenty-five thousand persons were said to have watched the performance.[18] The foreground shows a multitude of figures, many of whom are involved in pantomimic battles paralleling the action inside the arena. Since this festival was not held at carnival time, Callot has not included the *Commedia* actors, mountebanks, and *gobbi* found in the two *War of Love* plates. There are, however, dogs, horses, wagons, occasional couples, and even a pig. It is a highly detailed, bustling scene which underscores the spirit of the entire occasion.

The events inside the arena do not correspond exactly to the description of the festival. The written account given earlier indi-

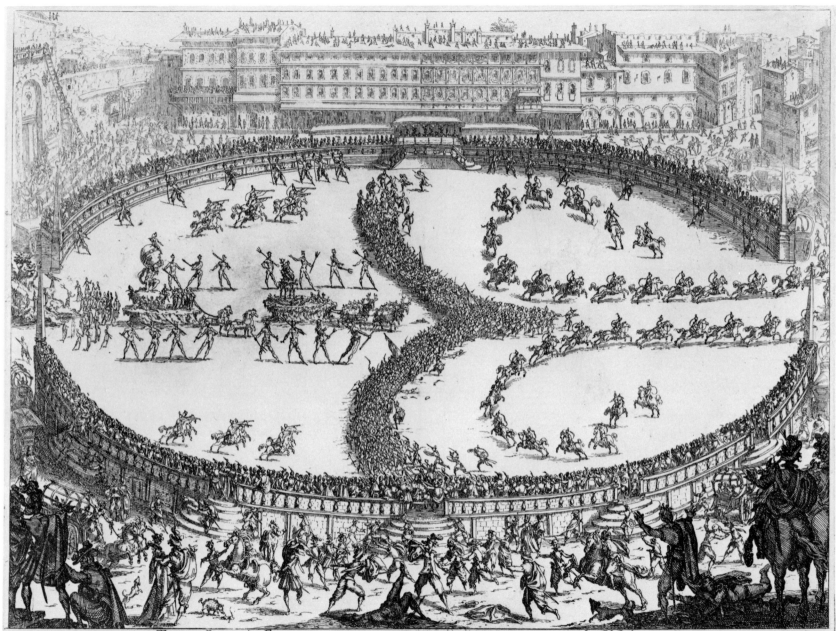

TEATRO FATTO IN FIRENZE NELLA FESTA A CAVALLO PER LA VENVTA DEL SER.ᵐᵃ PRINCIPE D'VRBINO
Qui fecero 42 Caualieri diuersi abbattimenti e dipoi un balletto ci si uide ancora una battaglia a piedi di 300 persone, oltre i Carri e l'altra gente per diuersi seruitij

Iullius Parigij Inu: Callot delineauit et F

FIGURE 42

cates the following sequence of entrances: Mount Parnassus, the Median army followed by the Sun, the Armenian army followed by Thetis, and then the cavalry and infantry battles. The plate shows the massed infantry battle at center in a symmetrical joined double curve with the cavalry at right, in two hook-shaped formations, preparing to leave the arena. At left are additional horsemen flanking three of the chariots: Thetis, the Sun, and, in the left opening, Mount Parnassus which seems to be making its entrance into the arena.

The legend at the bottom of the print reads, "Theatre built in Florence for the equestrian ballet honoring the visit of the most serene prince of Urbino in which forty-two horsemen fought among themselves, followed by a ballet, then another battle on foot among 300 soldiers, as well as the chariots and other persons of various functions." In the lower right-hand corner is inscribed "Iullius Parigij Inu: Callot delineauit et F."

L'ARRIVÉE DE L'AMOUR EN TOSCANE
(THE ENTRY OF LOVE IN TUSCANY)
(L. 166–167 / M. 618–619)

On the feast day of St. James, 25 July 1615, the Arno River and its banks were converted into a theatre for a presentation of *The Entry of Love in Tuscany*. A description of the spectacle was published[19] and Callot provided two illustrations: one a river panorama and the other a detailed view of Love's wagon. Solerti printed an account of the event as recorded in Tinghi's diary.[20] A translation of selected details follows.

And on that day his most serene highness, Prince Don Carlos, and Pavolo Giordano went along the Arno by coach, in the area between Saint Trinity Bridge and the Carraia, where the festival had been prepared. The event had been designed and written by Ferdinando Saracinelli, grand chancellor of the order of Saint Stephen and private valet to his most serene highness.

Love, weary of seeing his subjects tormented and suffering and wishing a pleasant and tranquil life for them, free of complaints and sighs, resolved to liberate them from his wagon and relieve them of fear, suffering, anguish, grief, furor, anger, jealousy, pain, and, in short, all cruel effects. Thus, he converted his wagon into an oared vessel, placed his subjects under his command, and made them lead him from Cyprus, by way of the Arno, to Tuscany where he wished to place his throne in order to rule benevolently over the beautiful ladies who resided there. For this purpose he sent his ambassador to Pleasure, who in a series of verses explained his master's intent. Meanwhile the superb Theatre of the Arno was filled with spectators awaiting the boat race, the usual entertainment given annually during the Saint James festival.

Pleasure recited his message from a most superb pageant wagon together with Smiles, Delight, Joy, Gladness, Contentment, Gaiety, and others. He then circled the theatre several times while they all sang a madrigal. After this he followed two wagons, one with a group of musicians playing on wind instruments and the other with a group playing on stringed instruments. A great deal of singing followed and when this was finished the order was given to begin the boat race. His most serene highness and his noble brothers remained in the coach and traveled about the theatre while the grand duchess remained at the house of Iacopo Lanfredini with the four princesses. When the festivities were over they all returned to the Pitti palace.

(Figure 43) Le théâtre de l'Arno (Theatre of the Arno)
(L. 167 / M. 619)

The print shows a portion of the Arno between two bridges and the banks on each side. This area is dominated by the wagon of Love at center surrounded by various aquatic activities: jousts, boating contests with two, three, and four oared vessels, swimmers, acrobats, and a human pyramid. Both banks and bridges are crowded with spectators and hundreds of others can be seen in the windows and on the roofs and balconies of the buildings in the background. The spectators in the foreground include an interesting variety of figures and groups, some mounted, some in conversation, some around wagons. There are hawkers, the omnipresent dog, a child relieving

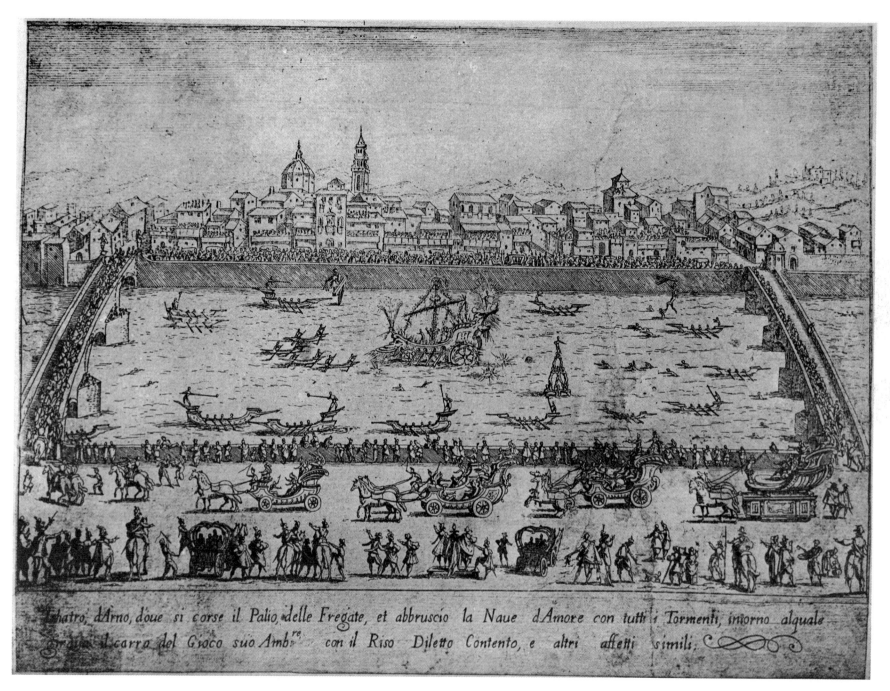

Teatro, d'Arno, d'oue si corse il Palio, delle Fregate, et abbruscio la Naue d'Amore con tutti i Tormenti, intorno alquale
in carro del Gioco sùo Amb.re con il Riso Diletto Contento, e altri affetti simili.

FIGURE 43

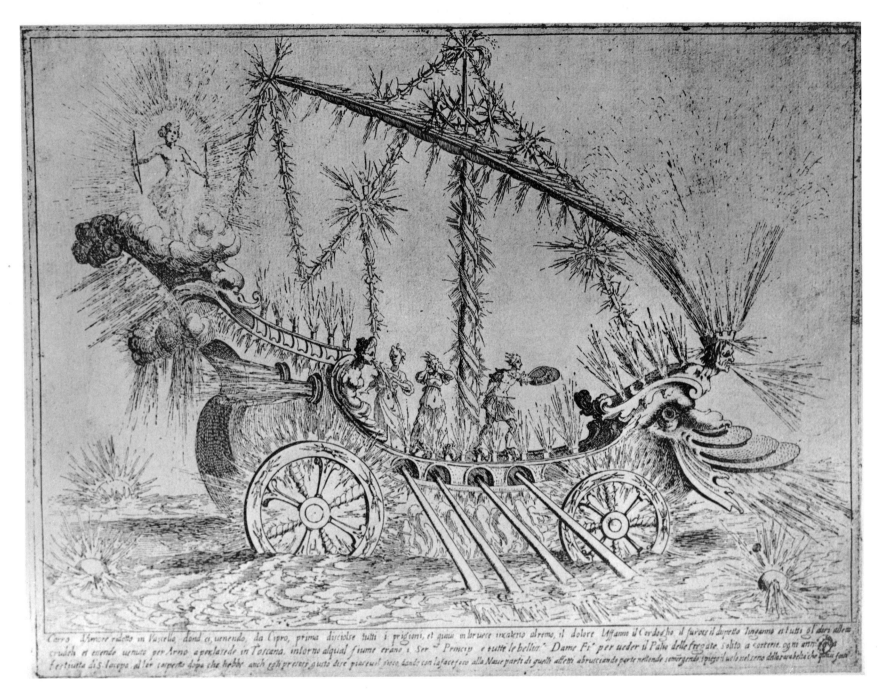

Carro, d'Amore ridotto in Vascello, donde, ei uenendo, da Cipro, prima disciolse tutti i prigioni, et quau in lor uece incateno al remo, il dolore, l'Affanno il Cordoglio il furore il dispetto longanno et tutti gl'altri affetti crudeli et essendo uenute per Arno, a preclaro se in Toscana, intorno al qual fiume erano i Ser.mi Principi e tutte le belliss.e Dame Fi.e per ueder il Palio delle fregate, solito a corrersi, ogni anno, la

festa dalla S. Ioseppe, al lor cospetto, dopo che hebbe, anch'egli preteso, gusto dire piaceual foco, dando, con la face foco alla Naue parte di quelli affetti abbruciando parte mettendo sommergendo spiego il uolo, nel cielo della sua belta che felici furo...

FIGURE 44

himself, and what seems to be two *gobbi* at right center. In the foreground street a parade is in progress. Four horse-drawn pageant wagons, shown with Pleasure at the rear, are moving at the left preparing to cross the bridge and circle the Theatre of the Arno. Near the front of the procession, behind the second pair of horses and immediately in front of the first wagon, is a pair of *zanni* in a typical Callot pose.

In the margin at the bottom of the print is written "Theatre of the Arno, where the frigate-race was run and the Vessel of Love burned with all the Torments, around which circled the Wagon of Pleasure his ambassador, with Smile, Delight, Contentment, and other similar sentiments."

The etching is unsigned.

(Figure 44) *Le char de l'Amour* appelé aussi *Le vaisseau d'artifice* (*The Wagon of Love* also called *The Vessel of Fireworks*) (L. 166 / M. 618)

In this print the Wagon of Love is shown in isolated detail moving to the right instead of to the left as in the preceding plate. Love, completely surrounded by a halo, stands high at the rear of the vessel holding his traditional bow and arrow. Three figures stand on the main deck in seemingly distressed attitudes. Two are female and the third, a male, holds a sword and shield. The heads of the four oarsmen on the near side are visible. Elaborately constructed with three figureheads incorporated into the structure, the entire vessel is ablaze with fireworks, from the railings, portholes, mast, rigging, and figureheads. A pinwheel turns at the top of the mast and three balls of fire blaze in the water.

The inscription at the bottom of the print reads,

The Wagon of Love, transformed into a vessel, has come from Cyprus where he [Love] first released all his prisoners and in their stead chained to the oars of his vessel all the cruel effects including suffering, anguish, grief, fury, spite, and deception. He arrived at the seat of Tuscany by way of the Arno, around which river were his most serene highness and all the beautiful ladies of Florence gathered to watch the Frigate-Race which is usually run each year for the Festival of Saint James. In their presence, after taking pleasure and bantering pleasantly with them, Love then set fire to the ship with a torch so that some of the cruel effects burned and others drowned. He then explained his flight into the bay because of the rare beauty to be found there.

The etching is unsigned and undated.

(Figure 45) *L'éventail* (*The Fan*) (L. 302 / M. 617)

Exactly four years after *The Entry of Love in Tuscany*, Callot recorded another festival on the Arno in celebration of the feast of St. James. This was the staging of the symbolic battle between the weavers' and dyers' guilds of Florence. The etching is known as *The Fan* because of the elaborately Baroque frame used to enclose the scene. The festival was described in Tinghi's diary as follows:

On the 25th of July [1619] his most serene highness, wishing to give a little pleasure to the most serene grand duchess and all the people of Florence, commanded a festival on the Arno River between the Holy Trinity Bridge and the Carraia—namely, the great combat on the mountain between the two "nations" of Florence, that is, the *tintori* [dyers] and the *tessitori* [weavers]. The dyers were under the patronage of Fra Inolfo de'Bardi and the weavers under Rodrigo Alidosi, lord of Castel del Rio. There were fifty to each group. The dyers wore large red caps, around their shoulders a pilgrim's cape of white leather checkered with red, and tights of red cloth with silver stripes. They carried red clubs and shields, their insignia in red, and the instruments of their trade on a red field. They were accompanied by their captain. The weavers wore similar dress, more or less, but in black and white. They embarked upon three frigates each armed by these companies, appeared in the theatre, and given the start from the officer in charge they went at each other flank to flank with shield and club as indicated, and then met in hand-to-hand combat so that one was victorious twice and by the fourth battle the dyers were victorious and remained masters of the field. After the combat and music had finished and night had fallen they ignited a great pyramid full of contrived and bell-shaped flames. Within the space of

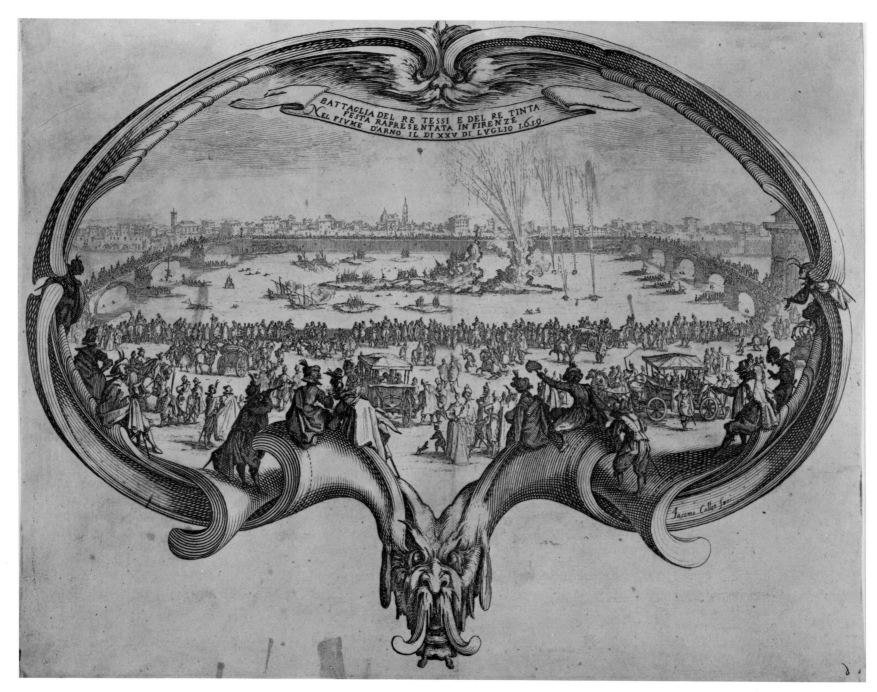

FIGURE 45

half an hour it was a marvelous sight, and after having set fire to two of the aforesaid frigates which made a very great fire, there was a beautiful celebration.

And the pretext together with the poem, which will be given below, was composed by Andrea Salvadori, Florentine poet, and the architect was Giulio Parigi, Florentine engineer. They had platforms of about twelve feet made for the populace which did not occupy the street but were down near the river. The theatre was very beautiful and one would judge that there were thirty thousand people in the stands, windows, and rooftops, and on the banks of the river.

And his most serene highness, wishing the women better to understand the theme of the festivities, had printed more than a thousand programs and had made five hundred fan lights or fire fans in oval shape, imprinted with the theatre in the form of the festival and with the handle of the fan in silver. He sent them to be delivered to Sir Antonio Paulsanti to the windows where the ladies and gentlewomen were, with a program and fan for each.

His most serene highness stayed with the Cardinal de' Medici and Prince Don Lorenzo to watch from a coach near the banks of the Arno opposite the house of Signore Alberto de' Bardi and her most serene grand duchess with the princesses and ladies were on the balcony of the house of the aforementioned Signore Alberto Bardi. The festival lasted from 10:30 at night ending at one o'clock in the morning.

Battle between the Weavers and Dyers
Festival held in Florence on the Arno River on July 25, 1619

Tinta, most powerful king of Tingitana, and Tessi, dreadful lord of Tessaglia, the former, captain of the Mamelukes, the latter captain of the Myrmidons, both of them in love with Queen Barulla, mistress of Sudicera, an island in the Ethiopian Sea, were, in order to prove their value, sent by her to acquire the sacrifice that Cyclops had prepared for Vulcan on the island of Sicana. She declared that she would take for her knight and lover the one who returned victorious with the spoils which were dedicated to that god [Vulcan].[21]

The Fan is one of Callot's most admired etchings and various critics have pointed out the influence it apparently had on Watteau a century later. The print is remarkable for the ingenuity of its frame, the arrangement of the figures, the spatial effect and perspective achieved, the intricate details, and the general arrangement of the plan.

Tinghi indicated that many of the spectators were provided with an illustration of the festival imprinted on a silver-handled fan. Callot has included a spectator in the foreground holding one of these fans. Mariette has written,

When the festival, which Callot etched and enclosed in a fanshaped scroll, was done in Florence, it was advertised by a published description. It is in quarto, twelve pages, entitled *Bataglia tra tessitori e tintori, festa da farsi in Firenze nel fiume Arno, il di 25 Luglio 1619, 4°, appresso il Cecconcelli*. The etching appeared simultaneously on a sheet of paper on which were also printed several pieces of Italian poetry written for the occasion. I have derived this from some notes accompanying the poem *Malmantile* published in Florence in 1750.[22]

The fan frame has a grotesque mask at top and bottom. The upper mask seems to grow out of the frame itself while the lower one is a more independent element although it corresponds to the general contours of the fan.

The center of the etching shows the river festival in full action. That part of the river between the Holy Trinity Bridge and the Carraia is shown again with a large island in the middle of the river. Visible on this island is a flat area, to the right of it a bridge leading to a high mountain with various levels, and next to it another peak exploding with fireworks. Soldiers abound on the flat islet, bridge, and center section. The latter is strongly reminiscent of the Mount Parnassus float used in *The War of Beauty* (cf. figure 37). A solitary figure stands at the highest point. Four smaller islets with soldiers on them flank the central structure. Eleven oared vessels can be seen, with four of the larger ones attacking the island. In the water are fireworks, mines, swimmers, and a human pyramid.

Thousands of figures are shown watching the festival. The majority of the spectators line the river banks and occupy all available space on both bridges. They can be seen under canopies, on scaf-

folding on the far bank, and some figures are even hanging from a rope on the left bridge. The most interesting figures, however, are in the lower half of the print where they are shown in varying degrees of detail. On the lower rim of the frame Callot has drawn twelve male figures arranged in four groups of three each. One of these is watching the festival through the newly invented telescope, and another holds the fan which Tinghi described. The middle ground is typically Callot with its focus on environment instead of the ceremonial. It is bustling with activity with men, women, and children in numerous attitudes of encounter. There is a dog again, as well as figures on foot, on horseback, and in the five carriages. The full excitement of the moment has been preserved in most imaginative detail.

The scroll at the top reads, "The Battle between King Tessi and King Tinta. Festival presented in Florence on the Arno River, July 25, 1619." At bottom right on the fan border is the inscription "Jacomo Callot fec."

LE COMBAT À LA BARRIÈRE
(THE COMBAT AT THE BARRIER)
(L. 575–588 / M. 492–501)

Late in 1626, Charles IV, Duke of Lorraine, gave political asylum to his wealthy and attractive cousin, the duchess of Chevreuse. While she was at Nancy, the duke and the prince of Phalsbourg served as her hosts and at 9 P.M. on 14 February of the following year a festival and tourney was given in her honor, with her husband present, in the Great Hall of the Ducal Palace. The prince sponsored the event and paid its expenses.

The program began with a procession led by the prince of Phalsbourg. His entry was followed by such lords as Messieurs de Macey, Vroncourt, Tyllon, Marimont, Couvonge, Chalabre, Brionne, Henry of Lorraine and his barons, and finally Charles IV himself. The fes-

tivities concluded with a stylized combat at the barrier and the victor's prize was awarded to Duke Charles by the duchess of Chevreuse.

An account of the event and its text was written by the blind Henry Humbert, and descriptive extracts from this work are quoted from time to time in the following pages. Humbert's book was described by Beaupré as follows:

Combat à la barrière presented at the Court of Lorraine, February 14, 1627. Represented by the prose and poetry of Henry Humbert. Embellished with the designs of Jacques Callot and dedicated by him to the Duchess of Chevreuse. At Nancy, by Sebastian Phillipe, Printer to his highness, 1627. . . . The text is paginated 1 to 58 and is followed by a page which indicates the order and placement of the participants. There are eleven etchings. The first serves as a frontispiece showing the coat of arms of the duchess of Chevreuse. Nine others, drawn in oblong quarto, are folded into the book. The final one, printed with the text on the top of page 53 shows the armed arm issuing from the cloud.[23]

Two supplementary prints are extant but do not appear in the final version of the book. They are described in their appropriate place below. The frontispiece and armed arms (a second one reversed in error and not included in Humbert) are not discussed here. A number of the etchings were printed on placards with appropriate verses below. They were issued independently of the book.

Callot worked in collaboration with Claude Deruet on this festival. Deruet had returned from Italy one year earlier than Callot and was artistic director of the ducal entertainments. There is some controversy over the responsibilities and contributions of the two men, but the division of labor seems evident. Callot designed the wagons, costumes, decor, and so forth and etched the plates. Deruet was responsible for the "moulage et décoration" of the wagons but not for their conception and was paid a thousand francs for this work. There is some evidence that the Callot etchings are an exaggeration of what was actually seen at the festival since an earlier working drawing of his, particularly for the Couvonges entry, indi-

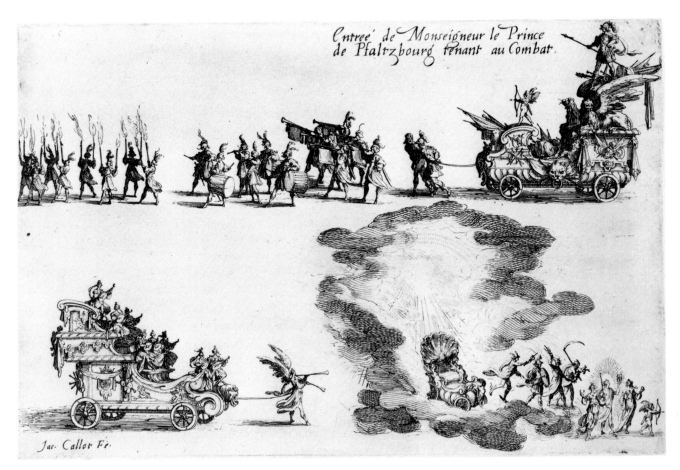

FIGURE 46

cates that the wagon was considerably less impressive. The wagons for the 1627 presentation were almost certainly built upon shells preserved from year to year and redecorated for each new occasion.[24] In effect, it was Callot who conceived the designs and Deruet who executed them for the performance. Callot's experience at the Medici court under the tutelage of Giulio Parigi is evident here.

(Figure 46) *Entrée de monseigneur le prince de Pfaltzbourg* (*The Entry of the Prince of Phalsbourg*) (L. 576 / M. 493)

The entry consists of five distinct units and begins with the group at the lower right-hand corner of the plate. Cupid, with drawn bow, leads the procession. Behind him is Apollo who has descended from his throne and stands between Juno and Diana. This trio is followed by Pluto, Neptune, and Saturn with Mercury at the rear.[25] The empty, wheeled throne is surrounded by clouds which are pierced by the sun's rays. The entire unit as depicted by Callot is probably an aesthetic impression rather than an accurate representation. The means by which the cloud-encased throne was moved through the hall is difficult to determine if the arrangement is accepted at face value. Perhaps there were persons hidden inside the throne, or perhaps the entire cloud unit rested on a wheeled platform and was moved by concealed manpower. The latter is the more likely conjecture and would satisfactorily explain the placement of the four central figures.

The second group consists of a large pageant wagon pulled by Fame who is blowing on her traditional trumpets (cf. note 13).[26] Although we are told that the wagon carries "twelve lute players," Callot shows us only eight. The music, according to Humbert, "had the power to soothe the listeners' souls for such sweet ravishments had never been heard before." Their costumes were "gowns of pink and violet-gray and white, embellished with tinsel."

Behind this wagon followed "twenty pages in similar finery [Callot shows only eight] each carrying two torches of white wax."

Next was a procession of twelve instrumentalists in the vanguard of the prince's wagon. It consisted of a pair of drummers, a pair of flutists, two more drummers, and two trios of trumpeters.

The triumphal wagon "drawn by Mars and Hercules was filled with countless trophies." At the top stood the "Prince himself, bearing sidearms and holding a lance in his right hand." Below him, holding a drawn bow, was another Cupid who "sang several verses." One can only hope that the instrumentalists in the second and fourth groups were playing in unison and not so loudly that the verses could not be heard.

The top right part of the print bears the inscription "Entry of Monsieur, Prince of Phalsbourg, Sponsor of the Combat." At bottom left "Jac. Callot Fe."

(Figure 47) *Entrée de monsieur de Macey* (*The Entry of Monsieur de Macey*) (L. 577 / M. 494)

The entry of de Macey was the least ostentatious of the processions since there were no wagons to accompany him. It began with four drummers and two flute players who were followed by four pairs of torch-bearing pages, a pike-bearer with a magnificent headdress, an unidentified nobleman and then de Macey who, Humbert says, "saluted the ladies with a dozen caprioles so high it seemed that Mars himself was ascending into the skies. He then announced his intent under the name of Chevalier de la 'Retraicte.'"

The top center of the print reads, "The Entry of Monsieur de Macey." At bottom right is inscribed "Jac. Callot in et Fec."

(Figure 48) *Entrée des sieurs de Vroncourt, Tyllon et Marimont* (*The Entry of Messieurs de Vroncourt, Tyllon, and Marimont*) (L. 578 / M. 495)

The three lords were preceded by Arion on a dolphin's back. According to Humbert, Arion "caressing his lute mingled the strains

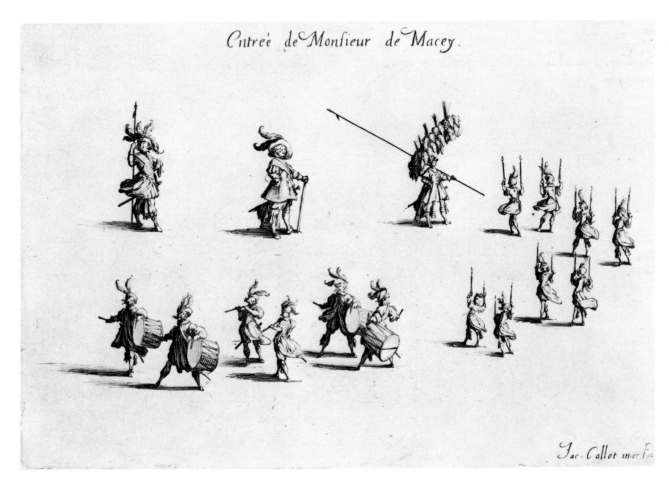

Entreé de Monsieur de Macey.

FIGURE 47

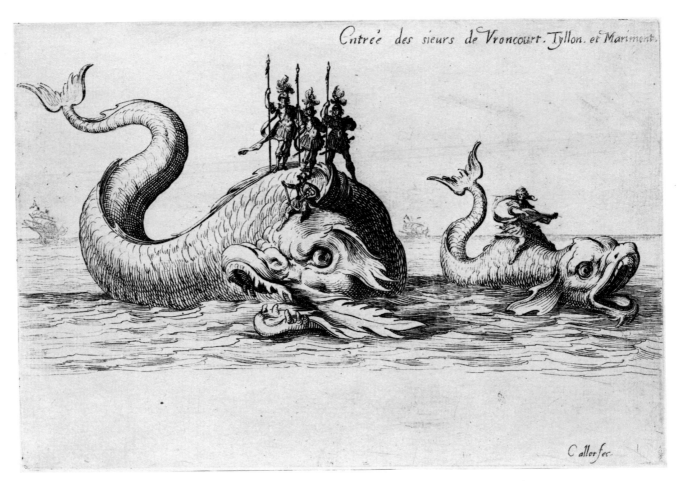

FIGURE 48

of music with the notes he sang. Vroncourt, Marimont and Tyllon followed as the illustrious Knights of Glory." Mounted on a larger and more imposing dolphin, each was boldly helmeted and bore a pike in hand. Their handsome retinue in livery of red and blue taffeta is not shown. Humbert's written account indicates that the dolphins were "in the midst of sea waves." Callot's treatment of the sea, the horizon, and the ships is artistic license, and we should not assume that the entry consisted of much more than the bottom of the dolphin pageant wagons encircled by artificial waves which hid the wheels or other means of locomotion. Apparently Callot chose to delete the accompanying retinue in favor of the more striking wagons.

Lieure calls attention to the fact that the first state of the etching contains the two small boats in the distance as well as the back part of the sea. In the second state these are effaced.[27]

At top right is inscribed "Entry of the Lords de Vroncourt, Tyllon, and Marimont." At bottom right "Callot fec."

(Figure 49) *Entrée de monsieur de Couvonge et de monsieur de Chalabre* (*The Entry of Monsieur de Couvonge and Monsieur de Chalabre*) (L. 579 / M. 496)

"Suddenly the eyes and ears of the spectators were captivated by a commotion at the entrance side of the Hall," states Humbert. It was the entrance of Messieurs de Couvonge and de Chalabre who were impersonating Minos and Rhadamante. Humbert continues:

In front of them marched the "Garrison of Hell" dressed only in fire and flames. There were thirty demons each carrying two torches whose artificial light occasionally formed dragons in the air which flew almost to the dome of the hall. They were followed by three ladies forming the court of honor for the princess of Hell. Their heads were covered with hissing snakes which frightened everyone with their forked, venomous tongues. In one hand they carried a blazing torch and in the other vipers and entwined serpents as frightening as their headgear. Minos and

Rhadamante, javelin in hand, with golden crowns studded with black upon their heads, were drawn on a machine, the back of which comprised a grotto vomiting forth many flames.

Callot does not show us the entire procession. Rather, he has attempted to capture the grotesque chiaroscuro of the event which in many ways reminds us of his treatment of *The Temptation of Saint Anthony* (see chapter 5). The small figures at the right are in postures reminiscent of the *Commedia* etchings. A giant devil leads the procession with three small figures tied to him, all of them playing on an instrument. The rearing animal, guided by two attendants, is probably a specially costumed horse. The grottoed wagon, drawn by a dragon, holds a seated figure with his lords standing behind him. In the semidarkened hall the effect of the flames, torches, and smoke must have been spectacular.

The bottom of the plate reads "The Entry of Monsieur de Couvonge and Monsieur de Chalabre" and is inscribed at bottom right with "Jac. Callot In. et F."

(Figure 50) Supplementary plate to *Entrée de monsieur de Couvonge et de monsieur de Chalabre* (L. 585 / M. 491)

Callot did this supplementary plate earlier than the print that was finally used in Humbert's book. The first plate was too small for the format of the book. It shows the procession in reverse and is in most respects similar to the one described above. The major differences to be noted are the absence of the small postured figures at the front of the group, the winged devil with his long club, the animal clearly shown with three heads and now identifiable as Cerberus, guardian of the entrance to Hell, and the seated figure who appears as a male attendant to the lords.

At the upper left the plate reads, "The Entry of Monsieur de Couvonge and Monsieur de Chalabre." At bottom right "Ja Callot In et Fecit."

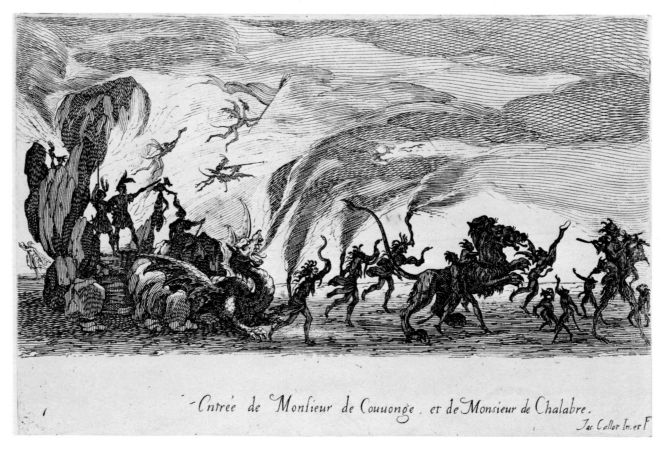

Entrée de Monsieur de Couuonge. et de Monsieur de Chalabre.

Jac. Callot In. et F

FIGURE 49

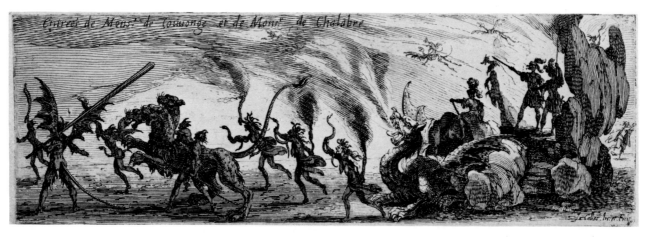

Entrées de Meus.^r de Couuonge et de Mons.^r de Chalabre

FIGURE 50

(Figure 51) *Entrée de monsieur le comte de Brionne*
(*The Entry of Monsieur de Brionne*) (L. 580 / M. 497)

The Count of Brionne, grand chamberlain to Charles IV, represented himself as Jason in quest of the Golden Fleece. His entry consisted of three wagons. The first was a representation of the island of Colchis floating on the sea. "In the center the Fleece was seen attached by golden chains to the branches of a tree. At the foot of the tree was a fearsome dragon exhaling as many flames as the firebrands of Jupiter. He kept such a guard over the rich booty that even the songs of Mercury would not have charmed his watchful eyes," Humbert says. The second wagon bore the brass Palace of Fame, with Fame "on the threshold blowing Jason's praises on her two golden trumpets." Finally came Jason's vessel, the *Argo*, with Jason "in silver armor" standing on the poop deck. The armed ship sailed in waters filled with sea gods who played on such varied instruments as horns, harps, lutes, tambourines, and flutes. The sirens in front of the boat can be seen only in early proofs of the print.

The first and third floats were probably set in tanks filled with water after the manner used for the chariot of Thetis in *The War of Beauty* (see figure 38).

At top left the plate reads, "This is the Entry of the Count of Brionne, Grand Chamberlain to His Highness, representing Jason." At bottom left "Callot fec."

(Figure 52) *Entrée de monseigneur Henry de Lorraine*
(*The Entry of Henry of Lorraine*) (L. 581 / M. 498)

Five wagons constituted this entry. On the first, according to Humbert, "appeared Fidelity drawn by a griffon"[28] (there are two in the print) whose whiteness

shamed the snows of Mt. Rhodope. Her robe was white satin decorated with gold lace and scattered with embroidered hearts.

Constancy, mounted on a wagon drawn by a flying dragon, wore a pink satin robe adorned with silver tinsel and enriched with a thousand flowers embroidered in gold.

Perseverance, matching the perfection of her two companions, wore an amaranth-colored satin robe covered with silver lace upon which glittered an infinity of embroidered stars. Led on by Time, she stood upraised in order to trumpet the praises of Pyrandre, the name selected by the Magnanimous Prince in order to testify to the live coals in his bosom which were stoked by his generosity.

Next followed a choir mounted on a phoenix,[29] whose "wings stroked a pile of aromatic faggots in order to keep alive the fire conceived by the sun's rays. The musicians, dressed in pink and blue robes, gave angelic voice to the sweet harmony of the lutes."

Finally Pyrandre appeared on a salamander drawn by a swan mounted by "the little god who causes one to fall in love. Since the salamander recognized fire as the only element of its life, it was in the middle of the flames which exuded sweet fumes that not even the perfumes of Arabia could rival. Pyrandre, in armour of cross-hatched silver, was accompanied by the Barons of Magnieres, Carelle, Moyuron, Bresson, Verduisant, Riancourt, and Magat le fils. They all wore helmets and carried lances."

The top center of the plate reads, "The Entry of Monseigneur, Henry of Lorraine, Marquis of Moy under the name of Pyrandre." At bottom left is inscribed "Jac. Callot fe."

(Figure 53) Supplementary plate to *Entrée de monseigneur Henry de Lorraine* (L. 586 / M. 490)

This supplementary plate done by Callot was discarded because it was too large for the format of the book. It does not bear his name. The etchings are not identical, but there are no significant differences between them.

(Figure 54) *Entrée de son Altesse* (*The Entry of Duke Charles IV*) (L. 582 / M. 499)

The procession concluded with the entry of Charles IV. He was preceded by a large group of musicians dressed in silver, white, and

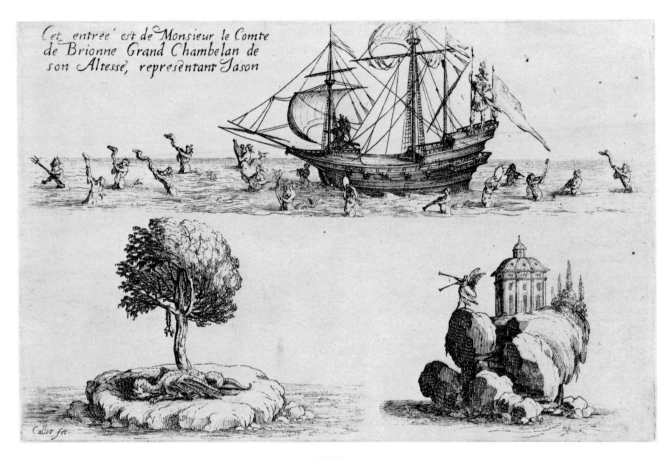

Cet entrée est de Monsieur le Comte de Brionne Grand Chambelan de son Altesse, representant Jason

Callot fec.

FIGURE 51

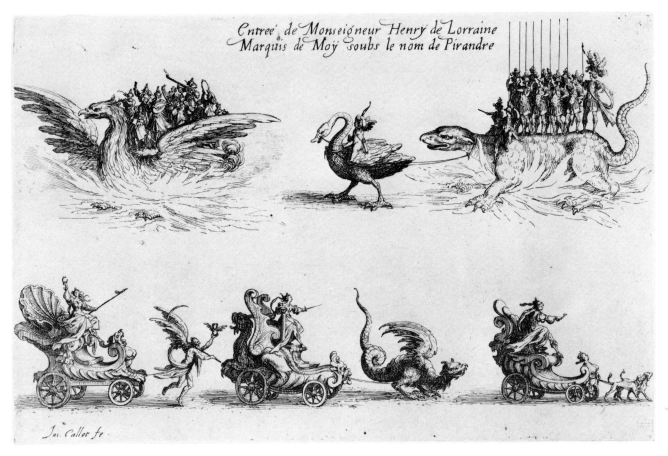

FIGURE 52

63

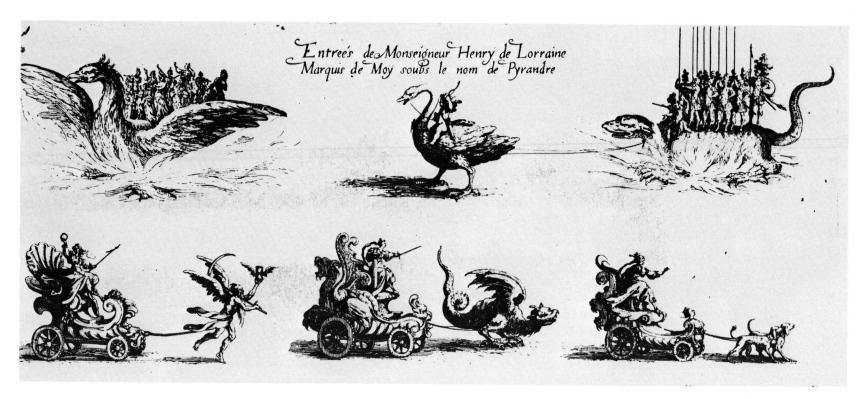

FIGURE 53

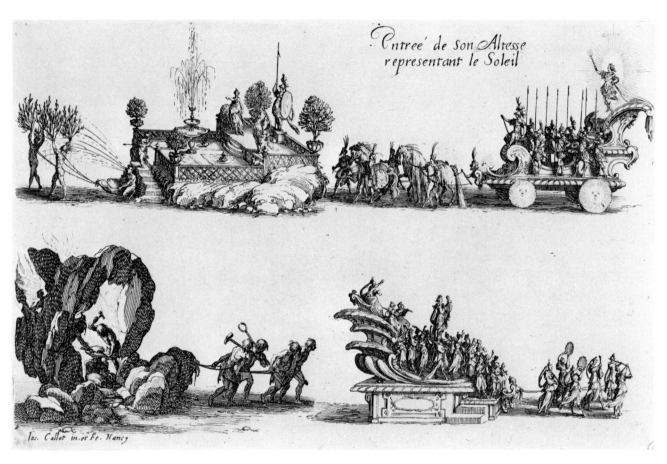

FIGURE 54

65

blue linen "on a golden chariot led by six nymphs," according to Humbert.

Next followed a wagon in the form of a cave drawn on by four workers, two of them carrying a hammer and tongs. At the rear of the cave Vulcan and Cyclops could be seen forging the arms of the Sun, tempering them like "those of the gallant Achilles whose arms, at the prayers of Thetis, protected him against all the artifices of Death. One would have thought thunder and lightning issued from the cave so great was the noise of the fire, anvils, hammers, and breath of the bellows."

After this din passed there appeared a wonderful garden. "The fruits which hung from the green branches of its trees were no less rich than those of the Hesperides. It had two fountains," one at the foot of the steps and the other at center. "The perfumed waters scented the entire hall with a musky odor." On the upper level stood Juno, Pallas Athena, and Venus who, "since the judgment of Paris, came near one another only to express their mutual dislike. Now, respect for the great Sun made them reconcile their differences, and that subject of reconciliation was sung by the childish voice of Venus' son who stood at the portal of the garden."

Finally, the wagon of Charles IV appeared drawn by four magnificent horses. The duke stood above at the rear resplendent as the Sun. Humbert says,

His majestic bearing deserved the homage of all the gods. Accompanying him were Messieurs d'Iche, Darconat, Baron de Cressia, de Florainuille, Baron de Maupas, de Beaujeu, Baron de Vannes, de Bornay, Baron de Bulgneuille, de Beaulieu, Florainuille de Faim, and Talange, all of them helmeted, holding lances, and dressed in silver armor. They were as heavenly bodies upon which the Sun had deigned to dispense the favor of his rays. Two field marshalls marched before him: the Marquis de Remouille and Monsieur de Couvonge.[30]

Above right is written "Entry of His Highness, Representing the Sun." At bottom left "Iac. Callot in. et Fe. Nancy."

66

(Figure 55) *Entrée de son altesse à pied (The Procession on Foot)*
(L. 583 / M. 500)

"With the tour of the hall completed, Juno, Pallas Athena, and Venus brought his highness his precious armor freshly drawn from the forge which he donned, with the help of their lovely hands, upon a garment truly worthy of the Sun. This radiant Sun who had formerly moved only in the azure circles of Mount Olympus, having honored the earth by his descent, now made his entrance into the arena," so continues Humbert's description.

Callot gives us a one-point perspective view of the depth of the hall. Hanging from the ceiling is a heavens painted in colors designed to reflect the light of the torches and the chandeliers. A symbolic group is placed at its center. Below are three archways filled with the wagons of the final entry: at the left the garden, at center the duke's throne, at right the forge where his armor had been fashioned.

The center of the floor is divided by the barrier to be used for the forthcoming joust.[31] The duke's retinue is ranged in two rows on each side and he himself stands at the bottom center of the print. Flanking him behind are two figures, one of them with the elaborate headdress seen in de Macey's entry (figure 47). Before him on each side are the field marshalls.

The multitude of spectators is seen watching the event from three sides. In the lower left corner of the print is the royal box with steps leading up to it with the seat of honor, in the front row, occupied by the duchess of Chevreuse. The ornate draperies which frame the picture are an artistic convention and are not meant to represent actual hangings in the hall.

At bottom center is written "Entry of His Highness on Foot" and at bottom right "Iac. Callot In. et Fecit."

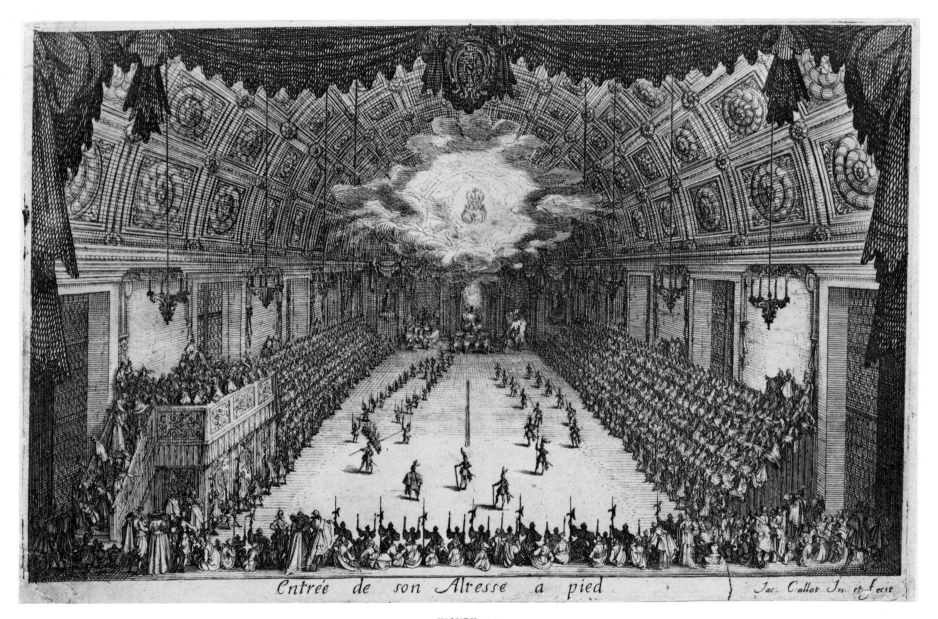

Entrée de son Altresse a pied Jac. Callot In. et fecit

FIGURE 55

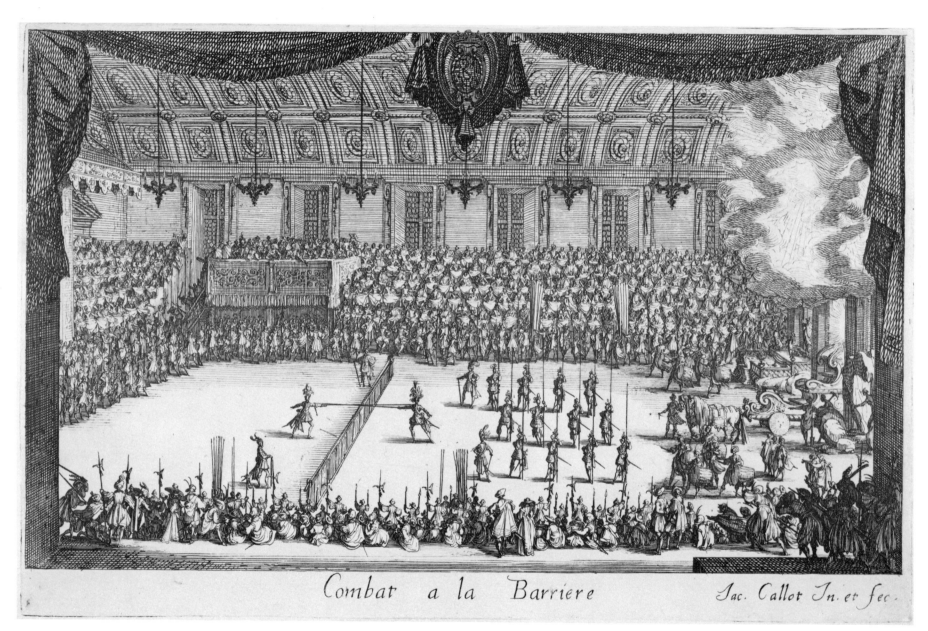

Combat a la Barriere Jac. Callot In. et fec.

FIGURE 56

(Figure 56) *Combat à la barrière* (*The Combat at the Barrier*)
(L. 584 / M. 501)

This print shows us the climax of the festivities. The duke and his adversary are at joust with a retinue and the officials of the tourney in formal poses. The three wagons of the duke's procession can clearly be seen at the right with the heavens hanging overhead. Most of the seated spectators appear to be women with the men standing at floor level. A pair of lance-bearers stand at opposite sides of the arena. The number and positions of the windows, chandeliers, and rosette decorations of the ceiling do not correspond to the previous plate. As one scholar points out, "In order to describe the episode better, Callot has exaggerated the intensity of the light in such a way that we almost forget that the festivities are nocturnal without the presence of sunlight."[32]

The combat was a carefully controlled affair and there seemed to be little question that the duke would be awarded the victor's prize: "Anyone who has seen a ship amidst the reefs in an agitated sea can imagine the storms and tempests of the blows. The invincible champion calmly withstood the attack so that his assailants would experience the strong counterbalance of his own hand. The length of this furious combat scarcely put him out of breath and it ended with an infinity of eulogies which applauded the duke's munificence."

At bottom center is written "Combat at the barrier" and at right "Iac. Callot In. et fec."

(Figure 59) *La carrière de Nancy* (*The Public Square of Nancy*)
(L. 589 / M. 621)

The etching shows the new Public Square of Nancy at carnival time in February 1626. The entire square is depicted with the ducal palace at the rear. Callot's own house has been identified as the third one up the street from the lower left-hand corner of the print.

This tumultuous panorama contains examples of almost every theatrical element we have considered to this point. There is action everywhere. At first glance the work seems a jumble of heterogeneous elements, but close scrutiny indicates that it has been carefully planned. There are distinct centers of interest and units of activity, some of which are isolated and some which wind through the picture and unify it.

Most of the action is in the foreground. Starting in the lower left-hand corner is a group of spectators surrounding a platform set on wheels. Some figures are mounted and some are dressed in carnival costumes. On the platform are several acrobats, one doing a backbend, another a handstand on the back of a horse, and another ringing a bell to attract the crowd. The next group to the right is dominated by a Harlequin on a pair of high stilts. With his left hand he dangles some cloth from a line which is eagerly sought by some of the revelers. With his right hand he scatters something[33] to a figure below who is lying on his back. Several spectators watch from behind and further to the right is a trio of *Commedia* figures, one playing on a tambourine and two others cavorting in postures similar to those we have seen earlier. Toward the center is a pair of cavaliers dueling with swords, a carriage, and then a horse kicking his hind legs, causing a group of neighboring bystanders to disperse. Next, angling in to center from the right is a mounted procession with the horsemen carrying tall lances and shields. A procession wagon, with one of several *gobbi* in the immediate foreground, completes the right side of the print. The wagon itself is a fabricated rock drawn by a pair of weary centaurs. It is led by Love (Cupid) who is bound and blindfolded along with other enchained captives and trophies. At the summit of the rock stands the triumphant figure of Mars with lance in hand.

At left of center, just above the foreground figures, is a sleigh drawn across the cobblestones by a horse. At the prow is a hippogriff, a mythological creature resembling a griffon but with the

body and hind parts of a horse. At the left are visible several other sleighs being drawn up the alley into the far distance.

The center triangle of the print is comprised of a combat at the barrier. Spectators are contained behind a fence on each side, and at right a roofed-over grandstand has been erected to seat the honored guests. Near it is the long barrier with two mounted jousters on each side contending with their long lances. Many spectators watch from their windows and several are on the rooftops, particularly at the left where one is blowing on a trumpet.

At center, in the sky above, is the coat of arms of Lorraine flanked by a pair of eagles. From it streams a banner with the following inscription: "Carrière and New Public Square at Nancy, site of the Jousts, Tourneys, Combats, and other Various Entertainments." At bottom left "Iac. Callot In. et fecit."

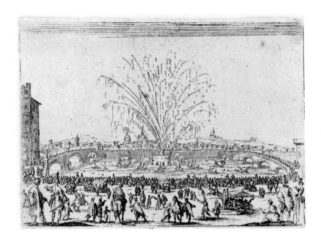

FIGURE 57

I CAPRICCI (THE CAPRICES)

The Caprices (see general notes in chapter 2) contains two small etchings which depict festivities. As with the other plates of the series, each exists in two states, the earlier done in Florence in 1617 and the second executed in Nancy four years later.

(Figure 57) *Le feu d'artifice sur l'Arno* (*Fireworks on the Arno*)
(L. 258/472 // M. 856/857)

This plate, done two years after *The Entry of Love in Tuscany* and two years before *The Fan* (see chapter 3), depicts a fireworks display in the same location on the Arno. In all three plates the bridges and major buildings in the background are similar. Other architectural and topographical details vary considerably. Lieure tells us that on 25 July 1616 the grand duke sponsored a festival on the Arno. Cupid's castle with four towers, all constructed of painted cloth, was set in the river and attacked with fireworks by four vessels. He maintains that Callot must surely have attended

FIGURE 58

and recorded the event in this print.[34] Callot's treatment of the foreground figures is typical. On the river itself is the artificial island with the castle. Surrounding it are numerous boats and figures in the water. The far bank and both bridges are crowded with spectators.

(Figure 58) *Une fête sur la Place de la Signoria, à Florence*
(*A Festival at the Square of the Signoria in Florence*)
(L. 259/473 // M. 858/859)

This small print depicts a celebration taking place in the Square of the Signoria (Piazza della Signoria) probably on 24 June 1617, the feast day of Saint John the Baptist. The ceremony marked tributes and honors extended to the grand duke by the various cities of his realm. A large figure with his back to us stands in the left foreground pointing at the Old Palace (Palazzo Vecchio) in front of which stands Michelangelo's statue of David. (In 1873 the statue was replaced by a replica and the original was moved to the Academy where it stands today.) At the left corner of the Old Palace can be seen Ammannati's Fountain of Neptune and at the right the Loggia dei Lanzi with its three large arches.[35] The square has a crowd of celebrants clustered around a flag-topped podium. This group is surrounded by a circle of horsemen and the remainder of the square is filled with spectators and various other typical Callot groupings. See Appendix figure v for a similar treatment of this event done some years later by Jacobus Stella.

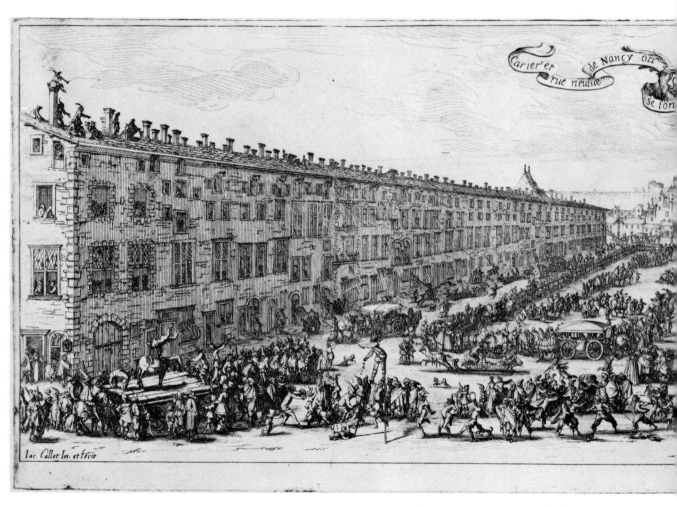

FIGURE 59

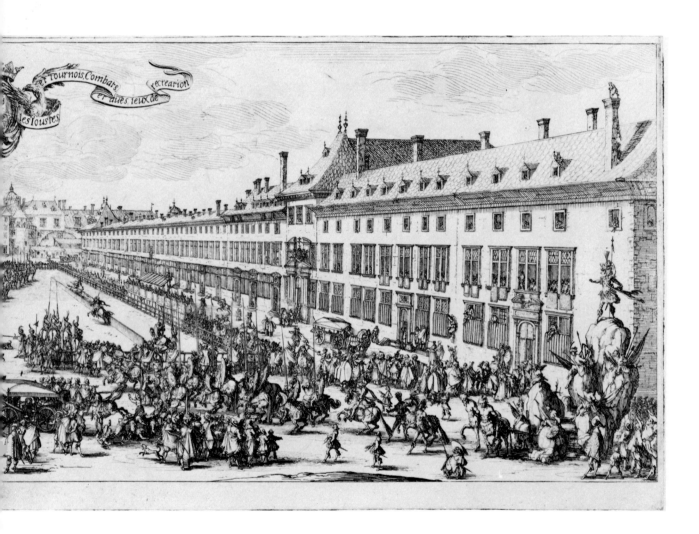

4 The Court Theatre

HISTORY AND BACKGROUND

The formal theatre of illusion and perspective was born and nurtured in Italy in the first half of the sixteenth century. This trend is observed as early as 1508 in Pellegrino's setting for *La cassaria* by Lodovico Ariosto. Numerous other examples followed during the next three decades, but it was not until 1545 that Sebastino Serlio first brought together in textbook form, in his *Architettura*, a number of the prevalent scenic practices of the day which had been inspired by a revival of interest in the works of the Roman architect Vitruvius. These scenic practices were devised for many types of entertainments: tragedies, comedies, musicales of various kinds, and most notably for the *intermezzi* which were interspersed between the acts of larger works. In 1580 Andrea Palladio began construction on the Teatro Olimpico at Vicenza, and after he died Vincento Scamozzi finished the building and added, for the opening performance in 1585, the elaborate perspective vistas behind the five openings in the stage facade. Three years later Scamozzi had also completed the tiny theatre at Sabbionetta with its raked stage and angled wings. Still another major theatrical concept of the late sixteenth century was realized about this time. This was the construction of a permanent proscenium arch at the Teatro Farnese in Parma in 1618. Earlier attempts by designers to provide a frame for the scenery of their temporary performances now became a fixed

75

part of a theatrical building. In 1595 Giovanni Bardi, Count of Vernio, leader of the *Camerata* of Florence, had gathered together a group of artists including Jacopo Peri, Ottavio Rinuccini, Giulio Caccini, and Vicenzo Galilei, father of Galileo. They sought to create dramatic pieces after the manner of the Greeks, and their efforts led to the development of a type of musicodrama with the opening performance of Peri's *Dafne* in 1597. Before long the music came to dominate the literary text, and opera, born of a mistake, emerged as a distinct genre reaching its apogee in the works of Claudio Monteverde of Mantua in the early 1600s. From this time on the energies and imagination of Italian scenic designers and architects were largely devoted to this new form, and the drama never flourished in Italy in quite the same way as it did in the rest of Europe. The use of periaktoi, angled wings, nested wings, perspective vistas, elaborate changes, and spectacular effects were carefully described in 1638 by Niccola Sabbattini in his *Manual for Constructing Theatrical Scenes and Machines*. These techniques and conventions found their way throughout Europe during the first half of the seventeenth century largely through the work of Inigo Jones in England, Giacomo Torelli in France, and Joseph Furttenbach in Germany.

Callot did not design for the theatre while he was in Florence. He was part of only two of the Medici court performances, recording the *intermezzi* for *La liberazione di Tirreno* and the setting for a five-act tragedy called *Il solimano*. He also created the frontispiece for the edition of a tragedy entitled *L'harpalice*. The first two are invaluable documents which tell us a great deal about the theatre of the day and the elaborate effects created on its stages and they reflect the diligence and preparation Callot brought to much of his work. He was shortly to leave Florence and return to Nancy where he completed some of his greatest masterpieces.

76

LA LIBERAZIONE DI TIRRENO E D'ARNEA (THE LIBERATION OF TIRRENO AND ARNEA, FOUNDERS OF THE TUSCAN RACE)
(L. 185–187 / M. 630–632)

Carnival time in 1616 (1617) coincided with the wedding of Ferdinand Gonzaga, Duke of Mantua and Caterina de' Medici, second sister of Cosimo II. Part of the festivities included a performance of the *veglia*,[1] *La liberazione di Tirreno e d'Arnea, autori del sangue toscano*. As with the earlier productions of *Guerra d'amore* and *Guerra di belleza* many of the same personnel were involved in the creation and recording of this Medici event. The libretto was written by Andrea Salvadori, the music composed by Marco da Gagliano, the dancing and jousting supervised by Agniolo Ricci, and the staging created by Giulio Parigi. Callot recorded all three of the settings. Although the prints are described as intermèdes, they do not represent the more common form of those interludes which were generally unrelated, elaborate entertainments between the acts of a comedy or tragedy. These *intermezzi* are an organic part of the entertainment since they stem from the plot of the *veglia* itself. As each act ended, the participants engaged in singing, dancing, or jousting, and as the action moved from the stage proper down two ramps and on to the floor of the hall, they were joined by the nobility. These dances, songs, and jousts were set pieces created by the persons named above. At the end of the final ballet, however, the participants danced freely into the early morning hours. The first of the three prints shows us the full interior of the theatre. The second and third show only the stage area at the end of the acts, presumably at the moment preceding the intermède itself. The *veglia* was given on the evening of 6 February in the Uffizi Theatre.[2] The libretto was composed of a "strange assortment

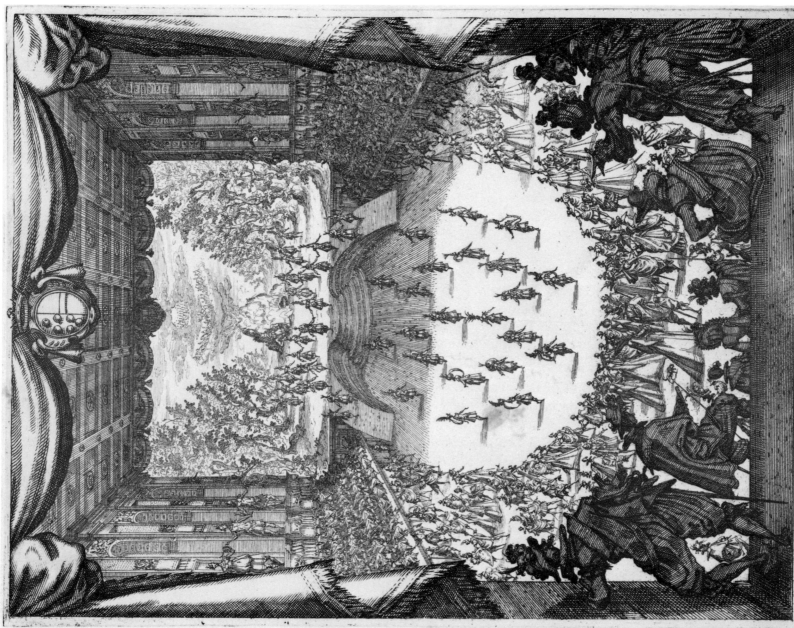

PRIMO INTERMEDIO DELLA VEGLIA DELLA LIBERATIONE DI TIRRENO FATTA NELLA SALA DELLE COM
DIE DEL SER.mo GRAN DVCA DI TOSCANA IL CARNOVALE DEL 1616. DOVE SI RAP.ta IL MONTE D'ISCHIA, CON IL GIGANTE
TIFEO. SOTTO.

Iulius Parigi Inu. Iacobus Callot F.

FIGURE 60

of episodes from classical mythology and from Ariosto's *Orlando Furioso*."[3] It was not published until 1668 and the etchings were issued independently of the text.

(Figure 60) *Première intermède: le géant Tiphée sur le Mont Ischia*
(*First Interlude: The Giant Typhon on Mount Ischia*)
(L. 185 / M. 630)

The *veglia* opens with the arrival of Hercules on the island of Ischia.[4] He has come to liberate Tirreno and his future mate Arnea who have been imprisoned there by the sorceress Circe. Under the volcano on the island lies the giant Typhon. Hercules promises to help and invokes the power of the gods. Mars and Jupiter appear on a cloud machine, and the latter splits the smoking mountain apart with his thunderbolts. Tirreno and Arnea are freed and the first intermède begins as twelve "Cavalieri del balletto" appear, and there is danced "a most beautiful ballet . . . , first on the stage and then by the same twelve dancers and by twelve richly appareled ladies in the center of the auditorium. The grand duke danced among the gentlemen, and the grand duchess among the ladies."[5]

Callot's etching of this first setting captures this moment. He shows us the Uffizi Theatre with its spectators as well as the stage. The drapery borders, with the escutcheon which frames the upper half of the print, are a decorative device and the Medici coat of arms can be seen repeated at the top of the proscenium arch. As with most of his theatrical documents Callot once again seems to be more inspired by the spectators than by the event itself. While the ballet, auditorium, and stage setting maintain a formal symmetry, the figures in the foreground and the spectators curved around the floor of the Uffizi are depicted with great variety and invention. Callot uses the large, nearly silhouetted foreground figures to focus attention for us. Again, characteristic poses appear, in particular the full figure at left who leans upon the wall with his foot on a stone. He is seen again in reverse in a nearly identical position in the companion pieces (L. 230 and L. 444) from *The Caprices*, entitled *Man with a Large Sword, Seen from the Rear* (see Appendix figure VII). Between his legs Callot has deftly inserted another figure with the face turned towards us. Near the center foreground is somebody's dog. About a hundred men and women are shown in various groupings forming the curve on the floor and hundreds more are seated in the tiers on each side of the floor. Nagler tells us that the new theatre built by Buontalenti in 1586 (and subsequently known as the Teatro Medico) "was nearly ninety five braccia long, thirty five broad, and twenty four high. The floor inclined toward the stage, descending approximately 2⅛ ells so that the spectators enjoyed an unobstructed view of the stage situated at the lower end of the auditorium . . . , Buontalenti installed six *gradi* against the longer sides of the auditorium. . . . The stage was elevated five ells above the floor of the hall."[6] Callot recreates these proportions for us but shows only four rows of seated figures on each side. Four sections of the walls separating the huge arches above these spectators are shown fronted with huge statues. On the stage is Parigi's setting for the first scene with its foliage wings, Typhon beneath the volcano, and the elaborate cloud machine above. The scene is a composite of the action culminating in the previously mentioned ballet. Forty-four paired dances are shown, half of them on the floor and half on the stage or in the process of descending the curved ramps leading to the hall. Callot has evidently taken some liberties in the geometric arrangement of the dancers as well as the number of participants. There is, however, the possibility that he is showing us a group of twenty-two persons at two different points in time: first, as they leave the stage and second, as they arrange themselves on the floor.

A translation of the legend at the bottom of the print reads, "*The First Interlude* of the Veglia *The Liberation of Tirreno* presented in the Hall of Comedy of the most serene grand duke of Tuscany for the carnival of 1616 wherein is shown the Mountain

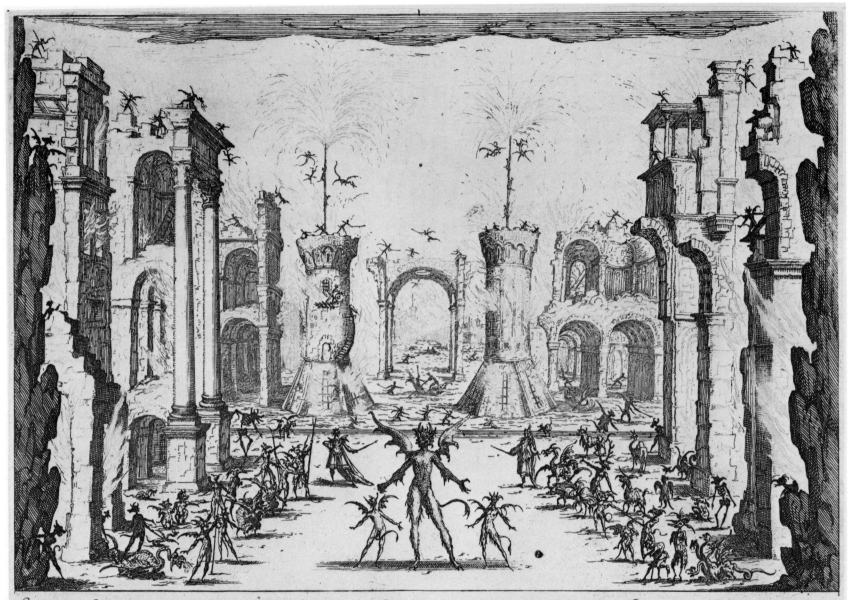

SECONDO INTERMEDIO DOVE SI VIDE ARMARSI L'INFERNO PER FAR VENDETTA DI CIRCE CONTRO TIRRENO

Iullius Parigii Inu: Iac: Callot delineauit F.

FIGURE 61

of Ischia with the giant Typhon beneath." The inscription at bottom right varies; the first three states of the print read, "Iullius Parigii Inu; Iacobus Callot F." and the fourth state reads, "Iullius Parigii Inu: Iac. Callot delineavit et F."

(Figure 61) *Deuxième intermède: l'enfer s'arme pour venger Circe* (*Second Interlude: Hell Arming Itself for Circe's Vengeance Against Tirreno*) (L. 186 / M. 631)

As the action of the *veglia* continues, "Circe reappears in a machine drawn by dragons, calling on Pluto to assist her in her fight against the forces of love. Pluto arrives with Minos and Rhadamanthus and they decide to send their warriors to help Circe. . . . With Pluto and the two infernal judges shouting 'a l'armi, a l'armi,' the warriors of both parties come forward for a combat at the barriers."[7] This marks the beginning of the second *intermède* where two groups of gentlemen, twelve to a group, meet in stylized combat with pikes and swords and fight for forty minutes to everyone's delight.

Many Callot scholars have pointed out that this Inferno scene was almost certainly the inspiration for his first version of *The Temptation of Saint Anthony* done later in the same year (see chapter 5).[8] The etching is an imaginative re-creation of the gathering of the infernal forces and is a blend of several styles. According to one of these scholars, "The forms of these creatures are in the medieval tradition but with something of the elegance of Mannerist *grotteschi* of the period."[9] The print is not physically related to the proscenium or hall as is the earlier one but focuses exclusively on the setting and the action.

Hell is represented by a series of wings depicting flaming buildings in various stages of ruin. The rear part of the stage is a painted backdrop with additional buildings, the river Styx, and two towers ablaze with fireworks. Cavorting devils are scattered at random throughout. On the stage floor at center is the exaggerated figure of

Pluto flanked by Minos and Rhadamanthus. On each side are rows of grotesque, Bosch-like monsters, many of which probably did not appear in the production but were included to enhance the effect of the etching. There are skeletons, billy goats, a camel, dragons, a figure with a stag head mounted on a cranelike bird, and other distorted, fantastic, and bizarre creatures which defy description.

The legend reads, "*Second Interlude* depicting hell arming itself for Circe's vengeance against Tirreno." At bottom right is inscribed "Iullius Parigii Inu: Iac: Callot delineauit F."

(Figure 62) *Troisième intermède: la bataille est arrêtée par l'amour* (*Third Interlude: Love Stops the Battle*) (L. 187 / M. 632)

After the combat of the preceding *intermezzo* the setting changes and the God of Love enters. "Amor and his chorus chant 'Non più guerra, non più furore!' This separates the fighters and after the three Graces have sung their madrigal in praise of constant love the evening's entertainment closes with a ballet," Nagler records.[10] This constituted the final *intermède* which came at the end of the *veglia*. The eyewitness, Gioseffo Casato, reported that "the ballet consisted of forty ladies and gentlemen and all of the jousters, attendants and pages who had previously taken part. Although the large number of persons created great noise and confusion it was not too extensive and the ballet was received with delight and admiration. When the ballet was over the festivities continued until almost 6 A.M. with a great deal of dancing among the princes and the ladies and gentlemen. There was great pleasure for all and their faces reflected the universal joy over the present marriage."[11]

The etching shows the combat in progress in the center of the stage. The combatants are flanked by lines of musicians playing on drums, flutes, viols, tambourines, viola da gambas, and harps. Then, conforming to a typical convention of Italian opera and *intermezzi*, a cloud machine descends from the heavens bearing Amor and a score of figures comprising a celestial orchestra. The setting is

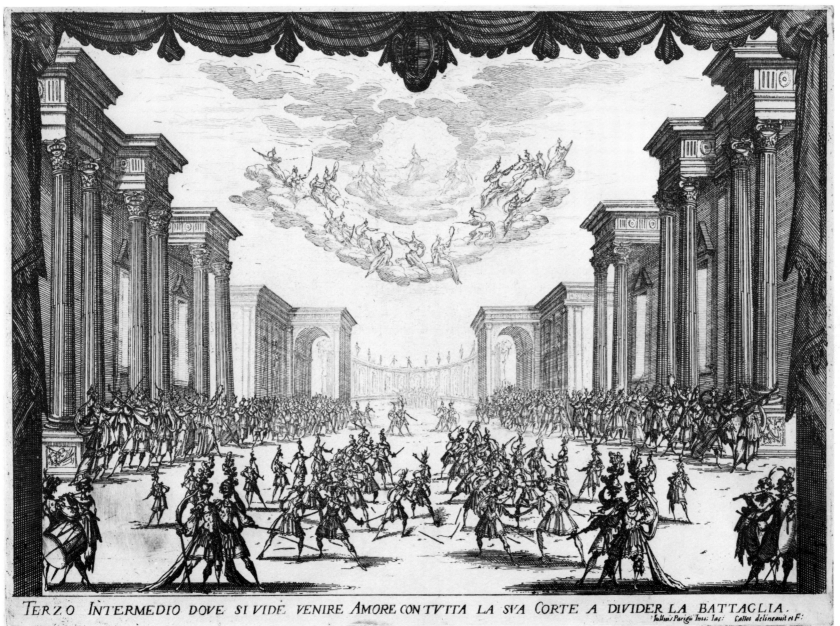

TERZO INTERMEDIO DOVE SI VIDE VENIRE AMORE CON TVTTA LA SVA CORTE A DIVIDER LA BATTAGLIA.

Iulius Parigi Inu: Iac: Callot delineauit et F:

FIGURE 62

bounded by the draped proscenium with the Medici insignia and composed of three sets of paired wings representing formal, columned buildings. This *cortile*, or courtyard, continues into the distant perspective backdrop and terminates in a curved vista of arches.

At bottom the legend reads, *"Third Interlude* where love is seen with his court coming to stop the battle." At bottom right "Iullius Parigii Inu: Jac: Callot delineauit et F."

IL SOLIMANO (THE SULTAN)
(L. 363–368 / M. 434–439)

Prospero Bonarelli's poetic tragedy *Il solimano* was published in Florence in 1620.[12] The volume contains a dedication to Cosimo II dated 8 December 1619 which may give us a clue to the date of its performance at the Medici court. There is evidence that this performance was a revival, the play having been performed in 1618 in Ancona before four thousand spectators. The work was published eight times during Bonarelli's lifetime.[13] It was illustrated with six etchings by Callot, the first a frontispiece depicting Soliman and the remaining five representing the unit setting and character arrangements for each of the five acts. The set design for the production is attributed to Giulio Parigi's son, Alfonso.

This series is perhaps the least interesting and original of Callot's theatre-oriented pieces. It is completely functional and affords little if any opportunity for the exercise of imagination and the inimitable touches observable elsewhere. Interest in the exotic subject matter may have been sparked by the political visit of Fakir al-Din, emir of Lebanon (called Caffardino by the Florentines), in November 1615. He was royally entertained during his stay and was part of Cosimo's plan to bring the Holy Sepulchre to Florence and have it installed in the Chapel of San Lorenzo. The dream eventually evaporated with the assassination of the fakir but the Middle East exerted a powerful influence on the Florentine imagination for several years.[14] While Callot apparently had little to do with the selection of the subject matter and the decor of *Il solimano*, he did attempt to perfect his skill in this exotic style. There are numerous extant sketches of Turkish costume and figure designs which appear in variations in *Il solimano* and other etchings done during this time. In addition there is a sketch of a stage setting that bears a strong resemblance to this work (see Appendix figure X).

The decor for the tragedy is a single conventional perspective scene which served for each of the acts. It represents a square in Aleppo in Syria. The figure arrangements are generally symmetrical and reinforce the architectural balance of the setting. The major figures are labeled according to the following key:

Sol.: Soliman, king of Thrace
Rus.: Rusteno, son-in-law of the king
Ac.: Acmat, the king's councillor
Mus.: Mustafa, the king's son
Or.: Ormusse, an orator
Ad.: Adrasto, Mustafa's lieutenant
Giaf.: Giaffer, gatekeeper of the city
Al.: Alvante, a Persian
Des.: Despina, daughter of the king of Persia
Rega.: Regina, Soliman's mother
Nut.: A nurse

(Figure 63) *Frontispiece* (L. 363 / M. 434)

Soliman stands holding an inscribed shield with his right hand and a scepter with his left. He is flanked by two pedestals bearing musical instruments, massed standards, armor, and weapons. A sea battle is etched on the face of each pedestal. In the background, in fine detail, can be seen a military engagement. The arms of the Medici with the Turkish crescent beneath dominates the top center of the print.

(Figure 64–68) *Acts I–V* (L. 364–368 / M. 435–439)

Except for the disposition of the characters and the burning of the city in *Act V* the five plates are substantially the same. The central vista is flanked by two streets, each leading off at an angle into the distance in a way somewhat reminiscent of the perspective vistas of the Teatro Olimpico some four decades earlier. The facades of the two buildings in the middle distance each have a statue, a woman at left and a man at right, standing above a fountain. Lieure points out that the one at right, particularly in *Act III* (Figure 66) is "in imitation of one which still exists in Florence near the Ponte Vecchio on the left bank of the Arno which represents a sixteenth century Bacchus by an unknown artist which dominates a stone basin" (see Appendix figure VIII).[15] These two statues vary in their postures from act to act and even the sex is changed in *Act IV*. There are also variations in the three tiny statues which surmount the arch in the central far distance.

The figures of the first four acts are poorly drawn to scale: the major characters loom much larger than the secondary ones surrounding them. The proportions are much more careful in the fifth act. This final act is the visual high point of the series. The static compositions have been replaced by a view of Aleppo in flames. The effect must have been quite startling with the artificial fire and smoke, the tumult of battle, the naked bodies, corpses, prisoners being led away, and victims falling from above. How much of this was actually accomplished on stage is uncertain but the Renaissance propensity for startling stage effects suggests that while the details may be somewhat exaggerated, the total impact of the etching is very similar to the one experienced by the spectators.

Each plate is numbered in the lower left-hand corner. The figure *4* is in reverse.[16] The inscription "Iac. Callot F." appears in the lower right-hand corner of the plates for *Acts I* and *III*. The others are unsigned.

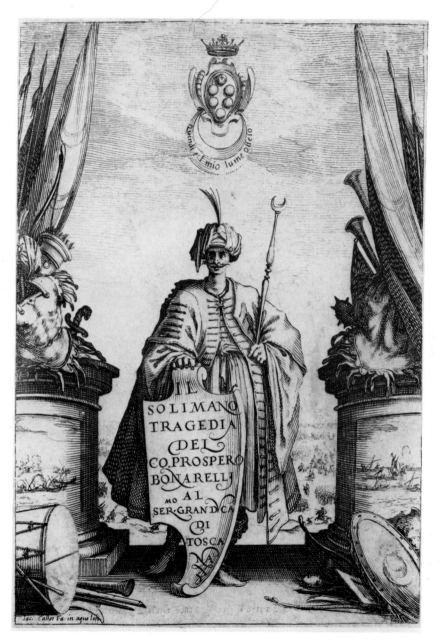

FIGURE 63

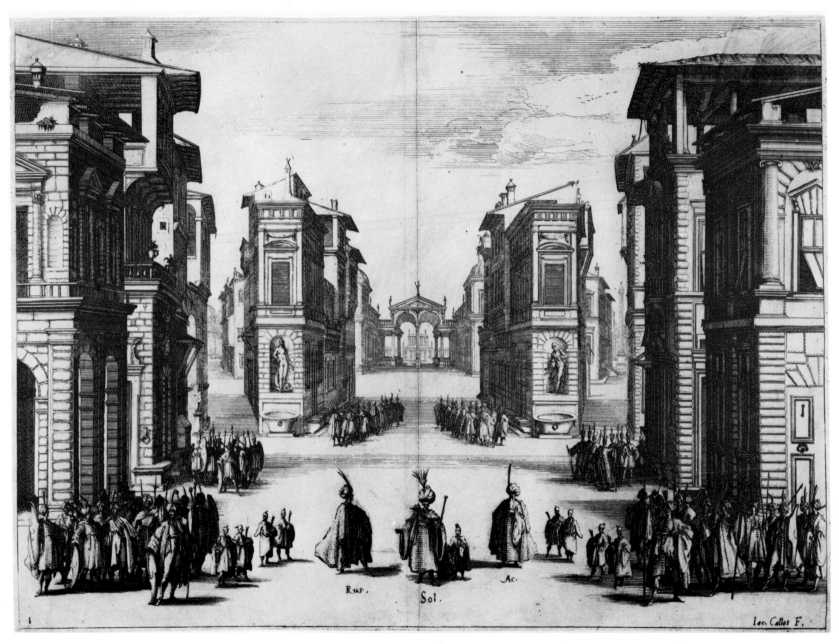

FIGURE 64

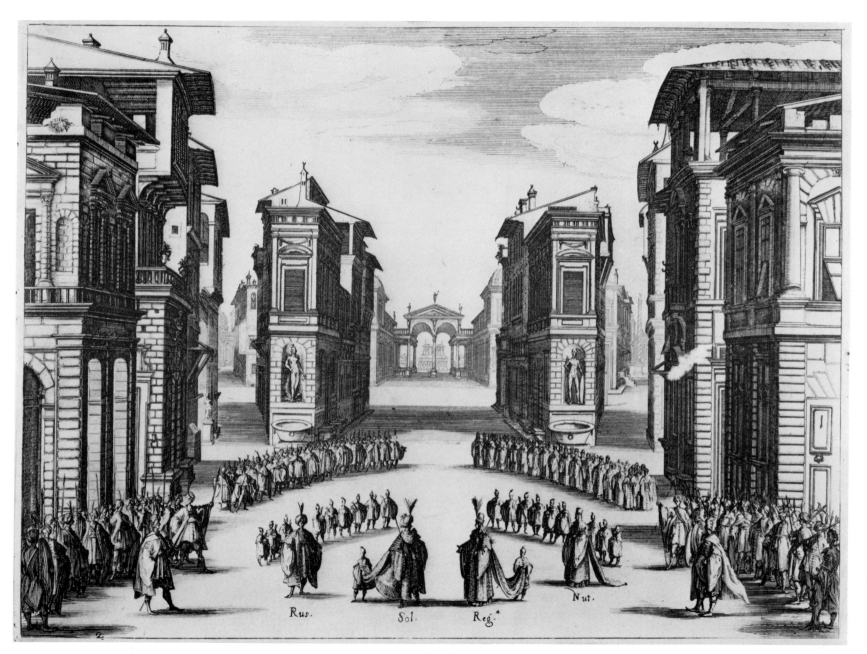

Rus. Sol. Reg. Nut.

FIGURE 65

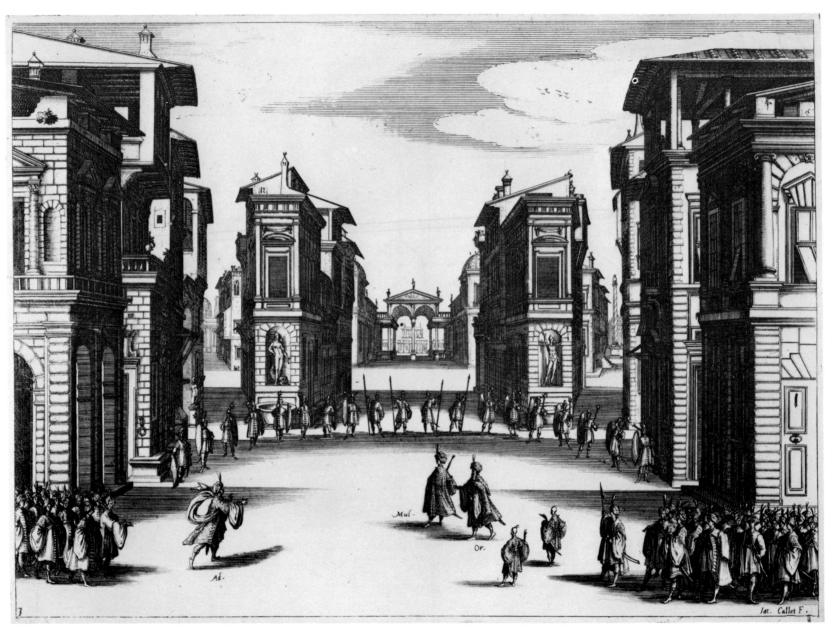

FIGURE 66

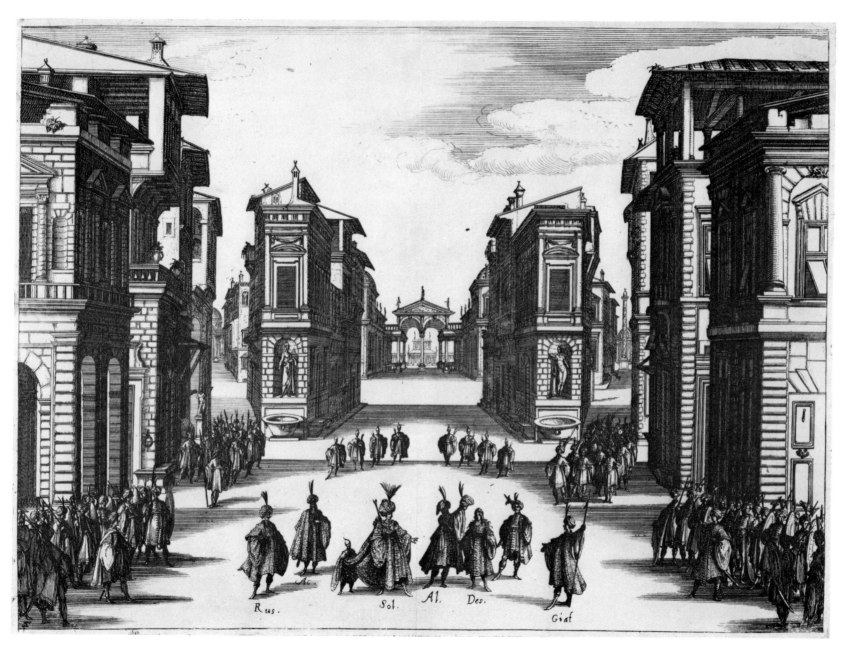

FIGURE 67

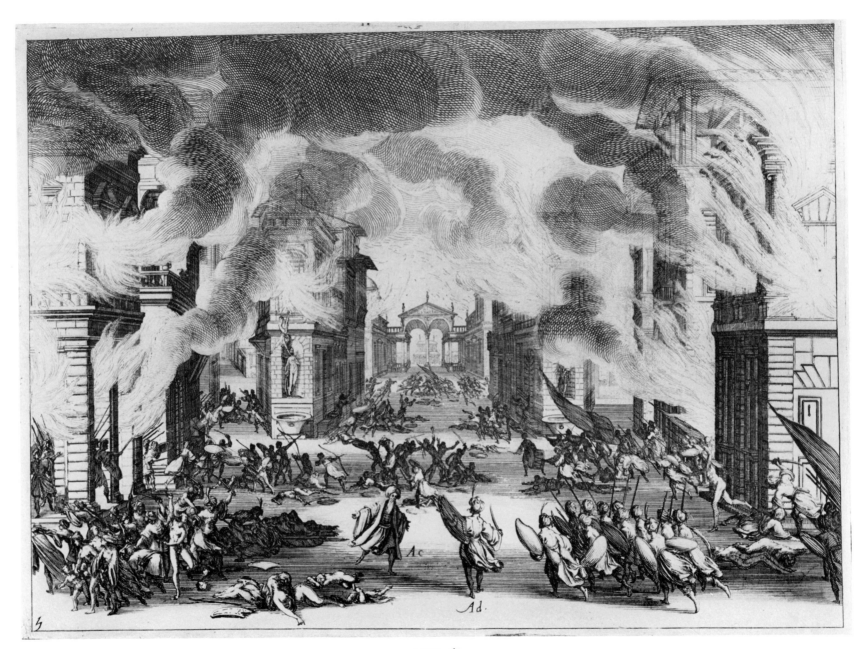

FIGURE 68

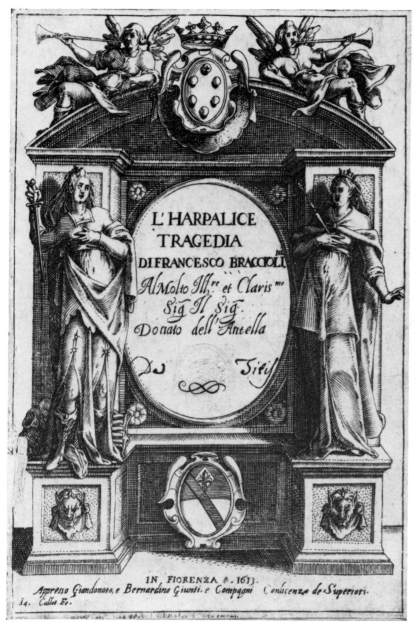

FIGURE 69

(Figure 69) *Frontispiece to L'harpalice* (L. 76 / M. 127)

In 1613 Callot engraved the frontispiece for the edition of Francesco Bracciolini's tragedy *L'harpalice*. The work was dedicated to Donato dell'Antella whose portrait (L. 294) Callot etched in 1618 on the occasion of his death. The play was published in Florence by Giandonato and Bernadino Giunti. The story deals with Harpalice, daughter of Marsilio, king of Spain. The apparitions, guardian angels, and thematic similarities to the Oedipus story are a conventional amalgam of classical devices and result in one of Bracciolini's less significant plays.

The engraving is a minor early piece and far less interesting than the frontispiece Callot did for *Il solimano* seven years later (see chapter 4). It is rendered in the style conventional to the period, with allegorical personifications on raised platforms, a formal architectural facade, coats of arms, and a variety of decorative figures. The large standing figures are difficult to identify although Mariette at one time stated that the one at the left was Tragedy and the one at the right was Eloquence.[17] Elsewhere he referred to them as Justice and Peace.[18] At the top two reclining figures of Fame flank the Medici coat of arms. Lieure does not identify the bottom escutcheon, but it is most probably the device of the Bracciolini family. At bottom left is inscribed "Ia Callot Fe."

 Miscellaneous

INTRODUCTION

There are various series and individual etchings done by Callot which do not specifically draw upon the *Commedia*, festivals, or the court theatres for their primary subject matter. Theatrical figures and situations are scattered throughout his work since Callot instinctively sought to dramatize so much of his materials. This final chapter deals with three quite separate works: one a series containing various hunchbacked figures, another a panoramic view of a country fair in incredible detail and variety, and third, Callot's first version of *The Temptation of Saint Anthony*. Each of the three contains details reminiscent of, or strongly influenced by, works treated earlier in this volume.

I GOBBI (THE HUNCHBACKS)
(L. 279, 407–426 / M. 747–767)

The frontispiece to this series carries the inscription "Varie Figure Gobbi / di Iacopo Callot / fatto in firenza / l'anno 1616" and at bottom right "excudit Nanceij." Most historians feel that the series manifests a style developed much later than this date and generally agree that at best the 1616 date represents early drawings made in Florence but that the final plates were etched in Nancy about 1622.[1]

In addition to the Rabelaisian frontispiece the series contains twenty additional plates, each depicting a single deformed figure in grotesque posture. Nothing more is shown than the ground on which he stands or the shadow that he casts. Whether they were intended as caricatures[2] or comic fantasies[3] is uncertain, but the plates

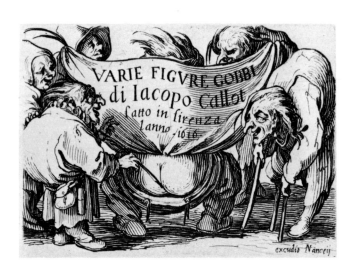

FIGURE 70

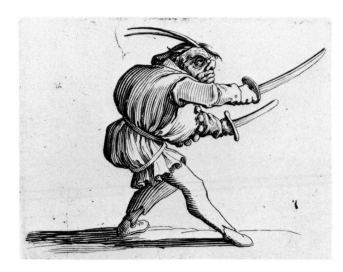

FIGURE 71

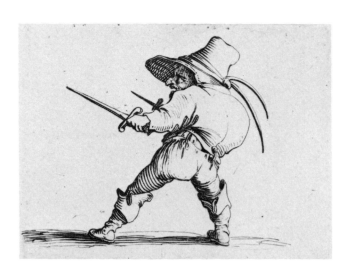

FIGURE 72

92

constitute variations on the theme of grotesque deformity. Callot probably encountered these hunchbacked dwarfs during his stay in Florence where they formed troupes of entertainers. Solerti tells us that it was customary for the *gobbi* to perform on 6 July, the feast day of Saint Romulus and makes special note of their appearance in Florence in 1612. He also indicates that the 1612 presentation has been preserved in a published narration by one Paolo Baroni entitled *La famosa giostra de'gobbi, con tutte le feste fatte nella serenissima gran piazza ducale de Firenze.*[4] In addition, there is evidence that Cosimo II invited the *gobbi* troupes to give special performances in his sickroom in hopes that the laughter would provide an efficient remedy for his tuberculosis.[5] Ternois feels that the grotesque facial delineations, the immense or squashed noses and the enormous eyes are essentially "masques de théâtre."[6] The theatrical orientation of several of these plates is obvious and the selected examples which follow show how they are related to some of the figures of the *Balli di Sfessania.*

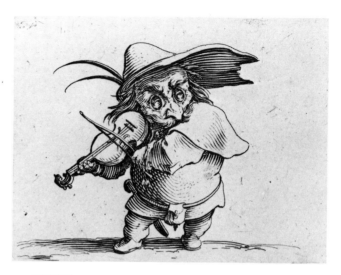

FIGURE 73

(Figure 70) *Frontispiece* (L. 279 / M. 474)

This print sets the tone for the entire series, identifying the contents, establishing Callot as the artist, and generally preparing the reader for the grotesque and mordant quality of the figures which follow.

(Figure 71) *Le duelliste aux deux sabres*
(*Dueller with Two Sabres*) (L. 413 / M. 758)

(Figure 72) *Le duelliste à l'épée et au poignard*
(*Dueller with Sword and Dagger*) (L. 414 / M. 755)

Despite Lieure's label for the first of these two pieces, he explains in his analysis that "the right hand holds a sabre, the left a dagger."[7] The pompon buttons, half-mask, and long narrow feathers are reminiscent of the *Commedia* figures. If these two figures are examined together, a pairing very similar to the *Scaramucia and*

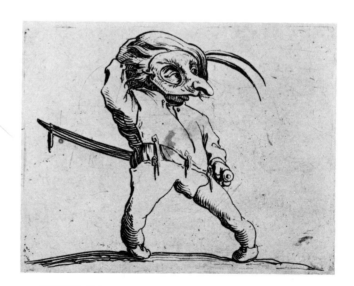

FIGURE 74

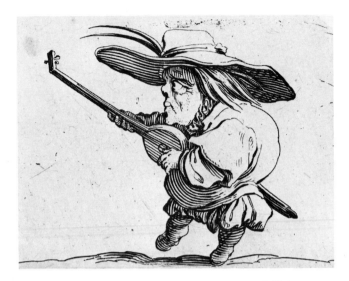

FIGURE 75

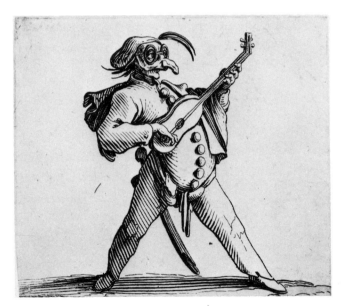

FIGURE 76

Fricasso and *Taglia Cantoni and Fracasso* prints of the *Balli* is evident (see figures 11 and 24). The profiles and extended arms and legs bear many resemblances.

> (Figure 73) *Le joueur de violon (The Violin-Player)*
> (L. 418 / M. 759)

> (Figure 75) *Le joueur de luth (The Lute-Player)*
> (L. 420 / M. 761)

Each of these two plates shows an instrumentalist, one with a violin and the other with a lute. Familiar details are apparent again: the sword sheath showing from behind, the omnipresent feathers, a mask, and the jagged brimmed hat of a Gian Farina (figure 17), and others.

> (Figure 74) *L'homme masqué aux jambes torses*
>
> (*Masked Figure with Twisted Legs*) (L. 419 / M. 760)

This etching shows a full front view of a figure with legs twisted inward, sword sheath with its broken tip, feathered cap, and the stylized comedian's mask.

> (Figure 76) *Le comédien masqué jouant de la guitare*
> (*Masked Comedian Playing the Guitar*) (L. 425 / M. 767)

The resemblance between the figure in this print and Razullo (figure 19) is unmistakable. The guitar-playing character[8] is clearly the most definite parallel in this series with Callot's *Commedia* characters. The *Balli* and *Gobbi* series are closely related in time in that both were first delineated in Florence about 1616 and later etched in Nancy in the early 1620s. While the *Gobbi* set reveals more explicitly Callot's taste for the bizarre, grotesque, and cynical, it lacks the artistry and animation of the *Balli*. These deformed dwarfs are scattered throughout various other works of Callot. He included them among the festival crowds and also in his *Temptation of Saint Anthony*.

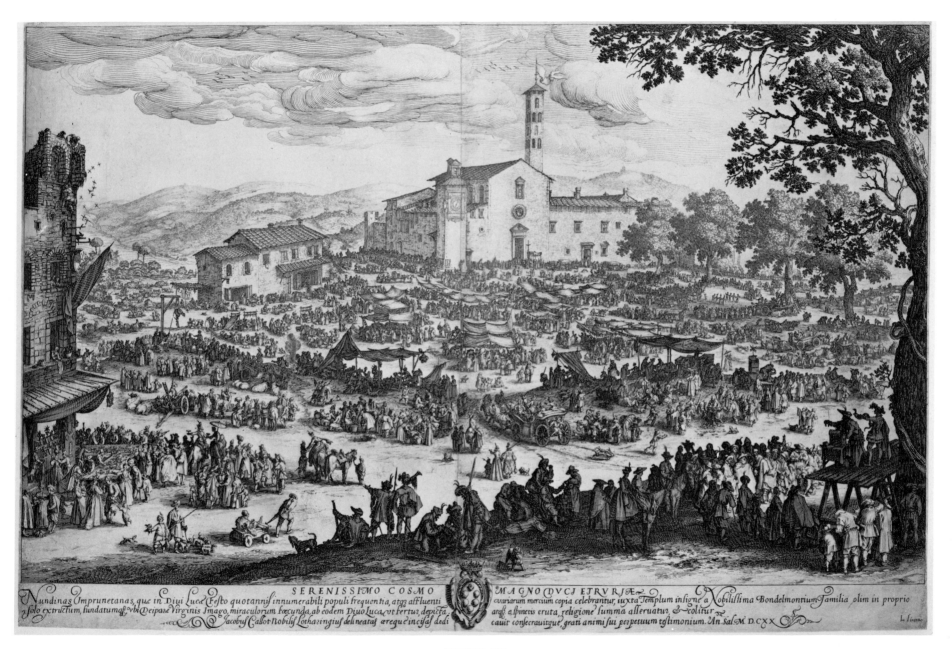

SERENISSIMO COSMO MAGNO DVCI ETRVRIÆ

Nundinas Imprunetanas, quæ in Diui Lucæ Festo quotannis innumerabili populi frequentia, atqz affluenti variarum mercium copia celebrantur, iuxta Templum insigne a Nobilissima Bondelmontium Familia, olim in proprio solo extructum, fundatumqz vbi Deiparæ Virginis Imago, miraculorum fœcunda, ab eodem Diuo Luca, vt fertur, depicta, arqz a spineris eruta, religione summa asseruatur, & colitur Iacobus Callot Nobilis Lotharingius delineatas æreqz incisas dedi cauit consecrauitque, grati animi sui perpetuum testimonium. An. Sal. M.DCXX

In fiorenzo

FIGURE 77

(Figure 77)

L'IMPRUNETA (THE FAIR AT L'IMPRUNETA)
(L. 361 / M. 624)

On 18 October 1619, the feast day of Saint Luke, Callot visited the annual fair held at the village of L'Impruneta, a few miles from Florence. Traditionally, the church there is said to house a portrait of the Holy Virgin painted by St. Luke himself. Callot was greatly impressed and made numerous sketches of the event. In 1620 he incorporated them into what most art historians feel to be his masterpiece and certainly the crowning achievement of his Italian career. *L'Impruneta* is an incomparable work and an analysis of it would justify a lengthy monograph. An initial glance at the work seems to reveal a confusion of detail and the eye does not know where to look first. But upon further study it can be seen that the etching is made up of numerous centers of interest, each containing highly individualized personalities reflecting different emotions, problems, and reactions to the event. An oil painting by Teniers the Younger, based on the etching, has enabled an indefatigable critic to determine that the work contains 1,138 persons, forty-five horses, sixty-seven donkeys, and 137 dogs (see Appendix figure XIII).[9] Almost anything one might expect at a country fair can be found: peddlers, stallkeepers, wine merchants, a dentist, a town crier, a cattle sale, and on and on.

Two details are of special interest. First is a country dance taking place in the upper right quadrant among the four oak trees in the background. In the center of a ring of spectators are the dancers who consist of four ladies facing four gentlemen. In the lower right-hand corner of the print is a trestle platform mounted by two figures. At right is an elegantly dressed snake charmer and at left a quack who is displaying his nostrums from an opened chest. He is dressed as a typical Callot *zanni* of a *Commedia dell'arte* troupe.

(Figure 78)

LA TENTATION DE ST. ANTOINE (THE TEMPTATION OF SAINT ANTHONY)
(L. 188 / M. 138)

In 1617 Callot completed his first version of *The Temptation of Saint Anthony*.[10] Very few prints were drawn from this Florentine plate and it remains one of his scarcest works.

The *Temptation* is not a theatre piece in that it is oriented to a specific event or character. Its total conception, however, is highly theatrical and dramatic, and within this print are various figures, attitudes, and techniques which have been discussed in the preceding works in this volume.

It was pointed out earlier that the second intermède of *The Liberation of Tirreno and Arnea* almost certainly had a direct influence on this work. Not only do we find the flying demons and strange animals again, but also the grotesque, tortured, and unearthly quality which informs both works. Familiar characters are seen once more: *gobbi* and *Commedia* figures, most of them parodied and distorted as they are scattered throughout the bizarre landscape. At bottom center is a pageant wagon. The structure itself is a skeletal framework drawn by four grotesque beasts. A distorted Cupid again stands with drawn bow, and high at the rear is a seated, naked figure holding a mirror reminiscent of Truth in the *Mount Parnassus* float of *The War of Beauty* and of other characters of this festival (see figure 37 and others). Two round dances similar to *La Ronde* of figure 29 are evident. One group is at right in front of the large arch and a second at left center on the mountainous ledge. The dancers of both groups belong to a world of distortion, obscenity, and frenzy. Still another dance is taking place around the pageant wagon. In the lower left-hand corner is a devil who foreshadows the Couvonge-Chalabre entry in *The Combat at the*

FIGURE 78

Barrier (figure 49). Elsewhere are a pageant boat, acrobats on a tightrope, the familiar silhouetting of foreground figures, and a scattered profusion of drinking, vomiting, urinating, and defecating characters.

This fantastic symphony is so varied and extravagant in detail that the viewer is hardly aware of the subject of the print. Saint Anthony is relegated to a position of minor importance, and one must look carefully to find him. A figure who barely commands attention, he stands inside the arch at right center with a nimbus about him.

The plate carries no inscription.

 Afterword

During his brief lifetime Callot was exposed to a large variety of continental theatre forms. Although he himself was not a designer or theatrical practitioner, he managed to leave behind a substantial body of work which chronicled the theatre of his time, and despite the fertility of his artistic imagination his documents have great historical value. His sense of careful planning is affirmed by the hundreds of theatrical sketches and drawings which are scattered among the museums, libraries, and private collections of the world and which could not be included in the scope of this book.

The theatrical iconography of Callot's day is quite extensive. There are numerous prints, paintings, and drawings dealing with this subject matter, and even if Callot had never recorded any of this material we would still be able to reconstruct and visualize most of the activities that took place. Callot's value to us lies not in his legacy of historical documents, but rather in his ability to isolate the essence of a theatrical experience, to capture the fleeting, ephemeral moment and present it with verve, incisiveness, and deep understanding. The cavorting figures of the *Balli di Sfessania* are never static, never silent. They speak to us of a fervor and excitement that has always informed the nature of creativity in the theatre. The same is true of much of his other work. Even his non-theatrical prints reflect an ability to depict real and imaginary events and persons with great dramatic imagination.

Appendix

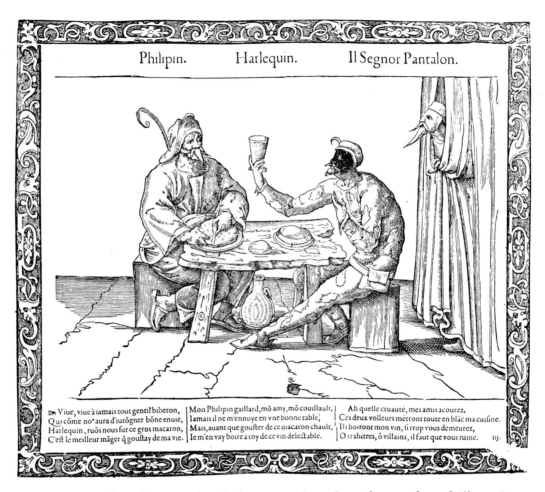

Philipin. Harlequin. Il Segnor Pantalon.

Viue, viue à iamais tout gentil biberon, | Mon Philipin gaillard, mô amy, mô couillault, | Ah quelle cruauté, mes amis acourez,
Qui côme no' aura d'iurôgner bône enuie, | Iamais il ne m'ennuye en vne bonne table, | Ces deux volleurs metront toute en blāc ma cuisine.
Harlequin, ruôs nous sur ce gros macaron, | Mais, auant que gouster de ce macaron chault, | Ils boiront mon vin, si trop vous demeurez,
C'est le meilleur māger ǭ goustay de ma vie. | Ie m'en vay boire a toy de ce vin delectable. | O trahitres, ô villains, il faut que vous ruine. iij.

FIGURE I. Eavesdropping as a theatrical commonplace. One of a number of illustrations showing a figure peering between the curtains. Duchartre (*La commedia dell'arte*) dates the print approximately 1577 and suggests that Harlequin might have been played by Simone de Bologna with the Gelosi company in the reign of Henry III.

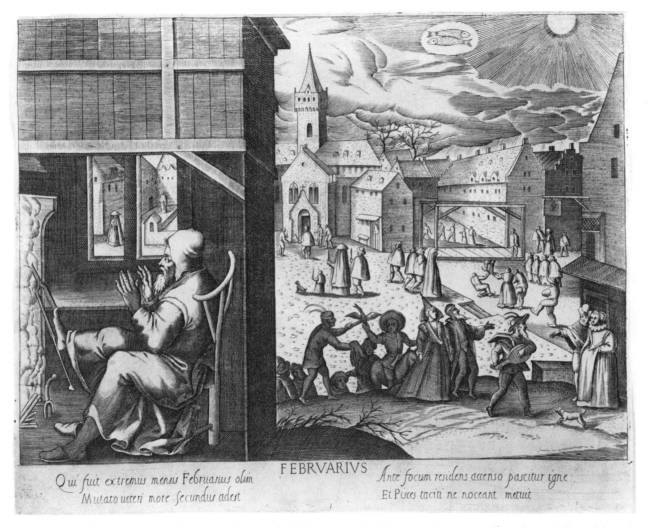

Qui fuit extremus mensis Februarius olim FEBRVARIVS Ante focum residens accenso pascitur igne
Mutato ucteri more secundus adest Et Pisces taciti ne noceant metuit

FIGURE II. *February*. From the series *Les mois*. This engraving is generally not attributed to Callot although Lieure catalogs it as number 3. It is of interest to us since it appears to depict a *Commedia* troupe being led on by a lute-player. Callot's name is not inscribed as in the *January* plate.

FIGURE III. Giulio Parigi's sketch for Lady Fame in *Guerra d'amore*. FIGURE IV. Giulio Parigi's sketch for Dawn in *Guerra d'amore*.

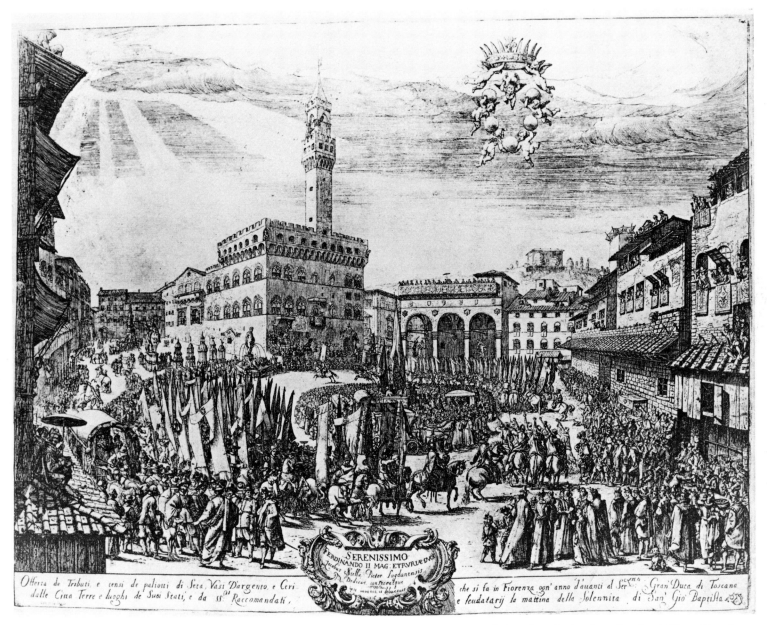

FIGURE V. *The Festival of Tribute to Florence* by Jacobus Stella. This is the same event and location depicted earlier by Callot (See figure 58).

FIGURE VI. The enema as stage business. From "Vie, aventures et mésaventures de Pantalone." Published in Rome between 1560 and 1580 by Lorenzo Vaccaro.

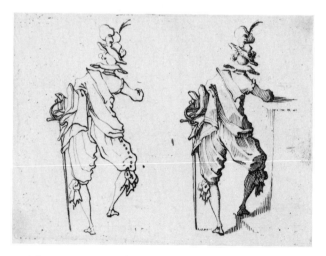

FIGURE VII. *Man with a Large Sword, Seen from the Rear* (L. 230).

FIGURE VIII. A sixteenth century Bacchus and fountain in Florence which served as a model for part of the *Il solimano* scene design.

FIGURE IX. Callot's sketch for the *First Interlude*. Compare this with figure 60, noting in particular the differences in treatment of the foreground figures.

FIGURE X. A theatre design by Callot. Black crayon and bistre.

FIGURE XI. Scene design for the marriage festivities of Ferdinand 1 and Christine of Lorraine in 1589. By Orazio Scarabelli after Buontalenti. Engraving dated 1590.

FIGURE XII. A seventeenth century stage model at the Drottningholm Theatre Museum inspired by Callot's second *Temptation of Saint Anthony*.

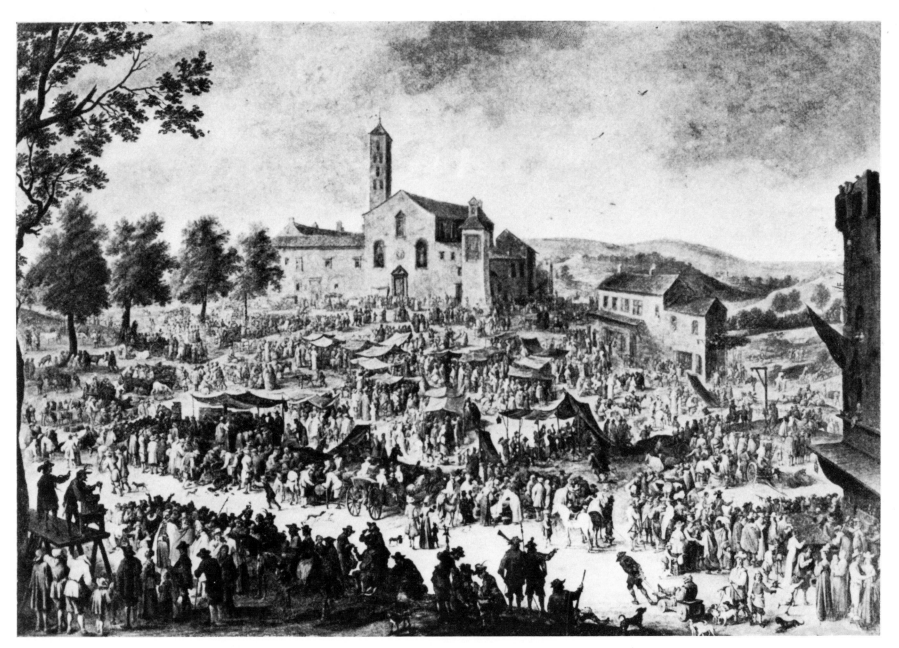

FIGURE XIII. A painting by Teniers le Jeune which reproduces Callot's *L'Impruneta*.

ILLVSTRISSIMO MAXIMOQVE VIRO D.D. LVDOVICO PHELYPEAVX DÑO. DE LAVRILIERE COMITI CONSISTORIANO SACRARVM IVSSIONVMIIIIIVIRO
 IA. CALLOT VOVET DEDICAT CONSECRATQVE.

Informes laruæ, cæcis stabulata latebris *Sancte senex, tantos sentis et despicis hostes?*
Monstra suum rupere Chaos, atque agmine facto *Hil spirat mortale tibi: nec Gaudia pectus.*
Lætiferis orbem violant lucemque venenis. *Blanda mouent, nec frangit Amor, nec funera terrent.*
Tot scelerum facies Erebo mutauit Eremum. *Cum Priuil. Reg.* *Mens infixa polo reparans, que ab Origine vires*
Interea vasti quid agis sub formice saxi *Israel excu 1635.* *Susinet in terris quas ridet in æthere pugnas*

FIGURE XIV. *The Temptation of Saint Anthony.* Second version. Etching. 1635. (L. 1416)

Notes

CHAPTER 1

1. Edwin de T. Bechtel, *Jacques Callot* (New York: Braziller, 1955), p. 13.
2. Bechtel, *Jacques Callot*, p. 6.

CHAPTER 2

1. Jules Lieure, *Catalogue de l'oeuvre gravé*, 3 vols. (Paris: Gazette des Beaux-Arts, 1924–1927), 2: 27–28.
2. Winifred Smith, *The Commedia dell'Arte* (New York: B. Blom, 1964), p. 9n11.
3. Joseph S. Kennard, *Masks and Marionettes* (New York: Macmillan, 1935), p. 6.
4. Allardyce Nicoll, *The World of Harlequin* (New York: Cambridge University Press, 1963), p. 75.
5. Daniel Ternois, *L'art de Jacques Callot* (Paris: F. de Nobèle, 1962), p. 54n14.
6. Lieure, *Catalogue* (1925), 2: 27. Lieure also claims (*La vie artistique*, 1: 39) that the *Balli* was inspired by a company of *zanni* which played before the grand duke between 19 November and 12 December 1612. Cf. Angelo Solerti, *Musica, ballo e drammatica alla corte medicea dal 1600 al 1637* (Florence: R. Bemporad and Son, 1905), p. 67.
7. Luigi Rasi, *I comici italiani, biografia, bibliografia, iconografia*, 3 vols. (Florence: Parigi, 1896), 1: 461–462.
8. Lieure, *Catalogue*, 2: 28.
9. Pierre Louis Duchartre, *La commedia dell'arte et ses enfants* (Paris: Editions d'Art et Industrie, 1955), p. 192.
10. Rasi, 1: 462.
11. Kathleen Marguerite Lea, *Italian Popular Comedy: A Study in*

the Commedia dell'Arte, 1560–1620, 2 vols. (Oxford: Clarendon Press, 1934), 1: 328.

12. Although the names are spelled differently in figs. 1 and 2 and the characters are shown in different costumes and masks, there is little evidence to suggest that they are distinctly separate characters rather than imaginative variations of the same one. Similarly, Cucorongna is very likely an onomatopoetic variant of Cucurucu. (See figs. 1, 16, and 19.)

13. Lieure, *Catalogue*, 2: 29.

14. Pierre Louis Duchartre, *The Italian Comedy* (New York: John Day, 1929), p. 177. "The character Gian-Fritello, or Fritellino, as interpreted by the actor Pietro Maria Cecchini, a member of the troupe of Tristano Martinelli." Cf. also Solerti, p. 101, and Lieure, *La vie artistique*, 1: 40n, 51. Cecchini came to Florence on 6 November 1615 at the invitation of Cosimo II. He played for the ailing grand duke and stayed several weeks. These personages had further influence on the *Balli*.

15. Lea, *Italian Popular Comedy*, 2: 493. "(cp. Florio, 'a little mestolino, an idle gull, a loggerhead good for nothing but to handle a ladle')."

16. Duchartre, *The Italian Comedy*, p. 160. "Guazzetto [Callot spells it Guatsetto] was a rollicking *farceur* closely related to Arlechino."

17. Duchartre, *The Italian Comedy*, p. 171. "When Mezzetino [Italian spelling] came into existence in the sixteenth century he was the double of either Scapino or Brighella."

18. Lea, *Italian Popular Comedy*, 1: 92. "The first literary appearance [of Pulcinella] that can be dated is in Cortese's *Viaggio di Parnasso*, 1621, . . . [and the] first illustration of the dress of the new buffoon in Callot's *Balli di Sfessania* belongs to 1622."

19. Lea, *Italian Popular Comedy*, 2: 492. Of Baggatino, as Lea spells it: "The nickname, which is probably connected with 'bagati,' a Venetian coin worth less than a farthing, is found also in the forms: Bagot, Bagatellino, Bagatto." Duchartre, *The Italian Comedy*, p. 60, points out that Bagatino, as he spells it, bears "close resemblance to Arlechino."

20. Lieure, *Catalogue*, 2: 30–31.

21. Gian Farina seems to have been identified with Scapino. Lea, *Italian Popular Comedy*, 2: 488–489, writes, "When in August 1612 T. Martinelli describes an actor as 'ZAN FARINA *overo* SCAPINO,' he can only be referring to Francesco Gabrielli, later *Scapino* of the Confidenti. The alternative names move from the general to the particular: Farina, with its allusion to the 'lazzo' of flouring the face, was the more common Zanni name and occurs as early as 1585 in G. S. Martini's *Bragatto* as *Gian Farina*."

22. Lieure, *Catalogue*, 2: 32.

23. Ibid.

24. Duchartre, *The Italian Comedy*, pp. 247–248.

25. Another example of this piece of comic business can be found in the illustrated Dutch scenario entitled *The Marvellous Malady of Harlequin*, the fifth illustration following p. 56 in Duchartre's *Italian Comedy*.

26. Lea, *Italian Popular Comedy*, 1: 48.

27. Cyril W. Beaumont, *The History of Harlequin* (New York: B. Blom, 1967), p. 40n. "A name given to a Zanni Mask created by Gabriele Panzanini."

28. Lieure calls the instrument a mandolin. *Catalogue*, 2: 33.

29. See Fricasso in fig. 11. Smith, p. 9, discusses Fracasso as a prototype: "And everyone, I suppose, knows Gautier's *Capitaine Fracasse*, a sympathetic attempt to clothe an old idea with flesh." She continues in a footnote, "It is odd that Gautier named his Gascon Fracasse, for Fracasso was at first a good-for-nothing more like Pulcinella than like the Capitano."

30. Lieure, *Catalogue*, 2: 33.

31. Duchartre, *The Italian Comedy*, p. 194.

32. Allardyce Nicoll, *Masks, Mimes, and Miracles* (New York: Cooper Square, 1963), p. 261.

33. Vito Pandolfi, *La commedia dell'arte*, 6 vols. (Florence: Sansoni, 1957–1961), 1: facing p. 321 (i.e., Guilo Pasquati, first Pantalone of the Gelosi troupe).

34. The shortened trousers of the later Pantalone came to be known as "pantaloons" and later "pants" and other variations.

35. Duchartre, *The Italian Comedy*, p. 286. Duchartre, however, does not specify which Zanotti he means. On p. 97 he lists a Giovanni Andrea Zanotti playing the role of Ottavio with the Fiorelli-Locatelli troupe (1653–1684) and on p. 288 an Andrea Zanotti (Ottavio) as a principal lover, ca. 1660. This obviously does not conform with the 1618 dating of the Callot etching. Lea, 2: 499, is more specific. "Zanotti Cavazzoni, Giovan Andrea, Ottavio (1632–95) in the service of the Duke of Modena at least from 1647." Lea, *Italian Popular Comedy*, 2: 496, also makes reference to the character Fabio who was mentioned by B. Rossi in 1584 and by Garzoni in 1585, and a Pavolino Zanotti, 1620, "who appears later as Finocchio" (p. 287) and a Paolo Zanotti "for Finocchio" (p. 303). Finocchio, however, was one of the *zanni* and not an *innamorato*.

36. Lea, *Italian Popular Comedy*, 2: 488.

37. Duchartre, *The Italian Comedy*, p. 168.

38. Nicoll, *The World of Harlequin*, pp. 75–76. Nicoll raises a question regarding the authenticity of Scapino's costume. His point is made in reference to the *Balli* Scapino but is relevant to both etchings. He writes, "It is possible that the artist did see Scapino on the stage dressed in the way he has drawn him; but even so, that would only mean that thus some Scapino was clad in Naples toward the beginning of the seventeenth century. Since a good deal of evidence shows that the Neapolitans tended to level the various clearly defined types under a few general forms, Callot's etching cannot be accepted as indicating Scapino's proper appearance, even assuming that it is an actor whom the artist has sought to delineate. Much more probably, the etching was inspired, not by a theatrical character at all, but by a Scapino of the carnival—and the same judgment appears proper concerning most of the diversely named persons presented in this series of 'Neapolitan dances.'"

39. Lieure, *Catalogue*, 1: 118, states, "His face is in profile" [!].

40. Ibid.

41. Nicoll, *Masks, Mimes, and Miracles*, p. 285.

42. Lieure, *Catalogue*, 1: 118.

43. Lieure, *Catalogue*, 1: 66. He points out that this figure is an imitation of one to be found in the foreground of one of the etchings by Callot in *The War of Love* (see fig. 34).

44. Ibid.

1. For an excellent account of these entertainments see A. M. Nagler, *Theatre Festivals of the Medici, 1539–1637* (New Haven, Conn.: Yale University Press, 1964).

2. The *Lettera / al Sig. Alberico Cybol / principe di massa / sopra il giuco fatto / dal granduca / intitolato guerra d'amore* gives the date as 12 February while Cesare Tinghi whose diary is reproduced in Solerti's *Musica* (see below) says 11 February. Contemporary sources and the Callot plates themselves date the presentation 1615, which would be 1616 when converted to our present calendar, since the Florentines celebrated the New Year during the third week in March. Georges Sadoul (*Jacques Callot, miroir de son temps* [Paris: Gallimard, 1969], p. 69) says the festival was given on Shrove Tuesday.

3. [Salvadori] *Gverra d'amore / festa del serenissimo grand duca / di Toscana / Cosimo secondo / fatta in Firenze il carneuale del 1615 / in Firenze / MDC. XV.*

4. Lieure, *Catalogue*, 1: 62n. The translation is modified in the sense that Lieure's is highly selective and my own, which is based on Lieure, includes only the most immediately relevant details.

5. See Appendix fig. IV for Giulio Parigi's sketch of Dawn.

6. Lieure, *Catalogue*, 1: 63–64.

7. Ibid, p. 66.

8. Ibid.

9. [Salvadori] *Gverra di belleza / festa a cavallo / fatta in Firenze / per la venuta del serenissimo / principe d'Vrbino / L'Ottobre del 1616. In Firenze, 1616.*

10. It would be helpful at this point to consider in some detail the relationship between Giulio Parigi and Callot in regard to both *Guerra d'amore* and *Guerra di bellezza*. The written accounts of both festivals tell us that Parigi created the designs. The extant costume sketches of Dawn and Fame further support this contention. The variety of signatures on the *Guerra di bellezza* plates, however, have added fuel to the arguments concerning this relationship. The plates are signed as follows:

Mount Parnassus (fig. 37)—"Iullius Parigii In. Callot delineauit et F." (at right)

Thetis (fig. 38)—"Iul. Parigi I. ₵allot F." (at right)

Thetis (fig. 39)—(sup. plate) No signature, not intended for publication

Sun (fig. 40)—"Iul: Parigi In—₵allot F. 1616" (at left)

Love (fig. 41)—"Iul: Parigi In: ₵allot F." (at left)

Ensemble View (fig. 42)—"Iullius Parigij Inu: ₵allot delineauit et F." (at right)

It will be noted that no two of the inscriptions are the same and that they exhibit the common tendency of the period toward variant spellings. The significance here lies not in the variants but in the distinctions that may be made among the terms *I* (*In* and *Inu*), *F.* and *delineauit.* Ternois (*L'art de Jacques Callot,* p. 168) addresses himself to the various ramifications of the problem. He points out that Parigi was responsible for the artistic organization, chariot and costume designs, and staging and that Callot "stepped in only after the festival was over for the purpose of engraving the most important episodes. But this does not mean that he was content simply to submit himself to the copying of his master's designs. The inscription . . . ('Iullius Pariggi inv. I Callot delineavit et fecit') defines each one's part." Regarding the inscriptions in the *Intermèdes* (see chap. 4), Mariette, in Edouard Meaume's *Recherches sur la vie et les ouvrages de Jacques Callot* (2 vols. [Würzburg: Libraire-Editeur J. Frank's Antiquariat, 1924], p. 304), wrote that they "only serve to confirm my opinion that Callot engraved these plates from his own designs, and that Parigi had only designed the machines" and, similarly (Meaume, p. 310) that *Mount Parnassus* inscriptions "show that Callot is the inventor and engraver of all the pieces in this set. If the other plates have been signed 'Jul. Parigi in. I Callot f.' it is only because Parigi invented the machines and that perhaps is all he had to do with the plates even though they are in his style.' " Finally, Sadoul, *Jacques Callot,* p. 47, says, "Several etchings signed between 1615 and 1618 Callot fecit, G. Parigi invenit, mean that Callot designed and engraved those machines staged and created by Parigi." My own view of the matter is that Parigi conceived of the wagons and costumes and that they were executed from his designs. Callot seems to have recorded the end product as well as having added some unique touches of his own. Callot was apparently less "homme du théâtre" at this time than we have a right to assume. When he returned to Nancy it was a different matter.

11. Solerti, *Musica,* pp. 115ff.

12. *Il cortigiano* (*The Courtier*) of Baldassare Castiglione (1478–1529).

13. See Appendix fig. III for Giulio Parigi's sketch of Fame. It should be pointed out that Fame (*Fama*) is better translated as "Rumor." This pejorative appellation is more consistent with the symbolic attributes of her costume. Fame is used here since it was in common usage in England at the time. For example, Thomas Dekker in 1604 describes her as a "Woman in a Watchet Roabe, thickly set with open Eyes, and Tongues, a payre of large golden Winges at her backe, a Trumpet in her hand" and Anthony Munday in 1618 refers to her seemingly playing on a golden trumpet "the Banner whereof, is plentifully powdred with Tongues, Eyes and Eares: implying, that all tongues should be silent, all eyes and eares wide open, when *Fame* filleth the world with her sacred memories."

14. The passage is from book 4 of Virgil's *Aeneid.* Fame is described at some length, a part of which follows:

Millions of opening mouths to Fame belong,
And ev'ry mouth is furnish'ed with a tongue,
And round with list'ning ears the flying plague is hung.
She fills the peaceful universe with cries;
No slumbers ever close her wakeful eyes;
By day, from lofty tow'rs her head she shews,
And spreads thro' trembling crowds disastrous news;
With court informers haunts, and royal spies;
Things done relates, not done she feigns, and mingles truth with lies.
Talk is her business, and her chief delight
To tell of prodigies and cause affright. (John Dryden translation)

15. Lieure, *Catalogue,* 1: 70.

16. Bechtel, *Jacques Callot,* p. 38.

17. Lieure, *Catalogue,* 1: 71. Lieure further maintains (*La vie artistique,* 1: 54) that Callot did this plate because the first did not conform to the description of the festival.

18. Solerti, *Musica,* p. 115.

19. *Descrizione / dell'arrivo / d'amore in / Toscana. / In gratia delle*

bellisime / dame fiorentine. / In Firenze. / Appresso Zanobi Pignoni, 1615:

20. Solerti, *Musica*, pp. 97–98.

21. Solerti, *Musica*, pp. 146–147.

22. Mariette, *Notes manuscrites*, as quoted in Lieure, *Catalogue*, 2: 2.

23. Beaupré, *Recherches historiques* (1845), as quoted in Lieure, *Catalogue*, 2: 71.

24. Jean Jacquot, ed., *Les fêtes de la renaissance*, 2 vols. (Paris: Centre National de la Recherche Scientifique, 1956–1960), 1: 168.

25. Lieure, *Catalogue*, 2: 72.

26. As with many of the processional wagons this one was almost certainly too heavy to have been pulled by the means shown in the etching. Most of the wagons, particularly where the bottoms are masked, probably were moved by persons hidden within (cf. n. 29 below).

27. Lieure, *Catalogue*, 2: 74.

28. Meaume, *Recherches sur la vie*, p. 213., who writes "drawn by dogs."

29. Meaume, *Recherches sur la vie*, p. 213, writes "drawn by an invisible engine."

30. Remouille and Couvonge are not readily distinguishable. It could hardly be the same Couvonge who appeared as Minos two entries earlier.

31. This seems to be the most logical explanation. In the following print (L. 584) the "structure" will be seen turned at right angle as it is used for the joust.

32. Jacquot, *Les fêtes*, p. 175.

33. These are "sugared almonds," according to Sadoul, *Jacques Callot*, p. 242, and "some small change," according to Lieure, *Catalogue*, 2: 79.

34. Lieure, *La vie artistique*, 1: 53, 53n. The narration of the festival was published under the title *Partita / d'amore / dal bel regno / di Toscana. / Per crudeltà / delle dame / Fiorentine. / In Firenze. Per Zanobi Pignoni, 1616. /* Cf. Solerti, *Musica*, pp. 108–109, 109n.

35. Lieure, *Catalogue*, 1: 101. Lieure makes use of the other name, *Loggia d'Orcagna* which comes from Vasari. The more common term *Lanzi* refers to the Swiss lancers of Cosimo I who were housed nearby.

1. *Veglia*, or vigil. This performance contained recitatives, orchestral accompaniments, ballets, jousts, and singing but could not, strictly speaking, be called an opera. It was a late evening's entertainment, a play with *intermezzi*.

2. The Uffizi Theatre was the Medici's permanent theatre designed by Bernardo Buontalenti. It opened in 1586 with a performance of Count Bardi's comedy *L'amico fido* with settings by Buontalenti. For a comprehensive account of this event see Nagler, *Theatre Festivals*, chap. 5.

3. Nagler, *Theatre Festivals*, p. 131. See entire chap. 12 for a detailed description of the plot and intermezzi. Bechtel, *Jacques Callot*, p. 17, maintains that the *Liberation* was Cosimo's way of celebrating the defeat of the Turkish fleet by the Tuscan defenders in the Tyrrhenian Sea during the previous year.

4. This account of the libretto and action of the *veglia* is drawn from Nagler. See n.3 above.

5. An abbreviated eyewitness account by one Gioseffo Casato is included in Solerti, *Musica*, p. 121n, and here translated by Nagler, *Theatre Festivals*, p. 133.

6. Nagler, *Theatre Festivals*, pp. 59ff., based upon Bastiano d' Rossi's *Descrizione / del magnificentiss. / apparato. / E di maraviglioso intermedi / fatti per la commedia / rappresentata in Firenze / nelle felicissimi nozze degl' illustrissimi, / ed eccellentissimi signori/ i Signor Don Cesare D'Este, / e la Signora Donna / Virginia Medici. / In Firenze, appresso Giorgio Marescotti. / l'anno MDLXXXV.*

7. Nagler, *Theatre Festivals*, p. 133.

8. Although the critics appear to have borrowed the idea from each other their unanimity lends strong support to the theory. A few examples follow: Lieure, *Catalogue*, 1: 72: "The artist's imagination is given free rein in this piece which undoubtedly gave him the idea for the *Temptation of Saint Anthony*"; Bechtel, *Jacques Callot*, p. 17: "This venture into diablerie may well have suggested to the artist his first *Temptation of Saint Anthony*, which soon followed"; Sadoul, *Jacques Callot*, p. 80: "It directly inspired Callot's first *Temptation of Saint Anthony*"; Ternois, *L'art de Jacques Callot*, p. 189: "It is acknowledged to be the source of Callot's first *Temptation of Saint Anthony*."

9. Brian Reade, *Ballet Designs and Illustrations, 1581–1940* (London: Her Majesty's Stationery Office, 1967), p. 5.

10. Nagler, *Theatre Festivals*, p. 133.

11. Solerti, *Musica*, pp. 121n, 124n.

12. Prospero Bonarelli, *Il solimano: tragedia del conte Prospero Bonarelli* (Florence: Cecconcelli, 1620).

13. *Enciclopedia dello spettacolo*, 9 vols. (Rome: Le Maschere, 1954–1962), 2: col. 760.

14. Sadoul, *Jacques Callot*, p. 131n.

15. Lieure, *Catalogue*, 2: 17.

16. The plates for *Acts IV* and *V* are identified in reverse in Lieure, *Catalogue*, 2.

17. Lieure, *Catalogue*, 1: 31n.

18. Ibid.

CHAPTER 5

1. Sadoul, *Jacques Callot*, p. 162; Bechtel, *Jacques Callot*, p. 124; Lieure, *La vie artistique*, 1: 83; Mariette and Meaume as quoted in Lieure, *Catalogue*, 2: 35.

2. Bechtel, *Jacques Callot*, p. 24.

3. Ternois, *L'art de Jacques Callot*, p. 133.

4. Solerti, *Musica*, p. 65. Baroni's work was published in octavo by Fantucci in Florence.

5. Sadoul, *Jacques Callot*, p. 94.

6. Ternois, *L'art de Jacques Callot*, p. 133.

7. Lieure, *Catalogue*, 2: 37.

8. The instrument identified by Lieure, *Catalogue*, 2: 39, as a guitar is somewhat different from the one played by Fritellino in fig. 23.

9. Lieure, *Catalogue*, 2: 14n.

10. A second treatment of the subject was done in Nancy about 1634, shortly before Callot's death. (See Appendix fig. XIV) It is quite different from the earlier plate although several details are retained. The first version is discussed here since it contains many more features rele-vant to the context of this study. It was the second version, however, which inspired the stage model preserved at the Drottningholm Theatre Museum (see Appendix fig. XII).

Selected Bibliography

Baur-Heinhold, Margarete. *The Baroque Theatre: A Cultural History of the Seventeenth and Eighteenth Centuries*. London: Thames and Hudson, 1967.

Beaumont, Cyril W. *The History of Harlequin*. New York: B. Blom, 1967.

Bechtel, Edwin de T. *Jacques Callot*. New York: Braziller, 1955.

Bjurstrom, Per. *Giacomo Torelli and Baroque Stage Design*. Nationalmusei Skriftserie 7. Stockholm: Nationalmuseum, 1961.

Bouchot, Henri. *Jacques Callot, sa vie, son oeuvre et ses continuateurs*. Paris: Librairie Hachette, 1889.

Bruwaert, Edmond. *Jacques Callot, biographie critique*. Paris: Henri Laurens, 1914.

————. *Vie de Jacques Callot, graveur lorrain, 1592–1635*. Paris: Imprimerie Nationale, 1912.

Courboin, François. *Histoire illustrée de la gravure en France*. 3 vols. Paris: M. Le Garrec, 1923–1928.

Duchartre, Pierre Louis. *La Commedia dell'arte et ses enfants*. Paris: Editions d'Art et Industrie, 1955.

————. *The Italian Comedy*. New York: John Day, 1929.

Enciclopedia dello spettacolo. 9 vols. Rome: Le Maschere, 1954–1962.

Félibien, André. *Entretiens sur les vies et sur les ouvrages des plus excellents peintres anciens et modernes; avec la vie des architectes*. 6 vols. 1725. Facsimile reprint (6 vols. in 1). Upper Saddle River, N. J.: Gregg Press, 1967.

Gori, Pietro. *Firenze magnifica, le feste fiorentine attraverso i secoli*. Florence: R. Bemporad, 1930.

Jacques Callot, das gesamte Werk. Introduction by Thomas Schröder. Munich: Rogner and Bernhard, 1971.

Jacquot, Jean, ed. *Les fêtes de la renaissance*. 2 vols. Collection Le Choeur des Muses. Paris: Centre National de la Recherche Scientifique, 1956–1960.

117

Jacquot, Jean. *Le lieu théâtrale à la renaissance*. Paris: Editions du Centre National de la Recherche Scientifique, 1964.

Kennard, Joseph S. *The Italian Theatre*. 2 vols. New York: W. E. Rudge, 1932.

———. *Masks and Marionettes*. New York: Macmillan, 1935.

Kernodle, George R. *From Art to Theatre*. Chicago: University of Chicago Press, 1944.

Lawrenson, T. E. *The French Stage in the Seventeenth Century: A Study in the Advent of the Italian Order*. Manchester, U. K.: University Press, 1957.

Lea, Kathleen Marguerite. *Italian Popular Comedy: A Study in the Commedia dell'Arte, 1560–1620*. 2 vols. Oxford: Clarendon Press, 1934.

Levertin, Oscar. *Jacques Callot, vision du microcosme*. Paris: Librarie Stock, 1935.

Lieure, Jules. *Jacques Callot*. 5 vols. (Part I: *La vie artistique*. 2 vols. Part II: *Catalogue de l'oeuvre gravé*. 3 vols.) Paris: Gazette des Beaux Arts, 1924–1927.

Löffler, Peter. *Jacques Callot, Versuch einer Deutung*. Winterthur, Switz.: Keller, 1958.

Magne, Emile. *Les fêtes en Europe au XVIIe siècle*. Paris: Rombaldi, 1930.

Mariette, Pierre Jean. *Abecedario de P. J. Mariette et autres notes inédits de cet amateur sur les arts et les artistes*. Edited by Ph. de Chennevieres and A. de Montaiglon. Paris: J. B. Dumoulin, 1853–1854.

———. *Notes manuscrites*. Preserved in Paris at the Cabinet des Estampes de la Bibliothèque Nationale, 1743–1774.

Marot, Pierre. *Jacques Callot d'après des documents inédits*. Nancy-Paris: Berger-Levrault, 1939.

Meaume, Edouard. *Recherches sur la vie et les ouvrages de Jacques Callot*. 2 vols. Würzburg: Libraire-Editeur J. Frank's Antiquariat, 1924.

Nagler, Alois Maria. *Theatre Festivals of the Medici, 1539–1637*. New Haven: Yale University Press, 1964.

Nasse, Hermann. *Jacques Callot*. Leipzig: Verlag von Klinkhardt und Biermann, 1919.

Nicoll, Allardyce. *Masks, Mimes, and Miracles*. New York: Cooper Square, 1963.

———. *The World of Harlequin*. New York: Cambridge University Press, 1963.

Pandolfi, Vito. *La commedia dell'arte*. 6 vols. Florence: Sansoni, 1957–1961.

Plan, Pierre Paul. *Jacques Callot: maître graveur, 1593–1635*. Paris: G. Van Oest et Cie., 1911, 1914.

Rasi, Luigi. *I comici italiani, biografia, bibliografia, iconografia*. 3 vols. Florence: Fratelli Bocca, 1897.

Reade, Brian. *Ballet Designs and Illustrations, 1581–1940*. London: Her Majesty's Stationery Office, 1967.

Sadoul, Georges. *Jacques Callot, miroir de son temps*. Paris: Gallimard, 1969.

Smith, Winifred. *The Commedia dell'Arte*. New York: B. Blom, 1964.

Solerti, Angelo. *Musica, ballo e drammatica alla corte medicea dal 1600 al 1637*. Florence: R. Bemporad and Son, 1905.

Ternois, Daniel. *L'art de Jacques Callot*. Paris: F. de Nobèle, 1962.

———. *Jacques Callot, catalogue complet de son oeuvre dessiné*. Paris: F. de Nobèle, 1962.

Vachon, Marius. *Jacques Callot: les artistes célèbres*. Paris: Librairie d'Art, 1886.

Where do astronomers work?

Some astronomers even fly into space to do their experiments, but most are earthbound. They do their work using telescopes and laboratories, as well as sending up robots called space probes to beam back information from the distant corners of space.

Important amateurs

Both amateur and professional astronomers make important discoveries. In 1995, two men spotted a comet – a frozen bundle of ice, rocks and dust that shoots through space, trailing a glowing tail. Thomas Bopp, a keen amateur astronomer, was stargazing in Arizona when he saw the comet. The other comet spotter was a professional astronomer, Alan Hale.

Child astronomers

In 1930, a little girl named Venetia Burney and her grandfather were talking about a newly discovered planet that didn't have a name yet.

Venetia thought it should be named Pluto, after a Roman god, since all the other planets were named after Roman gods.

Her grandfather passed the idea on to an astronomer he knew – and the name stuck.

Hale spotted the comet at home, from his driveway in New Mexico. The comet was named after both its discoverers – it's known as Comet Hale Bopp.

Comet Hale Bopp became visible to the naked eye in 1997, and it stayed visible for 18 months.

SILENCE

What's out in space?

There are all kinds of things out in the vast depths of space. From giant stars to tiny moons, from space dust to black holes, from planets made of gas to solid ones that people might live on one day.

When you first look up at the night sky, all the shining dots look more or less the same. But after a while you can see that some appear paler or brighter.

You'll see different shades too – red, blue or yellowish-orange. The longer you look, the more differences you'll spot.

What can you see in the night sky?

Some of the bright dots in the sky are burning balls of gas called stars, that give off their own light. Other dots are planets, which don't make light of their own; they just reflect the Sun's light.

Every now and then, a comet will appear in the sky, such as Comet Hale Bopp. Some comets are too faint to see, but others are visible with the naked eye.

You might also see a streak of light that looks like a star falling through the sky. These "shooting stars" aren't stars at all. They're called meteors and they're caused by tiny pieces of dust and rock called meteoroids burning up in the blanket of gases – or atmosphere – that surrounds the Earth. Sometimes, parts of these rocks survive and land on Earth. These are known as meteorites.

Part of an astronomer's job is to predict when and where things like comets and meteors will appear in the sky. Often, whether you can see them will depend on where you live and how clear the skies are.

In space, no one can hear you scream

In science fiction movies, you sometimes see two spaceships fighting. When one of them scores a deadly hit, you might hear a BOOM!

This would be impossible, in fact, as there's no sound in space, because there's no air to carry sound.

Rockets and planes

When you fly in a plane, you usually reach a height of about 10 km (6 miles) above the ground.

Some military planes go a lot higher, but not high enough to get into space. To do that, you need a rocket to blast you away from Earth.

Where is outer space?

Although astronomers are experts on outer space, even they can't pinpoint exactly where it begins. Most experts agree that it starts where our planet's atmosphere ends. The atmosphere is the air that we breathe, which is made up of lots of different invisible gases that swirl around us.

But deciding where the atmosphere ends isn't easy. The air grows thinner and thinner the higher you go into the sky, but saying where it stops and outer space starts is as tricky as deciding where a river ends and the sea begins, or when twilight turns into night.

But, once you get about 100km (62 miles) or so above the Earth's surface, there's no more air, and you're definitely in outer space.

This is the International Space Station, where astronauts live and work in space.

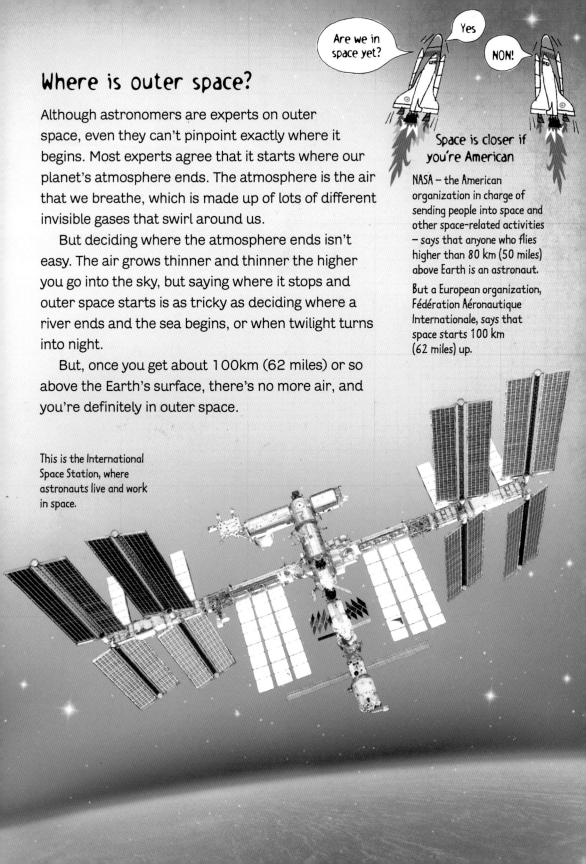

Space is closer if you're American

NASA – the American organization in charge of sending people into space and other space-related activities – says that anyone who flies higher than 80 km (50 miles) above Earth is an astronaut.

But a European organization, Fédération Aéronautique Internationale, says that space starts 100 km (62 miles) up.

What are light years?

Light years aren't years at all, but a way of measuring the massive distances in space without having to have numbers with lots and lots and lots of zeros.

One light year is the distance light travels in a year, which is a whopping 9.46 trillion km (5.9 trillion miles) – one trillion is a million times a million, or a one with twelve zeros.

How far to the nearest star?

One of the nearest stars to Earth is Proxima Centauri, about 4.2 light years away. Even the fastest spaceships would take over 100,000 years to arrive.

So, if astronauts flew there, only their distant descendants would actually arrive.

What is the Universe?

Astronomers study how the Universe fits together. The Universe is everything that exists and has ever existed and will ever exist. It's all the stars and planets and all the space in between them. That's a pretty big topic.

Mindbogglingly big questions

Astronomers ask big questions to match, such as, "Is there life on other planets?", "How did the Universe begin?" or, "Will Earth be destroyed by meteoroids?"

Space is full of gigantic objects, separated by enormous distances – distances you'd never have time to cross, even if you had the fastest possible spaceship, and if you lived for centuries.

As a science, astronomy is the opposite of looking at tiny things under a microscope, very close up. It's mostly about looking at massive things in the far, far, far distance.

Light from stars can travel for millions and millions of years before it reaches us. Planets travel fantastic distances at incredible speeds – the Earth itself is hurtling around the Sun at about 100,000 km/h (62,000 mph) – about 1,000 times faster than the top speed that even the craziest driver would hit on Earth.

Are we there yet?

This way to Proxima Centauri

It would take about a thousand times longer than a human lifespan to get to Proxima Centauri, one of our nearest stars.

You ask that every century!

14

Looking into the past

Amazingly, some of the things that astronomers study – and that you can see in the night sky – don't exist any more. That's a baffling thing to get your head around, at first, but this is how it works...

Like everything in the Universe, stars die eventually – some even explode.

Now, the light from a star can take years to reach us across the vast distances of space. By the time it does, the star you think you're looking at might have exploded. It's a little like hearing an echo of someone shouting. Although they're not shouting any more, you can still hear it.

This means astronomers can literally look into the past and see how the Universe used to be. Studying the light from long-dead stars has helped scientists come up with theories about how the Universe began.

When stars go boom

When some very big stars get older, they end their lives with a massive, unimaginably violent explosion.

An exploding star is known as a supernova. Tiny particles of the dead star are hurled out into space in all directions.

This image – which was taken using a telescope out in space – shows the remnants of an exploding star, known as a supernova.

Magic or a trick?

A stage magician named The Amazing Randi once played a trick on a class of schoolkids.

He gave them all personal horoscopes. Most of the children said that theirs was true. But then, Randi revealed that all the horoscopes were identical.

The secret of his success was being vague. Horoscopes often use vague wording that could apply to almost anyone.

What about astrology?

Most magazines have horoscopes in them, telling people with a particular "star sign" what will happen to them in the week or month to come. Horoscopes are based on an ancient way of studying the skies called astrology.

Astrologers claim to predict your future by looking at how the planets and stars were lined up when you were born. There are different types of astrology, but the basic idea is that what happens in space affects the lives of each person on Earth.

Star signs are also known as signs of the zodiac. The dates of each sign vary depending on the year you're born.

Aquarius
January 20 – February 18

Pisces
February 19 – March 20

Aries
March 21 – April 19

Taurus
April 20 – May 20

Gemini
May 21 – June 20

Cancer
June 21 – July 22

Leo
July 23 – August 22

Virgo
August 23 – September 22

Libra
September 23 – October 22

Scorpio
October 23 – November 21

Sagittarius
November 22 – December 21

Capricorn
December 22 – January 19

Is it true?

Although reading your horoscope and being told that you're going to win loads of money, or travel the world, is fun, there is no evidence to prove that astrology works.

Astrologers talk about a mysterious "pull" that planets have on us, but it's not something that can be measured, and no one has explained satisfactorily how it works.

If astrology were true, people born at the same time in the same place would lead similar lives. But studies done on "astro twins" haven't shown this at all. Of course, horoscopes are often vague, so they can *seem* to come true if you want to believe in them.

The stars say Hitler will attack tomorrow!

Onomy and Ology

Astronomy and astrology were actually mixed together for a long time. In the past, many astronomers who made accurate observations of the skies also believed in the mystical power of the planets and other heavenly bodies.

An ancient people called the Babylonians, for example, could predict eclipses based on their observations. But they also believed that eclipses contained special messages about human destinies.

It was only during the 17th century that astronomy and astrology really started to go their separate ways. There was a big shift in the way humans understood the world at this time, and scholars started to focus more on physical things that you can measure. Mathematical astronomy grew more and more important, while astrology was pushed aside.

Nonsense and science

A few thousand years ago, stargazers in the ancient kingdom of Babylon made a lot of observations that we'd call "scientific" today.

But what they did with this information was often not scientific at all.

For example, Babylonian stargazers might correctly predict an eclipse – so far, so scientific – but then explain the eclipse as a good omen for the king.

This amazing light show is known as the Northern Lights or Aurora Borealis – its scientific name in Latin. It's caused by particles (a scientific word for some of the smallest things we know of) from the Sun colliding with the Earth's atmosphere.

Chapter 2

Great balls of fire and a little ball of rock

You can't see our nearest star anywhere in the night sky. It can only be seen during the day. That's because it's the Sun. Like all stars, our Sun is a gigantic ball of burning gas. Sounds dangerous?

It often is. Although the Sun's a long way away, too much sunlight can burn your skin and even give you cancer. But we also need the Sun to survive.

The Sun gives us energy. It governs the seasons, the harvests, and even our sleep patterns. No wonder the Sun god was the boss in many ancient religions.

The other stars are too far away for us to feel their heat. But many of them are just as powerful up close. Many are much hotter still. By comparison, the Moon doesn't seem very impressive. It's just a dead lump of rock that reflects the light of the Sun. But even the Moon has its own powers over Earth.

What is the Sun?

The Sun is a gigantic, unimaginably hot ball of burning gases. It's mostly made of hydrogen – which is found in all sorts of things, from water to fertilizer, to nuclear bombs – and helium – which is used in floating party balloons.

The Sun's gases don't burn like wood or coal, which need the oxygen in the air to set them alight. The Sun burns without any oxygen.

At its core, the gases are so dense that their atoms (tiny building blocks of the Universe) get smashed together. This creates explosions that produce the Sun's heat and light.

Don't look now... or at all, ever!

If you want to look at the Sun... don't! It can damage your eyes – and even make you blind if you look directly at its fiery face.

Astronomers have special equipment to look at it, but you can Sun-gaze safely with a home-made viewing device. You need a pair of binoculars to make this.)

Put the caps on both ends of one side of a pair of binoculars. Prop up a piece of white cardboard and point one end of the binoculars at the Sun, and the other at the cardboard.

Look at the bright circle that will appear on the cardboard. Do NOT look through the binoculars. Twiddle the focus to get a sharp image.

Warning: don't get your sleeves or hands in the way of the light beam – it'll be hot!

Bright sparks

The Sun looks still and quiet in the sky, but in fact it's always churning and changing. Loops of burning gas, called prominences, whoosh up from the surface at up to 600 km (375 miles) per second. From time to time, massive explosions known as solar flares burst out too. Particles from these explosions zoom across space and hit Earth's atmosphere. This can sometimes mess with the equipment of airline pilots – luckily, though, not enough to make them crash. Major flares have the power to fry the workings of satellites, disrupt TV and radio signals and lead to massive power blackouts.

Our friendly local star

If the Sun was a lot farther away, it would look like the other stars: a twinkling point of light. But, because it's a lot closer than they are, it looks huge and feels hot. Even though it's not very hot as stars go, it's close enough for a lot of its heat to reach us. Still, even though it's close in star terms, the Sun is still about 150 million km (93 million miles) away from Earth.

Earth belongs to a set of planets and other objects that go around the Sun. Together, the Sun and its planets are known as the Solar System.

Compared to the Sun, the planets are tiny. The picture below shows Venus passing between Earth and the Sun. You can see just how tiny Venus is by comparison. It's roughly the same size as Earth.

How big? How hot?

• If the Sun were a hollow ball, you could fit about a million Earths inside it.

• If you flew in the direction of the Sun in a spaceship, your craft would burn up before you got within a few million miles.

• If the Sun was the size of a basketball, Earth would be the size of a pinhead.

• The Sun reaches up to 15 million °C (27 million °F) in its middle.

This photograph shows Venus passing between Earth and the Sun.

Venus

The spotted Sun

If you use the viewing device on page 20 to project an image of the Sun onto some cardboard, you might see dark blotches on the projected image.

These are sunspots – areas on the Sun's surface that are cooler than the rest, which makes them appear darker.

The surface of the Sun is always changing, so sunspots appear and disappear.

But they're not just little spots. They're usually about 20,000 km (12,000 miles) across.

...then there was one

In Ancient Chinese mythology, there were ten suns. They usually took turns in the sky, but one day they decided to appear all at once.

This made it unbearably hot so people asked them to take turns again.

When the suns refused, the god who was the father of all these naughty suns sent another god down from heaven to scold them. But he ended up destroying nine of the suns.

Legend has it that the one that was spared is the Sun we see today.

Inside the Sun

The Sun isn't the same all the way through. It has layers that are different temperatures. The middle is the hottest part and the surface is the coolest. Here's how they all fit together.

Corona
The corona is the outer layer.
Temperature: about one million °C (1.8 million °F)

Photosphere
The surface is called the photosphere.
Temperature: around 5,700 °C (10,300 °F)

Core
The middle, or core, is the hottest.
Temperature: up to 15 million °C (27 million °F)

Sunspot

Far bigger than the biggest planet

The Sun is so huge that if you put Earth and all the other planets in the Solar System on one side of a weighing scale, and the Sun on the other, the Sun would still be almost a hundred times heavier. The Sun makes up 99.8% of the Solar System's "mass" – a scientific term for how much stuff or "matter" there is in an object. Mass is a particularly useful idea when you're trying to understand how objects behave in outer space. When scientists talk about weight, they mean the mass of an object, multiplied by how much it's pulled by something called gravity...

And gravity is...?

Weeeeeeeeee!

Gravity is a force. The simplest way to describe a force is to say that it's a push or a pull. Gravity is a force that pulls objects together. All objects – from pencil sharpeners to planets – have a gravitational pull.

The strength of this pull depends on an object's mass. You can't feel the pull of small objects but the bigger something's mass, the stronger its pull.

Earth's mass is huge, which is why objects fall when you drop them. The Sun has an even more powerful pull. This is what stops Earth and the other planets from shooting off into space.

Spaceship Earth

The Earth travels around the Sun in a not-quite-circular motion, known as orbiting.

As Earth orbits the Sun, it spins around its own axis – an imaginary line through its middle – once every 24 hours. When one side of the planet faces the Sun, the other side is plunged into darkness. So, when it's daytime on one side, it's night on the other.

A weaker pull

The Moon's gravitational pull isn't as strong as the Earth's, because the Moon is smaller.

So, you'd weigh a lot less on the Moon than on Earth, even though the amount of stuff that makes up your body stays the same.

It's easier to talk about the mass of something than its weight, when you're talking about different places in space, because mass doesn't vary with gravity.

Sun

When your part of the world is still facing the Sun, but spinning away from it, that's when you get dusk.

Although Earth is moving at 108,000 km/hr (67,000 mph), you can't feel it. This is because its speed stays the same.

If Earth sped up, you'd feel it – just as when the driver puts his or her foot down in a car.

23

Just hot enough

If the Earth was much closer to or farther away from the Sun, we wouldn't be here. Just like Baby Bear's porridge in *Goldilocks and the Three Bears*, Earth was "just right" for life to develop – the range of temperatures here allowed plants and animals (including us) to thrive. If we were as close to the Sun as the planet Mercury, for example, it would've been far too hot for life as we know it to develop.

But it's not just about distance from the Sun. The gases in our atmosphere help protect us from some of the harmful rays the Sun sends our way, and they also help to keep the temperature steady.

Danger in the Sun

The Sun doesn't just provide us with bright sunshine. It also gives off light that the human eye can't detect.

One type of invisible light that it emits is called UV (ultraviolet) radiation. It can be harmful to humans if they get too much of it.

This is what makes you burn if you're outside too long when it's hot. It can also give you skin cancer.

What does the Sun do for us?

If the Sun was snuffed out tomorrow, we'd freeze to death pretty quickly. But even if we managed to keep warm somehow, the plants would die because they couldn't make food. Without plants, animals and humans would starve. We'd also suffocate, because plant life produces the oxygen we breathe.

Plants use the energy from the Sun to make food. This process is known as photosynthesis.

Christmas on the beach

Picture the scene: it's Christmas Day and you're lying on the beach. If that sounds chilly, you probably live in one of the planet's northern countries, known as the northern hemisphere. But if you live in one of the southern countries, known as the southern hemisphere, it would be summer at Christmas time.

This is because the Earth orbits the Sun at an angle. Different parts of Earth are angled towards the Sun at different times of the year. When your hemisphere is tilted towards the Sun, it'll be summer, as the Sun's rays hit that part of the Earth more strongly.

The Equator

There's an imaginary line running around the middle of the Earth, where the northern and southern hemispheres meet.

This is the Equator, and it runs through countries such as Somalia and Brazil.

At the Equator, the Sun's rays always hit the Earth at the same angle – head on – so there isn't much variation in temperature.

The amount of rain does vary though, so you get a wet season and a dry season.

In March, neither hemisphere is warmed more, so it's spring in the north and autumn in the south.

In January, it's summer in the southern hemisphere.

In June, the northern hemisphere is enjoying its summer.

Again, in September, neither hemisphere gets warmed more.

A little experiment

Try shining a flashlight directly at the ground. The ground should be lit up brightly. This is how the Sun shines in summer.

Now, try shining the flashlight at an angle. The light will spread out more and look paler. This is how the Sun shines in winter – the light is more spread out so it's colder.

During the summer, the days are longer and the nights are shorter. If the Earth didn't tilt, day and night would be the same length all year round.

Our faithful companion

A chip off the old block?

No one knows for sure how the Moon came into existence.

One likely theory says that a huge rock the size of the planet Mars bashed into the Earth about four billion years ago, sending a cloud of debris flying out into space.

This debris got trapped in orbit by the Earth's gravity, forming a ring. Over time, these pieces grouped into a ball – the Moon.

One day, we'll be the Moon!

Dark or far side?

We only ever see one side of the Moon. The side that's hidden from us is often called the "dark side" – although it's really the "far side" – as it isn't actually dark all the time.

It faces the Sun just as often as the rest of the Moon does.

But it always faces away from Earth, because of the way the Moon rotates as it orbits us.

The Moon is a big ball of rock that orbits Earth, just as we orbit the Sun. But while Earth and the Sun are changing all the time, the Moon stays pretty much the same. It's just a big ball of rock.

That may sound dull, but when you're looking at it from Earth, it's the second brightest object in the sky, after the Sun. It's close enough that you can see a lot of its craters, mountains, and other interesting lumps and bumps, with binoculars or a small telescope.

Unlike the Sun, the Moon doesn't give off its own light, so it's perfectly safe to stare at it. On a clear night, it can be a beautiful sight. It's been a popular topic for love songs and poems throughout history, and some people have even believed that the Moon has magic powers – that it could drive people insane, or turn them into wolves.

Tugging at the oceans

The Moon can't turn people into wolves, but it does have the power to move oceans. Whenever the sea creeps away from the beach at low tide or sneaks back up at high tide, the Moon is responsible.

As the Moon's gravity pulls at the Earth, the planet's surface bulges out on both sides – the side nearest the Moon, and at the spot directly opposite it.

You can't tell when the land is bulging out, since solid rock doesn't get pulled as much as liquid, but the effect on the sea is dramatic.

The bulging of the water causes tides, which are basically a wave that moves at a snail's pace through the sea. When the highest part of the wave reaches a particular coastline, it's called a high tide. When the wave has moved far away, you get a low tide.

As the Earth spins on its axis, different parts of the oceans are pulled at by the Moon. Each coastline gets two high and two low tides every 24 hours.

Tides are also affected by the pull of the Sun's gravity. But, because the sun is a lot farther away, it has much less impact, even though it's much bigger.

It's just a phase

Each night, the Moon shows us a slightly different face – from a round Full Moon to a skinny Crescent Moon. These shifting shapes are known as phases.

The Moon doesn't literally change shape. It just looks as if it does because the Sun's rays light up different areas of the Moon as it orbits us. We see more or less of its face depending on where it is in relation to the Sun, and how much light is falling on it.

Starving Moon

An Inuit legend says that the Moon is a god called Anningan, who spends his life chasing the Sun goddess through the sky.

Sometimes he gets so caught up in the chase that he forgets to eat, getting thinner until he becomes a skinny crescent.

Eventually he remembers to eat and fattens up into a Full Moon again, and the chase continues.

Waxing Crescent Moon

First Quarter

Full Moon

Last Quarter

Waning Crescent Moon

Here are some of the most
famous constellations.

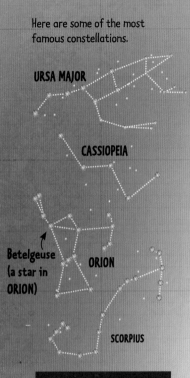

URSA MAJOR

CASSIOPEIA

Betelgeuse
(a star in
ORION)

ORION

SCORPIUS

ORION'S BELT

Little asterisms

You can also look for smaller
groups, known as asterisms.
These are made up of
parts of constellations,
or from stars in different
constellations. For example,
three bright stars at the
middle of Orion make up an
asterism named Orion's Belt.

Star bears and sky hunters

Astronomers divide the night sky into 88 areas,
known as constellations. You will see different ones
depending on which hemisphere you live in, and on
the time of year. Most constellations are named after
animals, objects or people, although they often don't
look much like the thing they're named after.

Orion and Ursa Major are a couple of the most
famous ones. Orion is named after a hunter from an
ancient Greek myth. Ursa Major is supposed to look
like a bear and its name means "Big Bear" in Latin.
But if you draw lines between the stars on a map of
the constellations, you get a weirdly shaped hunter
and a funny looking bear.

Different cultures have seen different pictures
in the sky. The constellation Scorpius, for example,
got its name from a Greek myth about a scorpion.
But, in ancient China, the same stars were part of a
dragon-shaped constellation. And in Hawaii, the tail
of Scorpius is known as Maui's Fishhook, after a god
who pulled the Hawaiian Islands up from the sea. But
the Greek and Roman names are the ones that stuck.

Turn left at Betelgeuse

There's nothing scientific about the way that stars
are grouped into constellations and the stars in them
aren't necessarily close together. But constellations
are still useful. On a clear night, you might see
thousands of stars, so it helps to have an easy way
to find your way around the sky. If you can spot, say,
Orion, that'll help you spot a star named Betelgeuse.
This enormous star marks the "shoulder" of Orion.

The Milky Way and other galaxies

All the stars you can see in the night sky without a powerful telescope are part of a group – or galaxy – named the Milky Way. We're actually inside the Milky Way – which is also known as "the Galaxy" with a capital "G" at the start.

With the naked eye, you can see some other bright galaxies as smears or clouds of light, but you can't make out individual stars. Other galaxies can only be seen using powerful telescopes.

So far, astronomers have spotted some that are up to 15 billion light years away. There are millions and millions of galaxies in the Universe, each with billions of stars in them.

This picture shows a galaxy known as NGC 1300. This shape of galaxy is known as a barred spiral galaxy.

Too close for photos

Spaceships can't get far enough away to take a photo of the Galaxy from the outside.

But scientists have pieced together what it probably looks like by studying its stars and the way other galaxies behave. It's probably a spiral shape, a little like the galaxy in the picture above.

Galactic slow dance

Galaxies are constantly rotating, on a slow spin cycle that takes millions of years.

Our Galaxy takes 230 million years to rotate once – measured as the time it takes the Sun to orbit the Galaxy's middle. This is also known as a galactic year. It's just one of these years since dinosaurs walked the Earth.

The two galaxies in this picture are colliding – ever so slowly.

Astronomers predict that NGC 2207, the larger galaxy on the left, will eventually swallow IC 2163, the smaller galaxy on the right, forming one huge galaxy.

In a galaxy far, far ago

The light from stars takes years to reach us, so we're looking back in time when we stargaze. But how far back are we talking about?

The farthest stars in our own Galaxy are 100,000 light years away, so light from those stars would've started its journey long before history began. The light from other galaxies has even farther to travel.

A galaxy that's sometimes visible with the naked eye, called the Andromeda galaxy, is 2½ million light years away. When its light reaches your eyes, you're seeing it as it was 2½ million years ago.

The lives of stars

All sorts of things could happen to a star in the time it takes for its light to reach us. Stars live busy lives: they burn, move, grow – even explode. Usually, the bigger the star, the bigger the drama.

Sometimes, the galaxy that a star "lives" in collides with another. This isn't like two cars crashing – it's more like two clouds merging, forming spectacular new shapes.

From little clumps to dying giants

All stars begin their lives in vast clouds of gas and dust, called nebulae. As these clouds swirl around in space, clumpy bits form inside them. When a clump grows into a giant ball, explosive reactions begin at the hot, dense core. The ball starts to burn fiercely, and a star is born.

Eventually, all stars run out of fuel and cool down, but this tends to take a very long time. Our Sun, for example, has about four billion* years of fuel left.

Most stars expand and turn red as they cool, becoming objects known as red giants. After that, stars of about our Sun's size shrink into a "white dwarf" - about the size of a planet, but an awful lot denser. Imagine a golf ball that weighs the same as a truck. But it's a peaceful end. White dwarves cool and die quietly.

Bigger stars - more than 1 ½ times the Sun's mass - make a more dramatic exit, exploding as a spectacular supernova.

*A billion is a thousand times a million or one with nine zeros.

The Orion Nebula is so bright that it's visible to the naked eye. About 700 stars have been observed forming there.

Live fast, die pretty

Some scientists think that when Eta Carinae, one of the brightest stars in our Galaxy, explodes, it'll be so bright that you could read by its light at night.

It's hard to predict when it will explode, though. It could be in 10,000 years – or it could be tomorrow.

Hurry up and die – I want to read!

Chapter 3

Wanderers in space

As we circle the Sun, we've got company. Earth is just one of many objects in orbit around the Sun – the star at the heart of our Solar System.

The largest of these circling objects are the planets, although there are plenty of others, from chunks of rock and ice to grains of dust.

If you glance up at the sky, the planets look a little like stars, but stars and planets are as different as fire and ice. And the planets themselves are a very varied bunch – from huge gas giants and tiny Moon-like balls of rock, to the warm, wet planet that we call home.

This photo of Mars shows its reddish-orange surface. But even when it's just a tiny dot in the sky, Mars has a reddish tinge.

Pesky things won't stay still!

Wandering stars

The word "planet" comes from an ancient Greek word meaning "wanderer" – Greek astronomers observed that, while the stars kept in the same positions in relation to each other, the planets seemed to wander around in the sky.

Lonely Earthlings

There are no little green men on Mars. Scientists haven't even found little green patches of moss.

Earth is the only place where life definitely exists. But we might still find life on Mars one day, or on Europa, one of Jupiter's moons, or on planets orbiting other stars.

To be or not to be?

Maybe not?

What is a planet?

Planets are basically huge objects in orbit around a star. In our Solar System, that means the Sun. Every planet's orbit is a different size, which means that a year is a different length on each one – because a year is counted as roughly one orbit of the Sun.

The planets nearest the Sun – Mercury, Venus, Earth, then Mars – are known as the inner planets. They're smallish and rocky, and you could stand on the solid surface of any of them, although you'd boil, freeze or choke on all of them except Earth.

The outer planets – Jupiter, Saturn, Uranus, then Neptune – are much larger. They're made out of ice, gas and sloppy liquids, so you'd sink into them if you tried to land. Some planets have their own moons, and astronomers are still discovering new moons around faraway planets.

This diagram of the Solar System is not to scale. The Sun is so enormous, and the distances are so vast, that it wouldn't all fit on the same page if you did draw it to scale.

Saturn

Jupiter

Discovering and losing planets

Astronomers have known about five of the planets
(not counting Earth) since ancient times. Those five
planets – Mercury, Venus, Mars, Jupiter and Saturn
– are known as the "naked eye" planets, because
they're "bright" enough to see with the naked eye.
But planets don't give off light; they just reflect the
Sun's glow.

It wasn't until 1690, after the telescope was
invented, that someone spotted Uranus – though it
was thought to be a star until 1781. Neptune was
discovered in 1846, and, finally, Pluto in 1930.

Or not so finally, as it turned out. Fast forward to
2003, when some new, planet-like objects of about
Pluto's size were discovered. This made Pluto's status
a little muddy. So, in 2006, a group of astronomers
came up with the first official definition of a planet.
This was bad news for Pluto – it was reclassified a
"dwarf planet" because it didn't make the grade.

Planet update

According to the International
Astronomical Union (a group of
important astronomers)
a planet is:

• in orbit around the Sun.

• round (or more or less round).

• big enough to clear the
area around it. That means it
either pulls any surrounding
rocks and debris down to its
surface, or it pulls them into
orbit around it.

There are also some dwarf
planets, including Pluto. But
not all astronomers agree with
the definition above,
and Pluto may one day be
considered a planet again.

Pluto
(Not currently
a planet)

Mercury

Uranus

Mars

Venus

Sun

Earth

Moon

Neptune

Named after: the Roman messenger god

Diameter: about 4,880 km (3,032 miles)

Distance from Sun: varies a lot, from about 70 million km (43.5 million miles) to 46 million km (28.5 million miles)

Length of year: 88 Earth days

Length of day: 59 Earth days

Temperature: -170 °C to 427 °C (-275 °F to 800 °F)

Atmosphere: Very thin

Moons: None

Weather: Not much, due to the lack of atmosphere

Scientists have learned a lot about the planets in our Solar System by using powerful telescopes. They've also sent robot spacecraft known as probes to orbit them all and send back pictures and information. But, so far, probes have only actually landed on Mars and Venus.

This image of Mercury was taken by the Messenger probe. It's been tinted to make it easier to see the features of the planet's surface.

A shrinking planet?

Some scientists think that Mercury may be shrinking. The theory is that, as the planet's molten core cools, it's getting smaller. Most things contract, or get smaller, as they cool.

Some scientists say the planet has shrunk by about 3 km (2 miles) over time.

Tiny little Mercury is named after a Roman messenger god, who zipped through the sky on winged sandals. The planet lives up to its name – it only takes 88 Earth days to orbit the Sun. But it rotates so slowly that a day on Mercury is the same as 59 Earth days.

You wouldn't be able to breathe there, as there's hardly any atmosphere. You'd also bake or freeze, depending on when you visited. In the day, it's hot enough to melt lead, but during the long nights, the temperature plummets as low as -170 °C (-275 °F).

The poisonous one: Venus

Venus has plenty of gas around it to keep the heat in. Too much for comfort, since the thick atmosphere traps the Sun's rays like the glass of a greenhouse. This is known as a greenhouse effect. As a result, Venus is the hottest planet in the Solar System.

The surface of Venus is completely hidden by thick, fast-moving, poisonous clouds. These clouds would melt your spacesuit and eat into your flesh if you went there. You wouldn't be able to breathe anyway, as the "air" is mostly made up of carbon dioxide – the gas that humans breathe out. And, to add to the list of reasons not to visit Venus, the atmosphere is so heavy that the air pressure would crush you.

Venus fact file:

Named after: the Roman goddess of love

Diameter: about 12,100 km (7,520 miles)

Avg. dist. from Sun: 108.2 million km (67.2 million miles)

Length of year: 225 Earth days

Length of day: 243 Earth days

Average temp.: 465 °C (870 °F)

Atmosphere: Very thick, mostly carbon dioxide, with acid clouds

Moons: None

Weather: Storms above the surface, with high-speed winds

Voyage to Venus

The hidden surface of Venus was a mystery for ages. Scientists thought it might be a huge swamp, or even a tropical paradise. But, since the 1960s, various probes have visited Venus, and we now have maps of most of its surface. But, craft have only ever been able to survive briefly on the surface, before their instruments were wrecked by the scorching heat and pressure.

This computer-generated view of the surface of Venus was created using information sent back by the *Magellan* probe.

Venus used to be called Earth's twin planet. It's just a little smaller, but has similar landscape features, such as volcanoes.

The sopping wet one: Earth

We live on a sopping wet sponge of a planet. Over 70% of the Earth's surface is covered in oceans, streams, lakes and rivers. Perhaps we should we rename it "Water"?

Then again, it's also a rocky planet. Beneath the oceans and where the land is, there's a layer of solid rock, known as the crust. Under that are layers of solid rock, hot liquid rock, hot liquid metal and hot solid metal.

Best beaches in the Solar System

Earth is the best place to hit the beach – the only place, if you like swimming. It's the only planet with liquid water that you can swim in.

Jupiter's moon Europa has lakes of liquid water, but they're frozen over. Saturn's moon Titan has lakes of liquid methane, but they're freezing – and poisonous too.

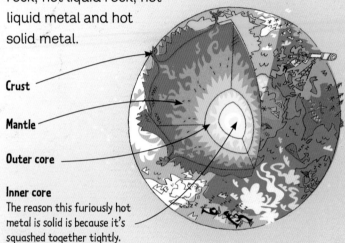

Crust

Mantle

Outer core

Inner core
The reason this furiously hot metal is solid is because it's squashed together tightly.

Very strange aliens?

All living things that we know of have carbon in them, so scientists tend to assume that life in other parts of the Universe will also be carbon-based (if we ever find any).

But it may be possible for life to form that's not carbon-based.

The ingredients of life

One of the reasons we have lots of liquid water is because the temperature on Earth is between the freezing and boiling points of water. That's thanks to our just-right distance from the Sun, and the fact that the gases in our atmosphere protect us from the extremes of heat and cold out in space.

One of these gases is the oxygen that we breathe. But our planet provides lots of other ingredients that make life possible, such as a substance called carbon. After water, it's the stuff that we have most of in our bodies.

I'm carbon free!

This photo of Earth was taken by astronauts orbiting the Moon.

Earth fact file

Earth is the only planet not named after a Roman god.

Diameter: 12,756 km (7,926 miles)

Avg. dist. from Sun: 150 million km (93 million miles)

Length of year: 365.25 days. "Leap" years have an extra day to balance this out.

Length of day: roughly 24 hrs

Temperature: from about -88 °C to 58 °C (-127 °F to 136 °F)

Atmosphere: Nitrogen and oxygen

Moons: one – the Moon

Danger, humans!

Although Earth is an ideal home for humans, the way we're treating our planet is making it less hospitable. For example, burning coal and oil for fuel creates gases known as greenhouse gases. Having too much of these creates a greenhouse effect, where the heat is trapped inside the blanket of gases. Earth is getting warmer as a result, which could make some places uninhabitable in the future. Still, the greenhouse effect is unlikely to become as fierce as it is on Venus.

Climate change

As the world gets warmer, the ice at the North and South Poles is melting. This is making sea levels rise, which is very worrying for people who live on low-lying islands and/or near coasts.

One day, some of those places will be under water.

Outside, looking in

Although we live on Earth and can observe it as closely as we like, we've learned all kinds of new things about it by studying it from space.

For example, weather forecasters use data collected by spacecraft that orbit Earth, known as satellites, to predict the weather. Satellites also study parts of Earth that are hard to see, such as the beds of deep oceans.

The red one: Mars

When you look at Mars in the night sky, it has an orange-red tinge, because the soil on Mars is a rusty red. If you landed on the planet, you'd see a dusty landscape of red sand dunes and rocks spreading out before you. The soil looks red because it contains a lot of rusted iron. Many scientists think there used to be a lot of water on Mars, long ago, and the water is what made the iron rust.

Mars doesn't have any lakes or rivers on its surface now. But, in 2008, NASA's *Phoenix Lander* spacecraft did an experiment, which showed that there's still some frozen water there. By melting icy soil in one of its instruments, the robotic craft proved that there is frozen water lurking below the planet's chilly soil.

We've learned most of what we know about Mars from the spacecraft we've sent there. No humans have visited yet, but craft that have landed on the surface have sent back incredibly detailed pictures and done experiments that've taught us a lot about what it's like on – and under – the planet's surface.

Mars fact file:

Named after: the Roman god of war

Diameter: about 6,780 km (4212 miles)

Average distance from the Sun: 228,000,000 km (141,672,588 miles)

Length of a year: 687 Earth days

Length of a day: About 40 minutes longer than a day on Earth

Average temperature: -23 °C (-9.4 °F)

Atmosphere: Mostly carbon dioxide and very thin – 100 times thinner than Earth's

Moons: Two little ones: Deimos and Phobos

Weather: Dust storms can sometimes cloud the sky for weeks or even months.

This photo of the surface of Mars was taken by the *Spirit* rover.

Is there life on Mars?

There are no aliens walking or slithering around on Mars, and no evidence of life of any kind. But scientists might still find tiny life forms one day, as robot ships land in different spots and sift through the soil.

Mars may have had a thicker atmosphere once. That means it could've been warmer and had liquid water, making it more hospitable for life to develop.

The Asteroid Belt

Beyond Mars lies the Asteroid Belt, where thousands of chunks of rock, or rock and metal, orbit the Sun. These chunks are known as asteroids. They can be as small as a pebble, or hundreds of miles across.

Most of them stay in the Asteroid Belt, but some do cross Earth's orbit. If a large one crashed into us, it could spell disaster. It's unlikely to happen in the near future, but there are scientists who monitor asteroid movements just in case. Various anti-asteroid weapons have been suggested, such as nudging the asteroid off course using a spaceship.

Why does water matter?

Most of the water on Earth is found in our oceans. These vast areas of salty water are believed to be the birthplace of Earth's first life forms, around 3,500 million years ago.

Finding water on Mars – or on other planets or moons – means there's more of a chance that there could be life on the planet. Or, at least, there might have been once.

Did an asteroid kill the dinosaurs?

Very occasionally, asteroids smash into the Earth, leaving large craters, like the craters on the Moon. There's one in the sea near Mexico, where a massive asteroid is believed to have slammed into Earth 65 million years ago.

It would've caused more damage to Earth than thousands of nuclear bombs. It may even have been the reason that all the dinosaurs died out.

This is Jupiter with a couple of its many moons. The big spot on the surface is actually a giant storm. It's more than twice the size of Earth.

Jupiter fact file:

Named after: the ruler of the Roman gods

Diameter: 142,984 km (88, 846 miles)

Av. dist. from Sun: 778.3 million km (484 million miles)

Length of year: 11.86 Earth years

Length of day: 9.9 Earth hours

Av. temp: -153 °C (-243 °F)

Atmos.: Hydrogen & helium

Moons: 67 and counting

Weather: Stormy and windy

Jupiter, Saturn, Uranus and Neptune are "gas giants" – they're made mostly of gas, but scientists think they may be liquid or even solid in the very middle.

Jupiter is the biggest planet in the Solar System by a long way. Our planet, for example, could fit inside it more than a thousand times over.

If Jupiter had been bigger still, it could even have become a star. That's because it contains lots of hydrogen, which is what stars use for fuel. If its mass had been 80 times greater, explosive reactions would have started inside it, turning it into a burning star.

Jupiter has gathered an impressive gang of moons around it, thanks to its super-strong gravity. 67 have been spotted so far, but there are probably more. Some of them are very lively – Io, for example, has lava flows that are thousands of miles long. There might even be life forms of some kind on the planet-sized Europa, down in the ocean under its icy crust.

The ringed one: Saturn

All the gas giants have rings around them, but Saturn's are the most impressive.

These rings are made mostly of ice chunks and a small amount of rock. These chunks can be as small as a fingernail, or as big as a car.

You can't see the rings around Saturn (or any of the gas giants) with the naked eye. So, although astronomers knew about Saturn in ancient times, no one saw the rings until after telescopes were invented.

Like Jupiter, Saturn has a lot of moons. One of them, Titan, is bigger than Mercury and has a thick atmosphere with a lot of nitrogen. It's probably the only moon in the Solar System with an atmosphere of any kind. It also has lakes of poisonous chemicals, such as methane and ethane at its north poles. Another moon, Enceladus, has cracks at its south pole. The probe *Cassini* has sent back images of jets of icy water shooting out of them and far out into space.

This picture of Saturn was taken using the Hubble Space Telescope.

Floating world

Saturn is massive, but it's the lightest planet, because its density – the amount of matter packed into the space it takes up – is so low. If there was an ocean big enough to fit Saturn in, it would float.

This image of Uranus shows its rings and six of its moons. A computer has been used to make the rings visible.

NOTE: when you say this planet's name, stress the first part, the "ur" part of the word.

Uranus fact file:

Named after: the Greek (and later, Roman) god of the skies

Diameter: 51,118 km (31,800 miles)

Average distance from the Sun: 3 billion km (1.8 billion miles)

Length of a year: 84 Earth years

Length of a day: 17.24 Earth hours

Av. temperature: -213 °C (-351 °F)

Atmosphere: Hydrogen, helium and a little methane

Moons: 27 known moons

Weather: Storms the size of the United States and steady temperatures

It took a long time for astronomers to discover Uranus – or, at least, to recognize that it was a planet. An astronomer named John Flamsteed first spotted it in 1690, but he thought it was a star. Various astronomers saw it after that, and thought so too.

When a man named William Herschel first spied Uranus through his telescope in 1781, he thought it was a comet. People had believed for so long that there were only five planets that it didn't occur to him that there might be more. But as Herschel observed the bright object, he calculated that its orbit was wrong for a comet, and it was too far away. After comparing notes with other astronomers, he decided it was a planet.

Uranus is a gas giant, but both Uranus and Neptune are actually more icy than they are gassy. In fact, they're sometimes called the ice giants. Uranus is mostly rock and ice, with some gas.

What makes it stand out is that it orbits the Sun on its side. It may have been thrown into this strange spin after being smashed into by a large object long ago.

After Uranus was discovered, astronomers noticed that something was pulling it out of its orbit. They decided that a large, unknown object must be affecting it.

Astronomers in France and Britain did calculations to predict where this object was and how big it would be. Using these predictions to guide him, a German astronomer named Johann Gottfried Galle spotted the planet in 1846.

Until a space probe flew there in 1989, Neptune seemed rather dull. But it actually has wild weather and the fastest winds in the Solar System. They reach up to 2000 km/h (1242 mph) – about the same speed as the fastest ever jet plane on Earth.

A NASA spacecraft called Voyager 2 took this image of Neptune. Like many photos of planets, the picture has been tinted to help you see different features on its surface, such as a storm known as the Great Dark Spot on the left.

The too-small one: Pluto

Pluto is a tiny, freezing, rocky little world. It's not just smaller than all the planets in the Solar System – it's even smaller than many of the moons. It's also very chilly and has a very thin atmosphere.

As it's so far away, no probes have been there yet, and it's hard to see it in much detail. Pictures taken using the most powerful telescopes suggest that Pluto may look like Neptune's moon, Triton, which is barren and rocky.

Pluto (on the left) and Charon, its closest moon

Trading places

No planet (or dwarf planet) has a perfectly circular orbit. Each one moves in an "ellipse" – a stretched-out circle or oval. Pluto's orbit is the most "eccentric" – that is, the most stretched out.

Its distance from the Sun varies so much that it's sometimes actually inside the orbit of Neptune. The next time this will happen will be in the year 2227.

Pluto was discovered after astronomers noticed that the orbits of Uranus and Neptune were being pulled out of shape by the gravity of an unknown object. "Must be a planet!" they thought, and the hunt for this orbit-bending "planet" began.

Pluto was spotted by American astronomer Clyde Tombaugh, in 1930, but it turned out to be too small to have much of a pull on Neptune and Uranus. Some astronomers decided there must be a "Planet X" tugging at them instead. But many astronomers now think that lots of little objects may be responsible.

At the edge of the Solar System

YOU ARE NOW LEAVING SUN TOWN

After being demoted from planet to dwarf planet, Pluto got a consolation prize; in 2008, a new class of objects – the Plutoids – were named after it. Plutoids are large dwarf planets, and there are four of them so far, including Pluto itself.

The others are Eris – which is actually bigger than Pluto – Makemake (sounds like "macky macky") and Haumea. More Plutoids might join them, as there are a lot of large objects near Pluto. This part of space is known as the Kuiper Belt – it's basically a much colder version of the Asteroid Belt, full of icy, rocky objects.

Far beyond the Kuiper Belt lies an area that no one's ever seen. Astronomers think this is where some comets come from.

Comets can appear in the Solar System from any direction, so it's thought that there's a big cloud of them all around its edges. This is known as the Oort Cloud, after the Dutch astronomer Jan Oort, who came up with the idea in 1950.

Planets outside the Solar System

Lots of stars have planets orbiting them. These planets are known as extrasolar planets or exoplanets. The first exoplanet was discovered in 1991.

Over 1770 others have been discovered so far. One day, we might find a rocky planet that has oceans, clouds and even life.

This comet is called Lovejoy. It was discovered in 2011.

This is a sketch of the planet
Saturn made during the 1700s
by an English astronomer
named Thomas Wright.

Chapter 4

Astronomy through the ages

Today, we know that the Earth goes around the Sun, and that stars are burning balls of gas. We know why the seasons happen, and that shooting stars aren't stars at all. But how did astronomers discover all those things – and more – in the first place?

It took thousands of years to build up the picture that we have today of how space works. Along the way, astronomers invented lots of clever tools to help them observe the skies. They also made plenty of mistakes and had a lot of furious arguments about what's true and what isn't.

This chapter explores some of the amazing discoveries – and crazy theories – that astronomers have made over the course of human history.

Astronomical circles

At Stonehenge, there is a pathway leading up to the main stone circle, known as the Avenue. Its direction lines up (more or less) with the Sun at the midsummer and the midwinter sunrise.

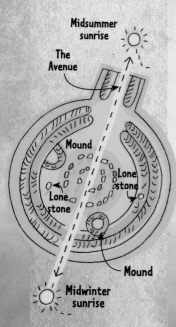

Midsummer sunrise

The Avenue

Mound

Lone stone

Lone stone

Mound

Midwinter sunrise

Outside the main circle are two mounds and two stones that form the corners of a rectangle.

The rectangle's sides line up with some of the Moon's movements.

So, the builders of Stonehenge may have used it to make observations of the Moon and the Sun.

Where did astronomy begin?

The first clues we have about early stargazers are mysterious stone circles, which are laid out so that some of their stones line up with sunrise and sunset at different times of year.

The most famous is Stonehenge, in south west England, which was begun around 5,000 years ago. It's hard to know for certain what it was used for, since it was built before the people who lived there started writing things down.

Some experts believe it may have been used to keep track of the seasons. Stonehenge and other stone circles were probably used as temples and burial grounds, too, and they may have been used in religious ceremonies.

This is a computer-generated image of Stonehenge. Archeologists use computer models such as this one to help them calculate the movements of the Sun, Moon and stars at Stonehenge.

What was astronomy for?

In ancient times, astronomy was vital for everyday life. The movements of the Sun, Moon, stars and planets were used to measure time and the seasons. Sailors and nomads – tribes of people who moved around a lot – used the stars to find their way.

Long ago, most people believed that everything that happened in the skies was caused by the gods – some thought that the planets and stars *were* gods. So stargazers looked for signs to tell them when to do important things, such as crowning a new king.

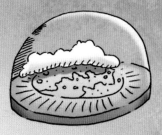

Pancake planet

Many early peoples believed that Earth was flat. They thought the sky must be a huge dome, with the stars, Sun and Moon attached to it.

No one ever went far enough to discover what happened when you reached the "edge" of the world.

The first written records

The first people to leave written records lived about 5,000 years ago in ancient Mesopotamia, where Iraq is now. In the years that followed, astronomers in that region made careful observations of what went on in the sky. They were also clever mathematicians, and we still use some of their ideas today, such as dividing an hour into sixty minutes.

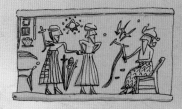

Keeping tabs

Astronomers from an area in Mesopotamia, known as Sumer, kept detailed records of what they saw in the sky.
Some of their diaries still survive on clay tablets.

Seeing the future in the sky

Around 5,000 years ago in Egypt, astronomers (who were also priests) noticed that the star we now know as Sirius appeared and disappeared at the same times each year. Whenever it reappeared, the Nile river began to flood. This meant they were able to predict the floods – although they thought that it was the gods who caused them.

Ancient Chinese astronomers made careful observations and detailed maps of the stars but they also thought that the skies could tell them about the future. Chinese emperors employed astronomers to tell them what the stars foretold.

Each part of the sky was thought to mirror part of China. If a "bad omen" such as a comet appeared in a particular spot, the emperor might even attack the part of the country linked to that area of the sky.

Sky sailing

The ancient Egyptians thought that the Sun was a god, named Ra, who sailed across the sky each day in his heavenly boat.

They also believed that the Nile flooded each year because the goddess Isis was grieving for her dead husband, Osiris. Her tears filled up the river, making it overflow.

A clockwork computer

Thousands of years ago, an ingenious clockwork object, known as the Antikythera mechanism, was lost in a shipwreck.

When it was found by divers in 1901, it was badly rusted, but scientists pieced it together.

It's thought that the ancient Greek device once had moving parts that may have been used to keep track of the movements of the stars and planets.

Astronomy for its own sake

About 2,500 years ago, the ancient Greeks were the first people to do astronomy for its own sake, not just to "see" the future. Greek stargazers discovered how to measure the Earth, and found out how eclipses happen. By studying the movements of the planets, they learned to predict when they would appear.

The Greeks were the first to prove that the Earth is a globe. Before that, most people had thought it was flat. A man named Aristotle noticed how ships seem to vanish over the horizon. If the world was flat, he reasoned, they should just get smaller and smaller. Their sudden vanishing act only made sense if the Earth was curved.

In the middle of things

Most people in ancient times believed that Earth was in the middle of the Universe. They thought that the Sun and everything else circled around us – after all, the Sun does *seem* to travel across the sky each day.

But this left a puzzle for astronomers. Sometimes, the planets seemed to change direction and go back the way they'd come. A Greek astronomer named Ptolemy said it was because the planets were moving around in little circles as they circled the Earth.

Even though the planets don't actually circle the Earth, people were still able to predict the movements of the planets using Ptolemy's model. This was because it was based on careful observations of the patterns the planets made in the sky. Astronomers used his model for over a thousand years.

One Venus or two?

The ancient Greeks had two different names for the planet Venus.

At first, they thought it was two different objects, as Venus can appear in the morning or the evening, depending on the time of year.

But, later, about 2,500 years ago, the mathematician Pythagoras realized they were one and the same planet. He may have got this idea from a people called the Babylonians.

Ptolemy's model is known as a "geocentric" system. "Geo" means Earth in Greek, and geocentric means Earth is in the middle.

I think that clears everything up perfectly.

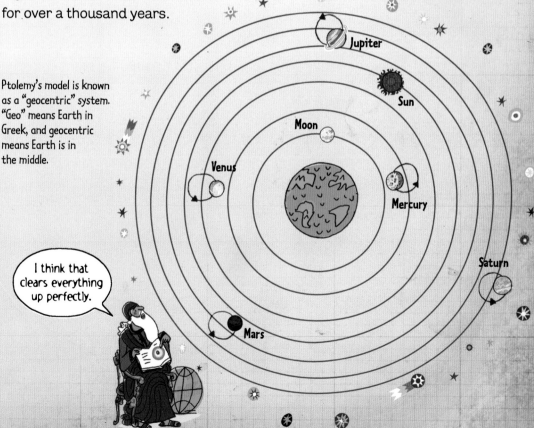

Middle Eastern astronomy

Ancient Greek astronomy had a big influence on the astronomers who lived in the area now known as the Middle East. During the 8th and 9th centuries, scholars there translated all kinds of Greek ideas.

It was a time when mathematics and astronomy flourished and astronomical instruments such as quadrants (used for measuring the positions of stars) became more sophisticated.

This is a painting of Middle Eastern astronomers using various tools to help them measure the height of stars and do calculations based on their observations of the skies.

The Muslim rulers of the area – the Caliphs – built observatories, usually on hills, to make stargazing easier. These were stocked with instruments and books, and often used for teaching young astronomers.

Stargazers in cities such as Baghdad could predict movements of the Sun, Moon and planets more accurately than Ptolemy had done. This was very useful for Muslims, whose prayer times are based on the Sun's movements.

A revolution in the sky

Greek and Middle Eastern ideas were passed on to Europe in the 13th and 14th centuries.

In the 16th century, a Polish clergyman known as Copernicus started to pick holes in Ptolemy's theories. Ptolemy had been forced to come up with fiendishly complicated rules to make the movements of the planets fit his geocentric system.

Copernicus wondered if there was a simpler explanation. What if the Sun was in the middle? This might explain why the planets seemed to change direction. As Earth whizzed past a slower planet, that planet would seem to go back on itself.

This is an astrolabe – a type of astronomical instrument invented by the Greeks and improved upon by Middle Eastern astronomers.

Astrolabes had rotating plates that acted as moving maps of the stars. They had lots of different uses, including telling the time.

This diagram shows what Copernicus thought the Universe looked like. Later, astronomers calculated that the planets moved in ovals, not circles.

A not-so-perfect world

Ptolemy also believed that the sky was perfect and its movements never changed. But in 1572, the Danish astronomer, Tycho Brahe, spotted what he thought was a new star. Actually, it was a supernova, and it disappeared a few months later. If stars could appear and then vanish, how could the sky be unchanging? Ptolemy's system was looking less and less convincing.

Made by kids?

Some stories say that the idea for the first telescope came to its inventor, Hans Lippershey, after watching his children fiddling around with glass spectacle lenses.

When they held up two lenses at once and looked through them, they noticed that they could see a weather vane on a nearby church steeple much more clearly.

The invention of the telescope

In the 17th century, a new invention came along that changed astronomy forever: the telescope. For the first time, astronomers had a tool that could make the stars look clearer and closer.

It's not certain who made the first one, but the person who usually gets the credit – Hans Lippershey – was a spectacle-maker, not an astronomer. In 1608, he discovered that lining up two glass lenses at each end of a tube made objects seem closer.

At first, people thought the device would be used in battles, to spy on enemy soldiers from a distance. But it wasn't long before an astronomer realized how handy it could be for stargazing.

Galileo gets a closer look

The first astronomer to use a telescope to scan the skies was an Italian named Galileo Galilei. He was a skilled craftsman and, as soon as he heard about the new invention, he set about making his own – and making it better. He eventually created a gadget that could magnify objects about twenty times.

He got a lot of praise for his achievement. The name telescope was actually thought up by someone at a party being held for Galileo.

This diagram shows you how light passed through Galileo's telescope. The lenses focus the light.

Eyepiece lens

Eye

Light from the sky

Objective lens

Object being looked at, such as a star

Copernicus was right

When Galileo peered through his telescope, he was amazed by what he saw. There were moons orbiting Jupiter, and mountains and valleys on the surface of the Moon. But, most importantly, he saw that Venus had phases, like the Moon. That doesn't sound dramatic, but it showed that Venus must be orbiting the Sun, not Earth.

So, Earth couldn't be at the middle of everything after all. Before looking through the telescope, Galileo had thought that Copernicus was probably right. But now he had the evidence of his own eyes.

What keeps the Universe together?

Another thing still puzzled astronomers – why didn't the planets float away? What kept them in orbit?

A man named Isaac Newton solved this mystery in the 1660s, with his theory that all objects attract each other with a pulling force. He named this force gravity, from the Latin for weight.

Newton also built telescopes. He improved on Galileo's designs by using mirrors, not lenses, giving clearer, brighter images.

Galileo's design sometimes gave objects a violet halo. Newton's mirror-based telescope helped to solve this problem.

Eyepiece lens

Eye

Secondary mirror

Primary mirror

Astronomy on trial

Galileo got in trouble with the Catholic Church when he published a book saying that the Earth went round the Sun.

The Church believed that Earth was in the middle of a perfect Universe. Going against that was a crime against God.

In 1633, Galileo was put on trial and made to take back what he said. He did, but he still knew he was right.

Newton's inspiration

Some stories say that Newton came up with his theory of gravity when an apple fell on his head.

It didn't happen quite like that – it took him a long time to piece together his ideas. But he certainly wrote about wondering why apples fell off the trees in his garden.

Stop my sailors from getting lost, will you?

Bigger and better telescopes

After Newton, astronomers built telescopes that gave even clearer views of space. William Herschel even managed to spot a new planet using a telescope he had built, although at first he thought it was a comet.

In the 1700s, James Short became one of the first professional telescope makers.

William Herschel used a telescope like this one to discover Uranus in 1781.

Royal astronomy

In 1675, King Charles II hired an Astronomer Royal, whose job was to make star maps to help sailors navigate.

Getting lost meant losing battles for the navy, so it was vital work.

Britain still has an Astronomer Royal today.

More than man-sized

When the Rosse telescope was officially opened, a man walked through its tube wearing a top hat and carrying an umbrella above his head, to give a sense of just how immense the instrument was.

On the right is the enormous Rosse telescope. To use it you had to stand on a platform high above the ground.

Some monstrously huge telescopes were built. These gave greater magnification, but they weren't always practical because they couldn't be moved.

In 1845, a wealthy mathematician named William Parsons (also known as Lord Rosse) created a gigantic telescope which many astronomers used to map the Moon's craters and to view never-before-seen stars.

The Universe gets bigger too

In 1923, an American astronomer named Edwin Hubble used an enormous telescope to identify other galaxies, millions of light years away. Before that, astronomers had thought our Milky Way *was* the Universe. Imagine thinking your country is the only one, then discovering millions of others. Hubble also calculated that other galaxies were moving away from us faster and faster. The Universe was expanding.

A new theory of gravity

About this time, a scientist named Albert Einstein realized that Newton's theory of gravity didn't always explain how objects behaved in space. He published his own theory in 1916, which explained that huge objects, such as planets, make space curve, so other objects fall in their direction.

But soon, scientists weren't just coming up with theories about space. They actually had the technology to send people out there to explore.

How far are the stars?

In 1838, a German named Friedrich Bessel was the first person to measure the distance to one of the stars – 61 Cygni.

He used a method called parallax – measuring how a star's position seems to shift over a year, compared to the other stars. Bessel estimated, fairly accurately, that Cygni was 100 trillion km (62 trillion miles) away.

This is the Hooker telescope at Mount Wilson Observatory in California. Hubble used it to reveal the true nature of other galaxies.

Time travel?

Einstein said that time could change speed depending on how fast you went compared to someone else.

Imagine a woman zooming through space in a spaceship at almost the speed of light, while her twin stays behind.

When she returns, her twin will be older than her. This is because time passes faster on Earth than it does for someone moving much faster.

Don't worry if you're baffled. Even scientists find my ideas tricky.

Chapter 5

A race into space

Since ancient times, people have dreamed of visiting other worlds, but it wasn't until the 1950s that those dreams started to become a reality. Getting into space became an obsession for two powerful nations – the United States and the Soviet Union (the former name for Russia and many of the smaller countries surrounding it).

Both spent vast sums of money on spaceships. First, they launched robot craft, then living creatures, and then, finally, humans. And humans didn't just fly into space. They went all the way to the Moon.

This photo shows an astronaut named Edward "Buzz" Aldrin on the Moon in 1969. You can see another astronaut, Neil Armstrong, reflected in his visor.

An early astronaut

An old Chinese story dating back to the 1500s tells of a man named Wan Hu who tried to launch himself into space using rockets powered by gunpowder.

Wan Hu, the story goes, attached firework-like rockets to a chair and sat down in it. As the rockets were lit, there was a bang. When the smoke cleared, Wan Hu was nowhere to be seen...

From bombs to spaceships

To get to outer space, you have to zoom up at thousands of miles an hour to make up for the fact that gravity is slowing you down.

People have known for centuries that you have to go really fast to get into space. But gravity-cheating speeds only became possible when rocket technology was developed in the 20th century.

Rockets work by forcing hot gas out through thrusters at the bottom, pushing the rocket up. During the Second World War, scientists built rockets with bombs in, but they also used rockets (minus the exploding part) to try to get into space. In 1942, a German *V-2* rocket reached the edge of Earth's atmosphere. Outer space was finally within reach.

A lap around Earth

In 1957, the Russians successfully launched a rocket into outer space. Mounted on this rocket was a tiny craft called *Sputnik 1* – a hollow metal ball, about the size of a beach ball, with a radio transmitter and other gadgets inside.

When it got far enough into space, the rocket fell away, and *Sputnik* orbited Earth alone. Russian scientists down on Earth were overjoyed to hear the "beep, beep, beep," of *Sputnik*'s transmitter over their radios.

This is a replica of *Sputnik 1*. The real thing was destroyed when it hit the Earth's atmosphere.

The Space Race begins

Sputnik 1 was the first man-made "satellite" – that is, an object that orbits another in space. But it wasn't just a first for humankind. It was a victory for the Russians over their rivals, the Americans.

Both the Soviet Union and the USA believed that conquering space would prove how powerful they were. This scramble into the sky became known as the Space Race. By launching *Sputnik*, the Russians had won the first lap.

Laika the spacedog

Later that year, a second *Sputnik* craft was launched with a passenger – a dog named Laika, which means "barker" in Russian. Laika endured months of harsh tests in machines that imitated conditions in space.

Laika stayed calm all through her training sessions and, when *Sputnik 2* launched, she made a successful orbit of Earth. But her journey only lasted a few hours. Sadly, Laika died when her cabin got too hot.

A mini metal moon

Our Moon is a natural satellite – an object that orbits another object in space.

As Earth's first man-made satellite, *Sputnik 1* joined the Moon in orbit, although its orbit was much smaller.

The little ship made about 1,400 orbits and was sometimes visible through binoculars or telescopes or even the naked eye. Some eager astronomers tracked its path through the sky.

Animals in space

In 1970, two frogs were sent into space to study the effects of motion sickness in spaceships. Frogs were used because their ears are quite like ours, and it's the parts inside our ears that give us a sense of balance.

All kinds of creatures have gone into space, including cats, tortoises, rats and flies.

Astropups

In 1960, the Russians sent two dogs, Strelka and Belka, into orbit and brought them home safe and sound.

The Russian leader at the time, a man named Nikita Khrushchev, gave a present of one of Strelka's puppies to the daughter of the US President, John F. Kennedy.

Ham the Chimp-o-naut

The next question was, could a living creature carry out tasks in space? In 1961, the Americans trained a chimp named Ham to pull levers, using bananas as rewards and electric shocks as punishments. Ham repeated his tasks in space and returned safely, too.

This is Ham with one of his keepers.

Space dummy

In 1961, Russians sent up a lifeless dummy in a spacesuit to test that the suit – and other equipment that a human astronaut was going to use – worked OK.

The dummy was named Ivan Ivanovich and was made to look very lifelike. It had eyes, eyebrows, eyelashes and a mouth.

In case anyone found Ivan when he landed and thought he was a dead body or an alien, they wrote "MAKET" – Russian for "dummy" – on his face.

Training for the Space Race

It was time to put a human into space. Both nations put their best military pilots through endless fitness tests, as well as written exams and special training to deal with the strange conditions in space.

For example, American would-be astronauts trained in a plane that flew up and down very fast, so they felt as if they were floating. It was nicknamed the "vomit comet" – you can probably guess why.

The first spaceman

The first person to fly into orbit was a Russian named Yuri Gagarin. It was a dangerous trip, as no one knew what the effects of space flight would be on a human.

I'm not dead, I'm a dummy.

We have lift-off!

On April 12, 1961, Yuri was strapped into the cabin of a spacecraft named *Vostok 1*. The cabin was just large enough to hold Yuri, plus the equipment he'd need.

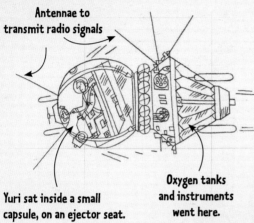

Antennae to transmit radio signals

Yuri sat inside a small capsule, on an ejector seat.

Oxygen tanks and instruments went here.

That morning, *Vostok 1* blasted off, attached to a launch rocket. Yuri cried out over his radio, "We're off!" He made it safely into space, circling Earth at a speed of 27,400 km/h (16,777 mph) on a flight that lasted 108 minutes.

Peering below him as he orbited the planet, he said, "I see Earth. It's so beautiful!"

After he zoomed back down into the atmosphere, Yuri activated his ejector seat and parachuted safely to Earth.

What if he dies?

The Russians were worried that Yuri Gagarin might die on his flight. They had several statements ready for the press – including one gloating about his success, and another announcing his death.

They also locked many of the capsule's controls, in case space made him act strangely and he pressed the wrong buttons.

Cosmo and astro

The word "astronaut" tends to be used to mean everyone who goes into space. But, technically speaking, people who go into space aren't *all* astronauts.

American space voyagers, or people who go into space on American craft, are known as astronauts. But Russian space voyagers, or people who've gone to space on Russian craft, are known as cosmonauts.

2nd place goes to...

The second person in space was an American named Alan Shepard.

On May 5, 1961, he flew up about 200km (115 miles) in the *Freedom 7* spacecraft. He didn't orbit Earth or go as far as Yuri Gagarin, but he became the first person to return to Earth inside his spaceship, splashing down into the sea.

The President's promise

The Americans were stunned at being beaten into space by the Russians, but it made them even more determined to get to the Moon first.

That same year, 1961, the American President, John F. Kennedy, made a speech promising to put a man on the Moon before the end of the decade. His promise was fulfilled with months to spare.

On July 16th 1969, a huge rocket blasted off into space, carrying a craft with three Americans on board – Michael Collins, Neil Armstrong and Edwin "Buzz" Aldrin. Their mission's name was *Apollo 11*, and the world waited eagerly to see if it would succeed.

Four days later, the *Apollo 11* team reached the Moon's orbit. Michael stayed on the command module, while Neil and Buzz flew down to the surface in a landing craft known as the *Eagle*.

This is Buzz Aldrin taking a walk on the surface of the Moon, near the *Eagle*.

Walking on another world

As Neil climbed slowly down the *Eagle*'s ladder to the surface of the Moon, he announced, "That's one small step for man, one giant leap for mankind."

Back on Earth, over 600 million people were glued to their television screens as Neil took the first, bouncing steps on the the Moon, protected from the cold and airless world by his spacesuit. Although his suit was heavy, the gravity on the Moon is weak, so he almost seemed to fly through the air.

The Americans had won a great victory and the *Apollo* astronauts went home as heroes.

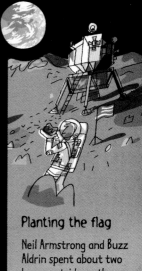

Planting the flag

Neil Armstrong and Buzz Aldrin spent about two hours outside on the surface of the Moon.

During this time, they planted an American flag, collected soil samples and took photos. These were printed in newspapers all over the world.

Friends at last

The Americans and the Russians were enemies for many years, but eventually they patched things up enough to work together in space.

In 1975, an American and a Russian spacecraft linked up. By the 1990s, cosmonauts and astronauts were living and working together in space.

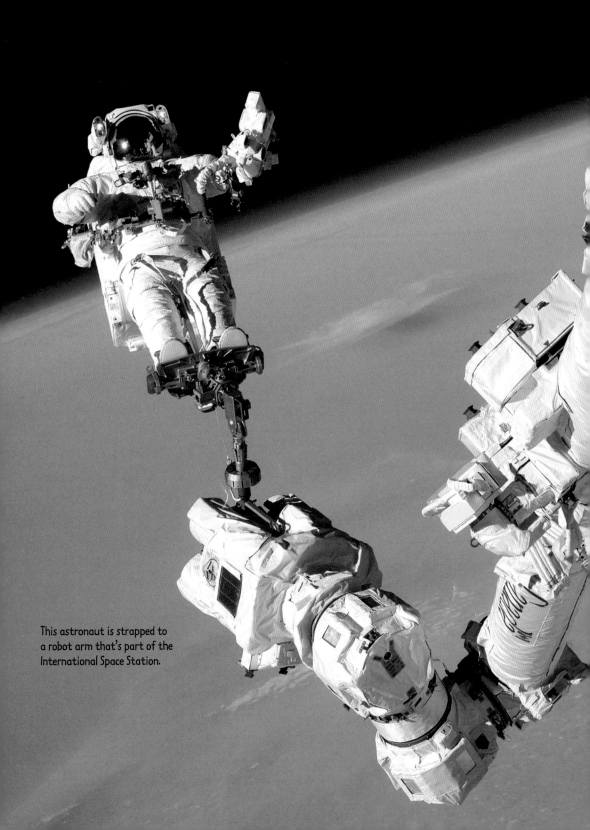

This astronaut is strapped to
a robot arm that's part of the
International Space Station.

Chapter 6

Life in space

Today, astronauts from all over the world blast off into space. Some even stay out there for months. Many modern astronauts are trained scientists who spend time in space doing experiments on space stations in constant orbit around the Earth.

What's it like to spend your working days floating around or slipping into a sealed suit and taking a walk in the airless void of space? How do you get to be an astronaut? And how do people eat, sleep and use the toilet in space?

Who goes to space now?

Astronauts from all over the globe now fly into space on Russian crafts as passengers. China has its own crafts, too.

Russian Soyuz craft

Chinese
Shenzhou craft

When Yuri Gagarin first blasted into space, he said it felt as if a heavy weight was pressing on him, like the feeling you get when a car speeds up, only much, much stronger. Technology has moved on, but the two minutes after launch are still a noisy, shaky ride.

A few minutes after a spaceship blasts into space, its rockets drop off and the ride gets smoother.

Once in orbit, astronauts experience something known as zero gravity or microgravity. This makes them feel as if they're floating, but they're actually falling. A ship in orbit is always falling in the direction of Earth, tugged by the planet's gravity. Its speed makes up for this tug, so it stays in orbit.

Some astronauts stay in space for months, on ships called space stations. There have been a few of these but the one up there now is the International Space Station (ISS). It orbits us about 16 times a day, 400 km (250 miles) up.

This is the ISS. It's sometimes visible from Earth with the naked eye, before sunrise or after sunset.

The first parts of the ISS were launched in 1998, and it was completed in 2011. It would've been impossible to build the whole thing on Earth: there aren't any rockets powerful enough to get something that big into the sky. Instead, it was put together in space.

Each new part was flown out by smaller ships, and then put together by the crew: there's been a team of astronauts – many of whom are trained scientists – who have lived, worked, eaten and slept there since 2000.

Now it's completed, flights from Earth still bring up new crew members and supplies, such as oxygen and medicine. Waste gets flown back down in small unmanned ships that burn up when they hit Earth's atmosphere.

Dextre the robot

The ISS crew get help with repair work from a two-armed robot named Dextre. The robot was added to the station by the Canadian Space Agency in March 2008.

Dextre does some of the repairs outside the station. Going outside is always risky, so Dextre makes life safer for the ISS crew.

Training to be an astronaut

Astronauts usually train for years before they go into space.

Many study science, mathematics or engineering, as well as taking special astronaut exams.

You have to be tough to live in the strange conditions of space. So astronauts have to pass lots of physical tests to prove they're up to it.

They also train in space-like conditions – for example, they use machines that make it feel as if they're in zero gravity.

How much does space travel cost?

Putting astronauts in space and keeping them there costs billions of dollars.

Sending up the NASA Space Shuttle used to cost around $450 million each time. In fact, shipping just a kilogram of water to the ISS costs about $5,000.

Still, governments spend a lot more on other things. The US government, for example, spends less than 1% of its money on NASA projects.

Daily (and nightly) life on board

Day and night don't mean much on board the ISS. The station circles Earth every 90 minutes, so the crew members experience 15 dawns every 24 hours.

They do try to keep to normal sleep patterns, but they don't sleep in beds. There are a few little cabins, but the astronauts can sleep almost anywhere as long as they attach their sleeping bag so they don't float around, bumping into things.

You can breathe normally on the ISS, as the station has its own air supply. But in space your body doesn't behave as it does in normal gravity. For example, when you're getting dressed, you might find that your arm is floating above your head instead of going into your sleeve.

Meals are tricky, too. Drinks and soups have to be sucked from plastic bags, through straws. The sauce on solid food has to be very sticky so it doesn't escape and the food itself can't be too crumbly. If crumbs floated away, it would be impossible to clean them up.

Working on the ISS

Much of the day is spent doing scientific experiments. The crew does tests to see how being in space affects objects, plants and people. Because they're working in zero gravity, they have to use restraints to stop themselves or their equipment from floating away.

Their experiments teach scientists more about how the human body works in space, and might help humans make longer space voyages in the future.

A drafty toilet

On Earth, toilets rely on gravity to flush. If you used a normal toilet in space, the water – and everything else – would float around in the air. To avoid this yucky experience, toilets in space use a vacuum cleaner-like machine to suck everything up instead.

The urine is then recycled into drinking water. That may sound disgusting, but once purified, it's actually very clean.

Breathing on the ISS

The ISS – and other manned spaceships – have a mechanical life support system that provides the crew with air.

This also keeps the temperature steady and does other tasks that keep the crew alive and comfy, such as providing clean water.

Some of the air comes from tanks of oxygen, but some is made on board using water, since water contains oxygen.

This astronaut is using an exercise machine on the ISS.

Bodies in space

Strange things happen to your body when you spend a while in space. On Earth, gravity is always pushing down on your spine, but the lack of gravity in space means your bones get weaker, and you get taller, too.

On Earth, you use your muscles just to stay standing or sitting. But in space, astronauts need to work out on exercise machines for at least 2½ hours a day just to keep their muscles from wasting away.

A space vacation

You don't have to be an astronaut to go into space. You just have to have enough money.

A tour company will soon be taking people on trips into space. A two-hour flight will cost around $250,000 and take passengers 100 km (62 miles) above Earth.

Passengers will experience weightlessness and take in amazing views of Earth and space.

How spacesuits work

Spacesuits have lots of layers to protect astronauts from heat, cold, and the Sun's radiation. The atmosphere shields us from this on Earth.

Each spacesuit has an air supply, plus microphones and earphones for communicating with the main spacecraft.

Space walks can last hours, so astronauts have to wear special underpants to collect their urine.

Oxygen to breathe

Water to drink

Urine pouch

Thick layers for protection from heat and cold

When astronauts go on EVA, they are usually tied to their craft by a cable to keep them from floating away.

Going on a space walk

Going for a walk outside a spaceship is known as Extra Vehicular Activity, or EVA. It's a tricky task, because space is a very hostile place.

To go on an EVA, you need a spacesuit to provide you with air to breathe and protect you from the cold – or extreme heat, if the Sun's shining on you. It can go down to about -160 °C (-258 °F) in the shadows and up to about +120 °C (+248 °F) in the light. A spacesuit also needs to protect against the Sun's deadly radiation and dazzling glare. So spacesuits are designed to block radiation, with visors to protect the wearer's eyes.

Even opening the door is complicated. Space stations have "airlocks" – doors that stop air from escaping into space.

A dangerous vacuum

Space is a vacuum – a place where there's no air. This is dangerous, and not just because you can't breathe there. On Earth, or in a spacecraft, the air presses on you. This is known as air pressure. But there isn't any in space. Even in a spacesuit, the pressure's quite low.

If you move too quickly between different pressures you can get a painful illness called "the bends" – deep sea divers get it when they come up too quickly. To avoid this, astronauts spend hours in the airlock before an EVA, where the pressure is lowered slowly, so their bodies can adjust.

Spaceships of the future

For many years NASA's fleet of Space Shuttles carried equipment and astronauts to the ISS. But in 2011 it took them out of commission. The plan is to replace them with a new type of vehicle known as *Orion*. These craft will look like older designs, such as the *Apollo 11* ships, but they'll be roomier and far more hi-tech. *Orion* craft won't be ready until 2020. So, in the meantime, NASA astronauts are having to hitch rides on Russian spacecraft to reach the ISS.

NASA has big plans for *Orion*. One day, they hope to send these ships to Mars. But there are still a lot of difficulties to be ironed out before people can travel to another planet. One of the main problems is the length of the trip. People who stay in space for over 100 days come back in a terrible state, with weak bones and muscles. The trip to Mars would take over 250 days. Research being done on the ISS may help to find a solution to this problem.

Burning up

Coming back into Earth's atmosphere is known as re-entry. During this, the air around a spaceship gets very hot. Any ship that's not heat-resistant enough could burn up.

In 2003, a Space Shuttle named *Columbia* broke apart after the heat-resistant tiles on the outside were damaged. The seven people on board were killed.

Bases on the Moon

No one has built a base on the Moon (or an alien planet) yet. But NASA has plans to start building a base on the Moon where scientists could live and work by in the future.

Ships could stop off there on their way to other planets, too.

These dishes — at the New Mexico site of the National Radio Astronomy Observatory — are known as the Very Large Array. They're used to pick up invisible light that some stars give off.

Chapter 7

Telescopes and other technology

Modern space technology can do some amazing things. There's a flying telescope in orbit around the planet right now, which sends back photos of distant corners of the Universe. Farther away, robots are flying to other planets to do experiments that will teach us more about alien worlds. Meanwhile, on Earth, astronomers are using powerful telescopes to learn more and more about the Universe.

The Hubble Space telescope is powered by energy from the Sun. When sunlight hits its shiny solar panels, the heat and light are turned into electricity.

When Hubble is in Earth's shadow, the telescope runs on batteries. These are recharged when Hubble's in sunlight.

Does Hubble ever point at Earth?

In theory, the Hubble Space Telescope could be turned to look at Earth, but it's unlikely that it will be.

For a start, astronomers are obviously more interested in the stars.

But even if they wanted to point Hubble at Earth, it's too risky. Hubble's instruments are very sensitive. Earth reflects a lot of light from the Sun, so Hubble might be damaged by its glare.

There's a telescope the size of a school bus flying in orbit beyond the ISS. It's called the Hubble Space Telescope. There are actually a few telescopes out in space, but Hubble is the most famous, thanks to the spectacular pictures that it takes.

Scientists control it from Earth, sending messages to its on-board computer, telling it where to point. Hubble's cameras send back images as information, which scientists then turn into pictures.

How does Hubble work?

Like many telescopes on Earth, Hubble uses mirrors to gather light. Usually, the larger the mirror, the clearer your view of space. But Hubble's mirror, which is about 2.4m (8ft) across, isn't as large as the ones in some Earth telescopes: it doesn't need to be.

Earth telescopes have to peer through the atmosphere to look into space. As the light from stars moves through the air, it jiggles around, which is why stars twinkle. This twinkling blurs the images seen through Earth telescopes. But, in space, there's no atmosphere, so Hubble gets an unspoiled view.

What can Hubble do?

Hubble shows us views of the Universe that were never possible before – from images of stars surrounded by dust that might someday turn into another solar system, to pictures of galaxies colliding. It can take photographs of objects that are 50 times fainter than anything visible from Earth.

In fact, Hubble can see some of the most distant known objects in the Universe, about 13 billion light years away. That means some of the light that Hubble picks up is almost as old as the Universe itself.

New discoveries

In 2006, Hubble discovered 16 new planets orbiting distant stars in our Galaxy. It did this by peering at 180,000 stars in a crowded part of the Galaxy, using its "Advanced Camera for Surveys" – ACS for short.

The planets were too far away to view directly, so astronomers used the ACS to measure the slight dimming that happens to a star when a planet passes in front of it.

This image, captured by one of Hubble's cameras, shows the remains of a dead star, 10,000 light years from Earth.

What's a black hole?

A black hole is a space object that has a lot of matter in an incredibly small space. Its powerful gravity sucks in everything nearby, even light.

You can't see black holes themselves. But scientists can locate them by the way their gravity pulls on nearby space dust and stars.

Seeing invisible things

Hubble has a "spectrograph" on board – a gadget used to study light. This has given astronomers vital clues about some of the Universe's strangest objects – from things called black holes, to invisible "dark" energy and matter. These things can't be seen, but Hubble has helped scientists study how they affect nearby objects.

Robot explorers

Robonaut

NASA has built a robot astronaut, called Robonaut, that can use screwdrivers and do many of the tasks that human astronauts normally do. It's currently being tested on the ISS

It's too dangerous and expensive to send humans to other planets just yet. In the meantime, remote-controlled machines fly to other planets and moons to beam back photos and other information.

Some of these orbit or fly past planets as far away as Neptune. Others have actually landed on other worlds – on Venus, Titan (one of Saturn's moons) and Mars. Mars is the most-visited planet in the Solar System, with six ships making successful landings.

In 2004, two identical robots, named *Spirit* and *Opportunity*, arrived on Mars. These little wheeled "rover" robots left their landing craft and trundled onto the planet's surface. Using photos taken by the rovers to guide them, scientists back on Earth steered the robots around slowly and safely, investigating rocks and sifting through soil.

The rovers have sent back stunning images of Martian sunsets, whirling dust storms and Earth shining in the planet's sky.

This is an artist's impression of the *Spirit* rover on Mars. Scientists hoped the rovers would last three months after landing. But *Spirit* kept going for six years, and *Opportunity* is still driving around. They were joined by the more advanced rover, *Curiosity*, in 2012.

The great alien hunt

No human has ever set foot on an alien planet. But have aliens visited ours? Most scientists think not, although intelligent life might exist on distant planets. Maybe they're wondering if we exist too?

In the 1960s, scientists started sending out signals into space – from pieces of music to mathematical equations – hoping that aliens would pick them up and get in touch.

Probes have also been sent out carrying information, such as pictures of humans and star charts showing how to get to our planet.

There's an organization that hunts for alien life called the Search for Extra-Terrestrial Intelligence (SETI). It studies information from telescopes and other space-scanning devices that might be able to pick up messages from aliens.

Alien abductions?

Many people believe they've seen aliens, or even been abducted by them.

Some say they've been taken to laboratories where the aliens experimented on them. But it's possible that these were hallucinations – the human mind can play powerful tricks sometimes.

Spying from space

Even if there aren't any aliens, space is still very busy. There are thousands of man-made, computer-controlled satellites circling the planet.

Every day, signals are beamed from Earth and bounced off communications and broadcast satellites, back down to another part of the planet. This transmits television signals and other information, such as telephone calls, all over the world.

Weather satellites and other scientific satellites study our planet and space. Mysterious spy satellites orbit the planet to observe enemy movements, photograph military bases and give early warnings of missile launches, among other top secret tasks.

Junk in orbit

Not all man-made satellites do useful jobs. Lots of floating pieces of space junk have also been pulled into orbit.

These include nuts and bolts that astronauts have dropped while repairing space ships, old batteries and parts of rockets that were used to launch crafts into orbit.

This junk could be a danger to spaceships, as it whizzes through space.

Space spin-offs

All these inventions are based on technology that was first developed for space travel:

- Pens that write upside-down
- Satellite navigation for cars
- Flat screen televisions
- Voice-activated wheelchairs
- Shock absorbing running shoes
- Invisible teeth braces
- Sleep suits for babies that warn their parents if they stop breathing
- Non-stick frying pans

Astronomy on Earth

Many of the telescopes that professional astronomers use are basically huge cameras, and the pictures they take are viewed on computer screens. Other telescopes gather information which is then displayed as a chart or a graph. So, many professional astronomers spend a lot of time studying wiggly lines on monitors rather than observing the skies directly.

Amateurs tend to stargaze the traditional way, peering up through telescopes, although some do hook their telescopes up to cameras or computers.

High up telescopes

The largest telescopes on Earth can cost millions and millions and can see billions of light years into space. They're usually housed in observatories, high up on mountains and away from the glare of city lights. Observatories are stocked with computers and other instruments as well as huge telescopes.

The Keck Observatory is 4km (2.5 miles) up a mountain in Hawaii. It houses the world's largest reflector telescopes.

Making pictures with light

The reason we can see stars in the sky is because they give off light. The telescopes that gather this light are known as optical telescopes, and there are three main types: refractors, reflectors and compound telescopes.

Refractors use lenses to gather and focus light, while reflectors use mirrors instead. Compound telescopes use a combination of mirrors and lenses.

Each type of telescope has its own advantages. For example, if you compare a refractor and a reflector of the same size, the refractor would usually be better for giving a clear image of bright objects such as planets. The reflector would (usually) be better for viewing fainter things such as nebulae.

Signals from the stars

Some professional astronomers use huge, dish-shaped "radio" telescopes, which pick up an invisible kind of light known as radio waves. As the name suggests, radio waves are what make radios work, but they also occur naturally.

Many objects in space, such as stars and galaxies, give off radio waves and other invisible types of light. By studying these, astronomers can learn more about the objects that give them off. Astronomers also turn radio waves into images using computers, so we can see parts of space that would be otherwise invisible.

A refractor telescope

Telescope tip

If you want to buy your own telescope, you can find out more about the different kinds on the Usborne Quicklinks Website – see the start of the book for more details.

One important thing to bear in mind is that the usefulness of a telescope depends on the size of its mirror or lens. Larger ones gather more light, so you can see the stars more clearly.

This is what the Sun and the Earth will probably look like in about five billion years' time. The Earth will be dry and dead and the Sun will be huge.

Chapter 8

The story of the Universe

Billions of years ago, at the beginning of the
Universe, there was nothing. Not the everyday
kind of nothing that you'd find in an empty box,
because an empty box still takes up space. At the
start of everything, there wasn't even any space.

How did we get from nothingness to a Universe
full of shining stars and spinning planets? And
what will happen to our Universe as it gets older?

Science fiction movies are full of scary ways
for the world to end, from alien invasions to
disgusting plagues, but what will really happen?
Will we be bashed out of the sky by an asteroid?
Will the whole Universe be destroyed one day?
One thing is almost certain – our precious, wet
little planet will some day come to an end.

Once upon a time...

...there was nothing at all. No Earth, no Sun, no light or dark. Nothing whatsoever – a hard thing to imagine, when you're used to today's busy, jam-packed Universe.

But one day, about 13.7 billion years ago, a tiny speck popped into existence. It was thousands of times smaller than the head of a pin, and hotter and denser than anything that has ever been since.

This speck contained all the stuff that has ever existed in the Universe. It exploded out in all directions so quickly that, within a second, it was already bigger than a galaxy.

The Universe explodes

Scientists call this strange, sudden beginning the Big Bang. The name makes it sound noisy, but actually it would have been silent. Things were expanding so quickly that sound simply couldn't have kept up – even if there had been any air to carry the sound.

In its first moments, the Universe became a blisteringly hot fireball. As this ball spread out, it cooled down and separated out into lumps of matter.

After this speedy start, it took another billion years or so before these lumps joined together to make the first stars. Our own Sun started to form about 5 billion years ago.

It's thought that the Sun and our entire Solar System is made up of dust and gas that came from an exploding supernova star. So the Sun, Earth, and everything on it is made of stardust – even you.

Space timeline

This is (roughly) how the Universe's life story has gone so far.

13.7 billion years ago the Universe begins.

12 billion years ago the first galaxies begin to form.

5 billion years ago our Sun is born. Earth forms over the next billion years.

600 thousand years ago the first humans appear. If the history of space were a 90 minute soccer match, humans would've been playing for a quarter of a second.

A ridiculous idea

An astronomer named Fred Hoyle gave the Big Bang theory its name.

He actually thought it was a load of nonsense but when he called it a "Big Bang" in a radio interview, the name stuck.

How do we know what happened?

The simple answer is we don't. Most scientists now agree that the Big Bang *did* happen, but there's still a lot we don't know about how the Universe began.

The Big Bang idea developed in the 1940s, after Hubble realized that the Universe was expanding. If it's getting bigger, scientists reasoned, it must've been smaller before. So perhaps it once wasn't there at all?

To learn more about the Big Bang, scientists at one of the world's largest laboratories have built a massive machine called the Large Hadron Collider or LHC. This is designed to recreate the conditions that would have existed just after the Big Bang.

Before this machine was turned on in August 2008, lots of newspaper headlines claimed that it might create a black hole and end the world. (It didn't.)

What shape is the Universe?

The Universe's shape remains a mystery. Some scientists believe it's round like a ball.

Others say it's more like a ring or a tube. Some scientists claim there is a "multiverse", made up of many universes – each one slightly different.

This machine is called the Large Hadron Collider or LHC, is at the CERN laboratory on the border of France and Switzerland..

Ways that we could be wiped out before the Sun kills us

- A massive comet or asteroid could crash into us.
- The Moon could be struck by a comet or asteroid, raining debris on our planet.
- Humans might kill themselves by polluting Earth, creating a killer virus, or starting a nuclear war.
- A flash of radiation far away in space, known as a gamma ray burst, could destroy the atmosphere and kill anything that lives on land.

Shh, don't mention the end of the world

It's not going to happen for millions of years but people can still be touchy about it.

Once, when famous scientist Stephen Hawking was giving a lecture, he was asked not to mention the end of the world in case it made people panic.

The end isn't very nigh

One day, all this will be gone: the book in your hands, the planet under your feet, not to mention your feet themselves. One day, the Sun will die and all life on Earth will be wiped out. Worried?

You shouldn't be, because Earth will be sticking around for a long while yet. By the time the Sun dies, your great, great, great, great, great, great (and many greats after that) grandchildren will be dead.

A scary old giant

Scientists think the Sun will die in about five billion years. But, before it reaches the end of its life, the Sun will start to get bigger and turn into a red giant. It may become 200 times bigger than it is now.

As it swells to a monstrous size, Mercury and Venus will be swallowed up. On our planet, the temperature will shoot up and all the water in the oceans will sizzle away – which will mean bye bye life on Earth.

Scientists aren't sure whether Earth will be swallowed too. If its orbit gets bigger, it might not, and it's the Sun that might help it make its escape.

As the Sun swells, it will lose some of its mass. This may sound odd. Why would its mass get smaller if it's getting bigger?

It's because the Sun will throw its outer layers of gas into space as it gets cooler. So, although the Sun will take up more room, there will be less matter in it. As its mass gets smaller, the tug of its gravity will get weaker, too. Then, Earth might be able to escape into a larger orbit and avoid becoming a snack for a hungry red giant.

Living on other worlds

If humans survive long enough, we'll need to find a new home before Earth is barbecued. We could build vast space stations, big enough to grow crops, or move to a planet that's farther from the Sun. Or we could find a planet in orbit around another star.

It's unlikely that we'll find a world with *exactly* the same conditions as Earth. But we could artificially alter its atmosphere and climate (known as "terraforming") or build sealed cities, where air could be made using gases in the planet's atmosphere.

Pricey planets

We don't have the technology yet to live on other planets or to build space stations that would support life forever.

This is partly because it's too expensive. But if Earth was ever threatened by disaster, governments would be sure to spend whatever it took to make a home in space for at least some of the human race.

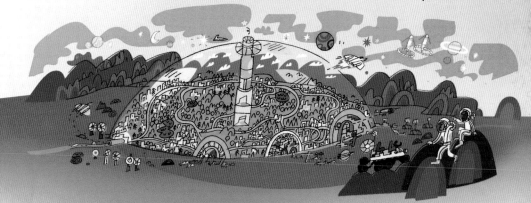

In the future, we could build domed cities like this one on other planets or moons.

Will the Universe ever end?

No one can be sure what'll happen when the Universe gets very old. Some scientists think it might collapse, getting smaller until it's squished out of existence in a "Big Crunch" – the opposite of the Big Bang.

But it's most likely that the galaxies will keep on rushing apart until you can't see one galaxy from another. Our Galaxy could become a lonely island of stars in a sea of darkness.

Bangs and crunches

Some scientists suggest that the Universe doesn't just have a beginning and an end, but a series of Big Bangs and Big Crunches. We could be living in the first Universe in this cycle... or the millionth.

Astronomy timeline

These pages show when some of the important events in the history of astronomy took place. The earlier dates that don't give an exact year are estimates.

13.7 billion years ago
The Big Bang

12 billion years ago
The first galaxies appear.

5 billion years ago
The Sun is born.

4 billion years ago
The Earth is born.

600,000 years ago
Humans first appear on the earth.

5,000 years ago
Construction of Stonehenge begins.

5,000 years ago
Written astronomical records made in Sumer.

5,000 years ago
Egyptians use astronomy to predict floods.

3,250 years ago
Ancient kingdom of Babylon becomes hotbed of astronomical activity.

2,500 years ago
Greek astronomers make big leaps forward.

A little under 2000 years ago
Ptolemy develops his theories about the Universe.

From about the year 800
Islamic astronomers build on Greek discoveries.

1543
Copernicus's theory that the Earth goes round the Sun is published.

1608
The telescope is invented.

1609
Galileo makes improvements on the telescope.

1633
Galileo is put on trial.

1660s
Isaac Newton discovers gravity.

1675 — London's Royal Observatory is founded.

1781 — William Herschel discovers Uranus.

1845 — William Parsons builds largest telescope to date.

1916 — Albert Einstein publishes new theory of gravity.

1920s — Edwin Hubble discovers galaxies are moving apart.

1930 — Pluto is discovered.

1937 — The radio telescope is invented.

1940s — Big Bang theory is developed.

1957 — *Sputnik 1* is launched into space.

1960s — Space Race is in full swing.

1969 — The first man on the Moon.

1970 — Near-fatal *Apollo 13* mission.

1975 — Russian probes land on Venus.

1976 — The US *Viking* probes land on Mars.

Today — Thousands of satellites orbit the Earth and astronauts are living on the ISS.

1981 — The first Space Shuttle *Columbia* is launched.

1986 — Soviet Union launches space station *Mir*.

1986 — Space Shuttle *Challenger* disaster.

1990 — The Hubble Space Telescope is launched.

1998 — Construction of the International Space Station (ISS) begins.

2003 — NASA *Columbia* disaster.

2006 — Pluto is demoted from planet to dwarf planet.

2008 — *Phoenix* probe finds frozen water on Mars.

2008 — The LHC is switched on at CERN.

Star charts

It can take a lot of time and patience to spot constellations. But it's a lot easier if you use star charts. The charts on the next few pages tell you where all the constellations and stars are at different times of the year, and in different hemispheres.

Northern hemisphere

Looking north

March
April
May

Looking south

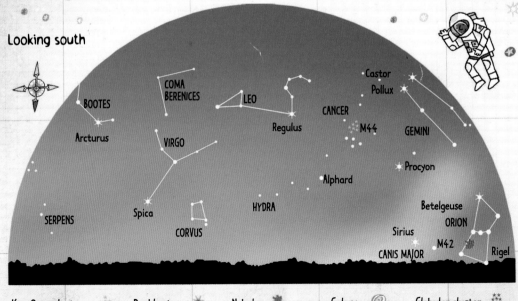

Key: Open cluster (a group of young stars) Double star (two stars together) Nebula (a cloud of gas and dust) Galaxy (a huge group of stars) Globular cluster (a group of old stars)

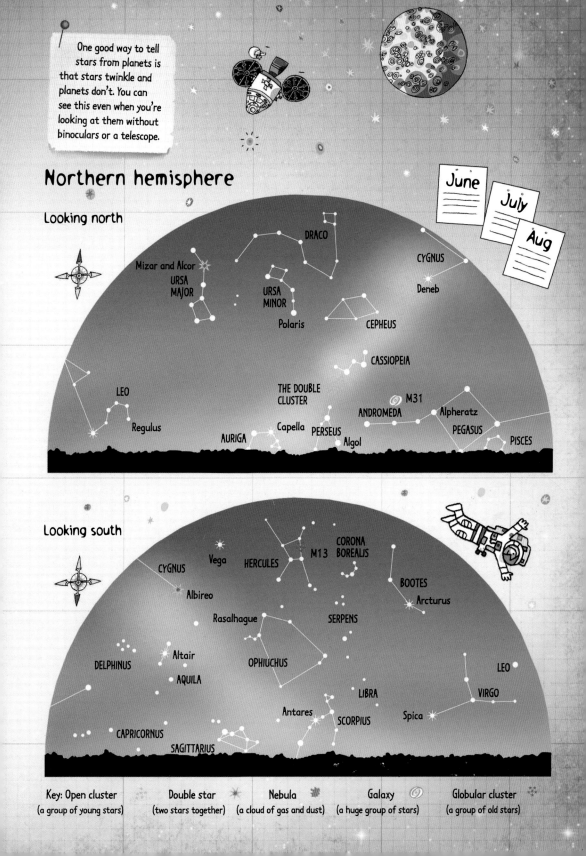

One good way to tell stars from planets is that stars twinkle and planets don't. You can see this even when you're looking at them without binoculars or a telescope.

Northern hemisphere

June
July
Aug

Looking north

DRACO

Mizar and Alcor
URSA MAJOR
URSA MINOR
Polaris

CYGNUS
Deneb

CEPHEUS

CASSIOPEIA

LEO
Regulus

THE DOUBLE CLUSTER

M31
ANDROMEDA
Alpheratz
PEGASUS
PISCES

AURIGA
Capella
PERSEUS
Algol

Looking south

CYGNUS
Vega
HERCULES
M13
CORONA BOREALIS

BOOTES
Arcturus

Albireo

Rasalhague
SERPENS

DELPHINUS
Altair
AQUILA
OPHIUCHUS

LEO
VIRGO

LIBRA
Spica

Antares
SCORPIUS

CAPRICORNUS
SAGITTARIUS

Key: Open cluster
(a group of young stars) Double star
(two stars together) Nebula
(a cloud of gas and dust) Galaxy
(a huge group of stars) Globular cluster
(a group of old stars)

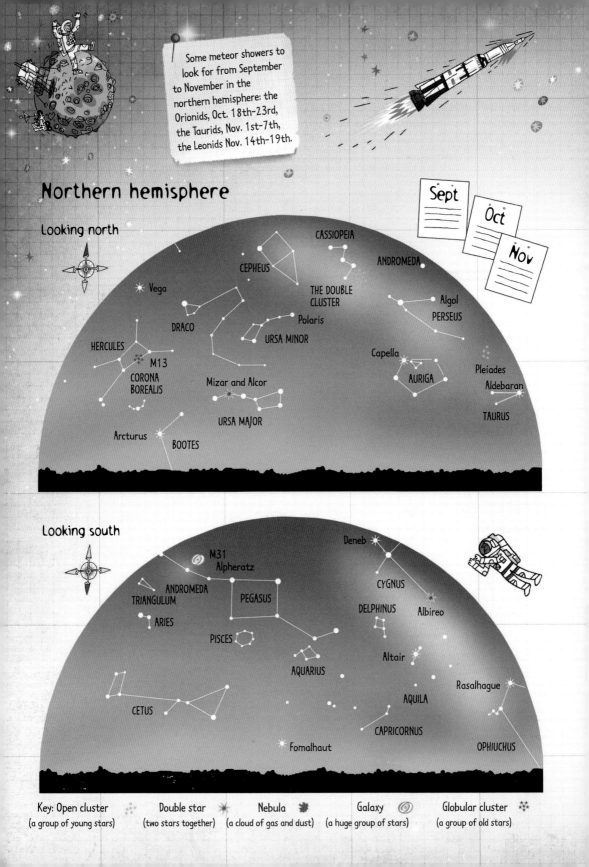

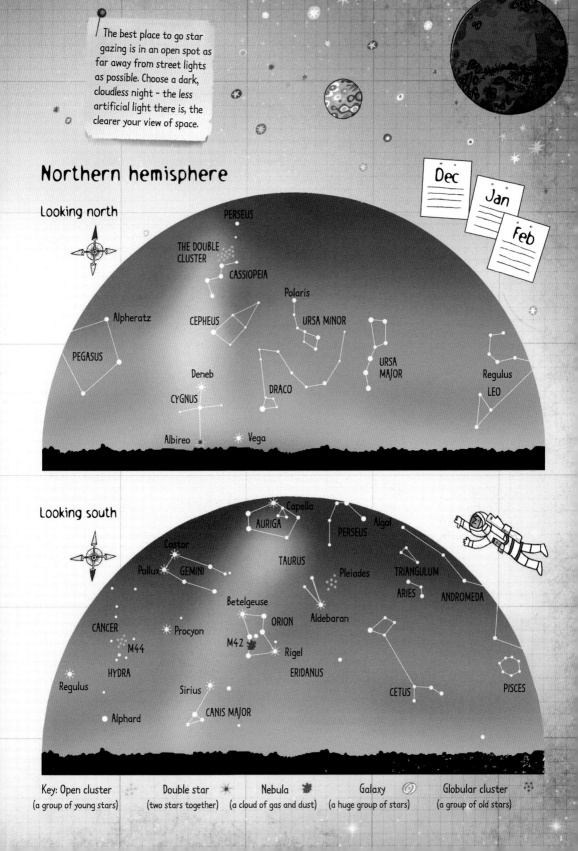

The best place to go star gazing is in an open spot as far away from street lights as possible. Choose a dark, cloudless night – the less artificial light there is, the clearer your view of space.

Northern hemisphere

Looking north

Dec
Jan
Feb

PERSEUS
THE DOUBLE CLUSTER
CASSIOPEIA
Polaris
Alpheratz
CEPHEUS
URSA MINOR
PEGASUS
Deneb
DRACO
URSA MAJOR
CYGNUS
Regulus
LEO
Albireo
Vega

Looking south

Capella
AURIGA
Castor
PERSEUS
Algol
Pollux
GEMINI
TAURUS
TRIANGULUM
Pleiades
ARIES
ANDROMEDA
Betelgeuse
ORION
Aldebaran
CANCER
Procyon
M42
Rigel
HYDRA
M44
ERIDANUS
Regulus
Sirius
CETUS
PISCES
Alphard
CANIS MAJOR

Key: Open cluster (a group of young stars) Double star (two stars together) Nebula (a cloud of gas and dust) Galaxy (a huge group of stars) Globular cluster (a group of old stars)

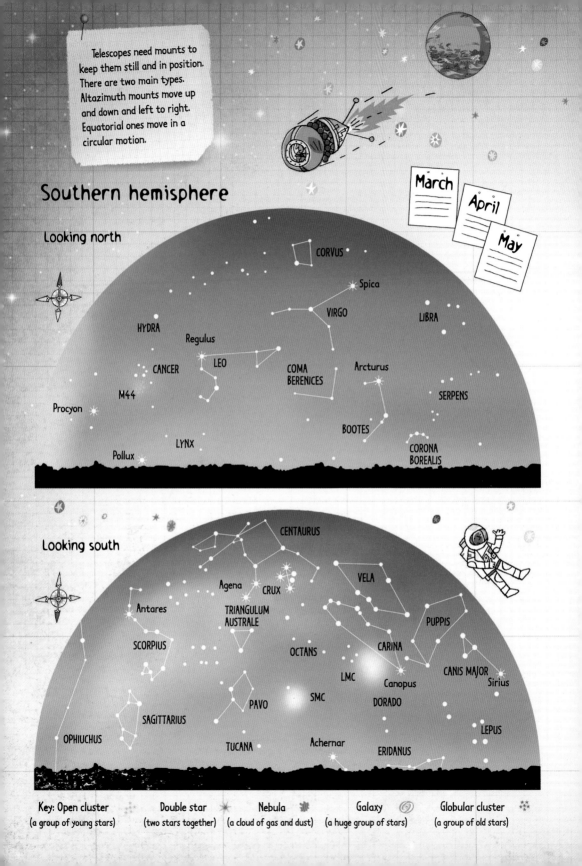

Telescopes need mounts to keep them still and in position. There are two main types. Altazimuth mounts move up and down and left to right. Equatorial ones move in a circular motion.

March
April
May

Southern hemisphere

Looking north

CORVUS
Spica
VIRGO
LIBRA
HYDRA
Regulus
CANCER
LEO
COMA BERENICES
Arcturus
SERPENS
M44
Procyon
BOOTES
LYNX
CORONA BOREALIS
Pollux

Looking south

CENTAURUS
Agena
CRUX
VELA
Antares
TRIANGULUM AUSTRALE
PUPPIS
SCORPIUS
OCTANS
CARINA
CANIS MAJOR
LMC
Canopus
Sirius
SMC
DORADO
PAVO
SAGITTARIUS
TUCANA
Achernar
LEPUS
OPHIUCHUS
ERIDANUS

Key: Open cluster (a group of young stars) Double star (two stars together) Nebula (a cloud of gas and dust) Galaxy (a huge group of stars) Globular cluster (a group of old stars)

If you're using a telescope, start off with an eyepiece with low magnification. You'll be able to see a wide section of the sky, which makes it easier to find things.

June

July

Aug

Southern hemisphere

Looking north

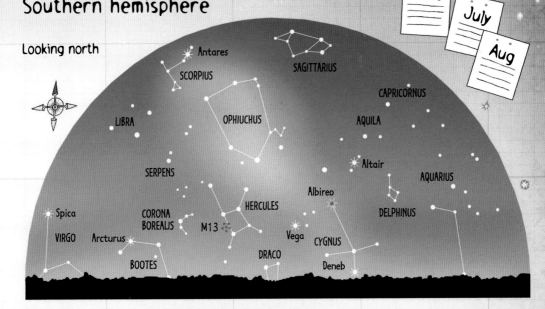

Antares
SCORPIUS
SAGITTARIUS
CAPRICORNUS
LIBRA
OPHIUCHUS
AQUILA
SERPENS
Altair
AQUARIUS
Albireo
Spica
HERCULES
DELPHINUS
CORONA
BOREALIS
M13
Vega
VIRGO
Arcturus
CYGNUS
BOOTES
DRACO
Deneb

Looking south

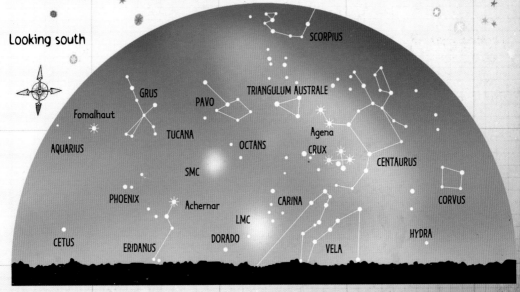

SCORPIUS
GRUS
TRIANGULUM AUSTRALE
PAVO
Fomalhaut
AQUARIUS
TUCANA
Agena
OCTANS
CRUX
SMC
CENTAURUS
PHOENIX
CARINA
CORVUS
Achernar
CETUS
LMC
DORADO
HYDRA
ERIDANUS
VELA

Key: Open cluster
(a group of young stars) Double star
(two stars together) Nebula
(a cloud of gas and dust) Galaxy
(a huge group of stars) Globular cluster
(a group of old stars)

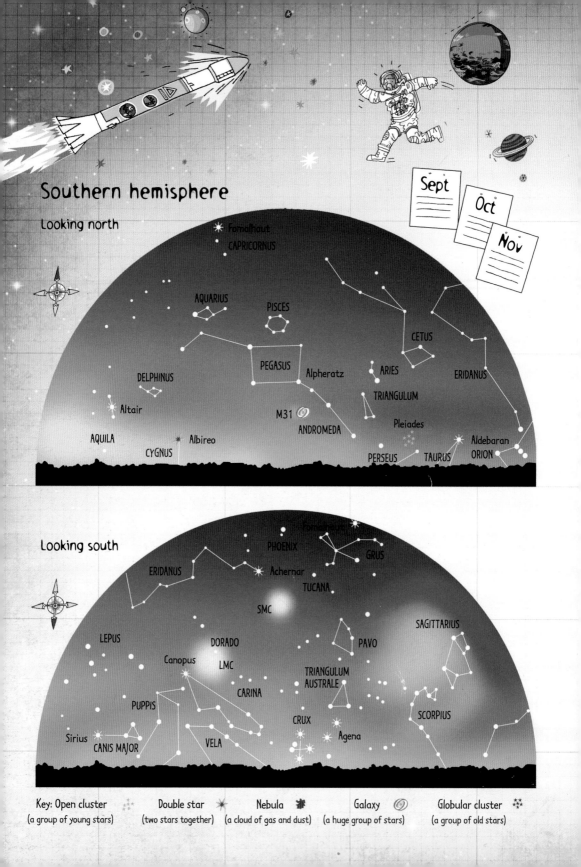

Southern hemisphere

Looking north

Sept
Oct
Nov

Fomalhaut
CAPRICORNUS
AQUARIUS
PISCES
CETUS
PEGASUS
Alpheratz
ARIES
ERIDANUS
TRIANGULUM
DELPHINUS
M31
Pleiades
Altair
ANDROMEDA
Aldebaran
AQUILA
Albireo
PERSEUS
TAURUS
ORION
CYGNUS

Looking south

PHOENIX
Fomalhaut
GRUS
ERIDANUS
Achernar
TUCANA
SMC
SAGITTARIUS
LEPUS
DORADO
PAVO
Canopus
LMC
TRIANGULUM
AUSTRALE
CARINA
PUPPIS
SCORPIUS
CRUX
Sirius
Agena
CANIS MAJOR
VELA

Key: **Open cluster** (a group of young stars) **Double star** (two stars together) **Nebula** (a cloud of gas and dust) **Galaxy** (a huge group of stars) **Globular cluster** (a group of old stars)

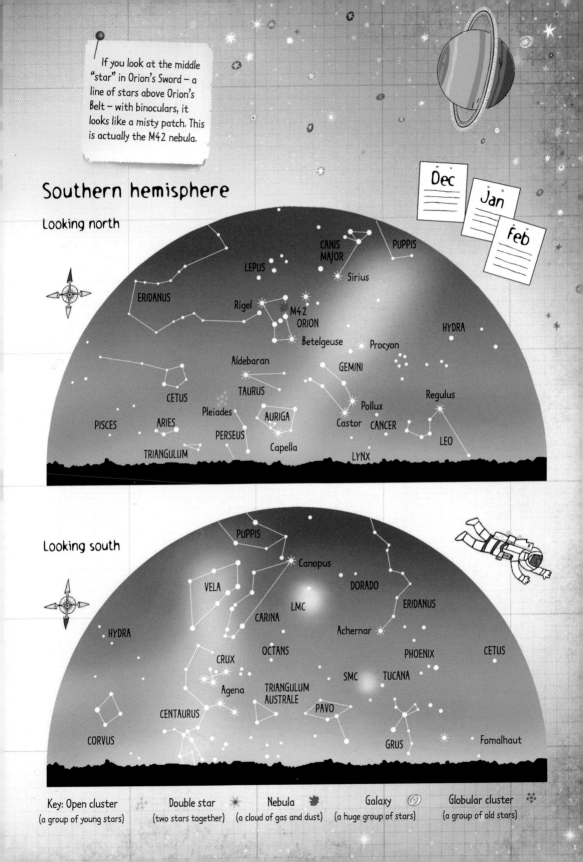

If you look at the middle "star" in Orion's Sword – a line of stars above Orion's Belt – with binoculars, it looks like a misty patch. This is actually the M42 nebula.

Dec
Jan
Feb

Southern hemisphere

Looking north

CANIS MAJOR
PUPPIS
LEPUS
Sirius
ERIDANUS
Rigel
M42
ORION
Betelgeuse
HYDRA
Procyon
GEMINI
Aldebaran
TAURUS
Pollux
Regulus
CETUS
AURIGA
Castor
CANCER
PISCES
ARIES
Pleiades
LEO
PERSEUS
Capella
TRIANGULUM
LYNX

Looking south

PUPPIS
Canopus
VELA
DORADO
LMC
ERIDANUS
CARINA
Achernar
HYDRA
OCTANS
PHOENIX
CETUS
CRUX
SMC
TUCANA
Agena
TRIANGULUM
AUSTRALE
CENTAURUS
PAVO
CORVUS
GRUS
Fomalhaut

Key: Open cluster (a group of young stars) Double star (two stars together) Nebula (a cloud of gas and dust) Galaxy (a huge group of stars) Globular cluster (a group of old stars)

Glossary

In this glossary, you can find explanations for some of the words you'll come across in this book. The words in *italic type* have their own entry elsewhere in the glossary.

ASTEROID A lump of rock or metal (or a mix of both) orbiting the *Sun*.

ASTEROID BELT Area beyond *Mars* where there are lots of *asteroids* and some *dwarf planets*.

ASTROLOGY Group of beliefs according to which the relative positions of *stars* and *planets* are used to predict what will happen to people born at certain times of the year. Someone who does astrology is known as an astrologer.

ASTRONAUT The name for an American or European person who goes into space.

ASTRONOMER A scientist who studies space, *planets*, *stars* and other objects found in space.

ATMOSPHERE The layers of gases surrounding a large object in space, such as a *planet*.

BIG BANG The theory that says the *Universe* had a sudden, violent beginning.

BIG CRUNCH The theory that one day the *Universe* will collapse in on itself.

BLACK HOLE Objects in space that have such a strong gravitational pull that they drag in everything around them. Not even light can escape, which is why they are black.

COMET A bundle of ice, dust and rock that has a gassy "tail" and is in *orbit* around our *Sun* or another sun.

COMPOUND TELESCOPE An *optical telescope* that uses both mirrors and lenses to gather and focus light.

CONSTELLATION A group of *stars* that appears to us to form a pattern in the sky.

COSMONAUT The name for a Russian person who goes into space.

DIAMETER The distance across the middle of a circle or through the middle of a sphere.

DWARF PLANET An object in *orbit* around a star that's too small to be considered a *planet*, but is larger than an *asteroid*.

EARTH Our home *planet*. It's the third planet out from the *Sun*.

ECLIPSE The partial or total disappearance of an object in space when another object passes between it and the viewer. An eclipse of the *Sun* is known as a *solar* eclipse. An eclipse of the *Moon* is a *lunar* eclipse.

EXOPLANET A *planet* orbiting another *star* beyond our *Solar System*.

EXTRA VEHICULAR ACTIVITY (EVA) The technical term for going outside a spacecraft.

EXTRA TERRESTRIAL Life form from somewhere other than *Earth*.

GALAXY A vast collection of *stars*.

GAS GIANT A large *planet* that's mainly made up of gas and liquid, rather than rock. In our *Solar System*, the gas giants are *Jupiter*, *Saturn*, *Uranus* and *Neptune*.

GEOCENTRIC Geocentric theories said that the *Sun* and *planets* *orbit* the *Earth*.

GRAVITY A force that tries to pull two objects together. The more *matter* an object has the stronger its pull.

HELIOCENTRIC Heliocentric theories say that the *Earth* and other *planets* *orbit* the *Sun*.

INNER PLANETS The four rocky *planets*, *Mercury*, *Venus*, *Earth* and *Mars*, whose *orbits* are smaller than those of the *gas giants*.

JUPITER The fifth *planet* out from the *Sun*.

KUIPER BELT An area of the *Solar System* beyond the *planets*, containing rocky objects and some *dwarf planets*, including *Pluto*.

LIGHT YEAR The distance that light travels in a year – about 9.5 trillion km or 5.9 trillion miles.

LUNAR To do with our *Moon*.

MARS The fourth *planet* out from the *Sun*.

MASS The amount of *matter* that an object is made of. Weight is calculated as mass times the gravitational pull of wherever you are.

MATTER A scientific word for the stuff that everything in the *Universe* is made of.

MERCURY The closest *planet* to the *Sun*.

METEOR A *meteoroid* that burns up as it reaches the *atmosphere*.

METEORITE A *meteoroid* that has landed on the *Earth's* surface.

METEOROID A piece of dust or rock in space.

MOON A natural *satellite* that orbits a *planet* or other large object in space. Our Moon is written with a capital M.

NATIONAL AERONAUTICS AND SPACE ADMINISTRATION (NASA) The part of the US government that's responsible for space travel.

NEBULA A swirling cloud of gas and dust where *stars* are born.

NEPTUNE The eighth *planet* out from the *Sun*.

OORT CLOUD A cloud of *comets* that's believed to exist at the edge of the *Solar System*.

OPTICAL TELESCOPE A *telescope* that uses lenses or mirrors to gather and focus light.

ORBIT To circle around another object in space. The route a particular object takes around another is also known as its orbit.

PLANET A large sphere in *orbit* around a *star*, such as the *Sun*.

PLUTO Used to be the ninth *planet* from the *Sun*, now classified as a *plutoid*.

PLUTOID A type of large *dwarf planet*.

RADIO TELESCOPE A type of *telescope* used to detect radio waves – a type of light that we can't see with our own eyes.

RED GIANT A *star* that is running out of fuel and is swelling up as it cools down.

REFLECTOR TELESCOPE A type of *optical telescope* that uses mirrors to gather light.

REFRACTOR TELESCOPE A type of *optical telescope* that uses lenses to gather light.

ROCKET A vehicle that boosts spacecraft into *orbit*. Rockets can also be used as bombs.

SATELLITE An object that is in *orbit* around a *planet*, *star* or another object in space.

SATURN The sixth *planet* out from the *Sun*.

SOLAR To do with our *Sun*.

SOLAR SYSTEM Our *Sun* and the *planets* and other objects that *orbit* around it.

SPACE RACE The rivalry between the former USSR and the USA to be the first to explore space.

SPACESUIT A sealed suit with an air supply that *astronauts* and *cosmonauts* wear in space.

STAR A burning ball of gas in space.

SUN the *star* at the heart of our *Solar System*. But any star with planets circling it is a sun.

SUPERNOVA An exploding *star*. The plural of supernova is supernovae. Some supernovae are visible from Earth.

TELESCOPE A tool used by *astronomers* to study the skies.

TERRAFORMING Altering a *planet* to make it more like *Earth* so that people can live there. For example, altering its *atmosphere*.

UNIVERSE A name for everything that exists and all of space and time.

URANUS The seventh *planet* out from the *Sun*.

VACUUM A place where there's no air or other gases. Space is a vacuum.

VENUS The second *planet* out from the *Sun*.

WHITE DWARF A small, dense *star* that's near the end of its life.

ZERO GRAVITY The feeling of weightlessness that people experience when they travel in space.

Index

Acknowledgements

Every effort has been made to trace and acknowledge ownership of copyright. If any rights have been omitted, the publishers offer to rectify this in any future editions following notification. The publishers are grateful to the following individuals and organizations for their permission to reproduce material on the following pages: (t=top, b=bottom, l=left, r=right)

p1 NASA, ESA and The Hubble Heritage Team (STScI/AURA); p2-3 NASA, ESA, N. Smith (U. California, Berkeley) et al., and The Hubble Heritage Team (STScI/AURA); p6-7 © Amana Images inc./Alamy; p8 (t) © Simon Stirrup/Alamy; p11 © Dennis di Cicco/Corbis; p13 (b) International Space Station, STS 127, and Earth, crew 27: NASA; p15 (b) NASA, ESA, and the Hubble Heritage Team (STScI/AURA), Acknowledgment: W. Blair (Johns Hopkins University); p18-19 © Joshua Strang/US Airforce/ZUMA/Corbis; p20 (t) Detlev Van Ravenswaay/SPL; p21 (b) © David Cortner/Galaxy Picture Library; p24 (b) © Gallo Images/Alamy; p26 (b) Francesco Reginato/Stone/Getty Images; p27 (br) Thierry Legault/ Eurelios/SPL; p29 (t) NASA/ESA/STScI/The Hubble Heritage Team/SPL; p30 (b) Debra Meloy Elmegreen (Vassar College) et al. & The Hubble Heritage Team (AURA/STScI/NASA); p31 (t) © Jon Christensen; p32 NASA/ESA/STScI/The Hubble Heritage Team/SPL; p36 (t) NASA/Johns Hopkins University Applied Physics Laboratory/Carnegie Institution of Washington; p37 NASA/JHU Applied Physics Lab/Carnegie Inst. Washington ; p39 Apollo 8/NASA; p40-41 NASA/JPL-Caltech/Cornell/SPL; p42 NASA/SPL; p43 NASA/ESA/STScI/J.Clarke, Boston U./SPL; p44 (t) NASA/ESA/STScI E.Karkoschka, U.Arizona/SPL; p45 (b) NASA/SPL; p46 NASA, ESA, H. Weaver (JHU/APL), A. Stern (SwRI), and the HST Pluto Companion Search Team; p47 NASA; p48 © 2008 The British Library, reference 49.e.15, plate VIII; p48-49 © Seth Joel/Corbis; p50-51 © Virtalis Limited; p54 Whipple Museum of the History of Science, University of Cambridge, Wh.5358.4; p55 (tr) © Werner Forman/Corbis, (br) Royal Astronomical Society/SPL; p58 (b) © Science Museum/Science & Society; p59 © Roger Ressmeyer/Corbis; p60-61 NASA; p62 (b) NSSDC, NASA; p63 (b) © RIA Novosti/TopFoto; p64 (t) Popperfoto/Getty Images; p65 (r) © RIA Novosti/SPL; p65 (tr) © RIA Novosti/TopFoto; p66-67 NASA/SPL; p68-69 STS-114 Crew, ISS Expedition 11 Crew, NASA; p70-71 International Space Station, STS 127, and Earth, crew 27: NASA; p73 NASA; p74 (b) NASA/SPL; p76-77 © Roger Ressmeyer/Corbis; p78 (b) NASA; p79 NASA and The Hubble Heritage Team (STScI/AURA); p80 (tl) NASA, (b) courtesy NASA/JPL-Caltech; p82-83 © Richard Wainscoat/Alamy; p83 (tr) © Photolibrary/Alamy; p84-85 Detlev Van Ravenswaay/SPL; p87 (b) Maximilien Brice, CERN

Edited by Jane Chisholm. Art director: Mary Cartwright. Picture research by Ruth King.

Cover design by Jamie Ball. Digital design by John Russell. With thanks to Rachel Firth and Will Dawes.